The Dorothy and Herbert Vogel Collection

Fifty Works for Fifty States

A joint initiative of the Trustees of the Dorothy and Herbert Vogel Collection
and the National Gallery of Art, with the generous support of the National Endowment for the Arts and the
Institute of Museum and Library Services.

This publication is produced by the
National Endowment for the Arts,
Washington, DC
Editor and Production Manager: Don Ball
Catalogue entries by Mary Lee Corlett
Designed by Fletcher Design, Inc./Washington, DC

Photo Credits:

Cover Image: *Red Cascade* (1996–97) by Pat Steir, a gift to The Speed Arts
Museum in Louisville, Kentucky.

Library of Congress Cataloging-in-Publication Data
The Dorothy and Herbert Vogel collection : fifty works for fifty states /
[editor, Don Ball].
 p. cm.
Includes bibliographical references and index.
1. Art, American--20th century--Catalogs. 2. Vogel, Dorothy--Art
collections--Catalogs. 3. Vogel, Herbert--Art collections--Catalogs.
4. Art--Private collections--Washington (D.C.)--Catalogs. I. Ball, Don, 1964-
N6512.D596 2008
709.73'074753--dc22

 2008035963

Preface

The National Endowment for the Arts and the Institute of Museum and Library Services are proud to support this ambitious project that underscores the remarkable vision of two people committed to acquiring and sharing the art of our time. The generosity shown by Herbert and Dorothy Vogel in their eagerness to distribute their marvelous collection to museums in each state is an inspiring testament to their strong sense of public service. In sharing their passion for material that represents a significant period of art making in the United States, the Vogels are ensuring that people who otherwise might have limited access to works such as these will be able to see, study, and enjoy them. The National Endowment for the Arts is dedicated to ensuring greater access to the arts for all citizens of this country, and the Institute of Museum and Library Services provides resources that enable our nation's museums and libraries to serve their communities with quality programs and collections. What better way to promote our respective missions and honor two patriotic American citizens than through the catalogue and Web-based learning resource for *Fifty Works for Fifty States*.

Dana Gioia
Chairman
National Endowment for the Arts

Anne-Imelda Radice
Director
Institute of Museum
and Library Services

TABLE OF CONTENTS

Foreword

DOROTHY AND HERBERT VOGEL have been extremely generous donors to the National Gallery of Art for almost two decades. Since 1991 the Vogels have given or designated as promised gifts approximately 1,100 drawings, paintings, sculptures, photographs, prints, and illustrated books. Drawn from the extraordinary collection of minimal, conceptual, and post-minimal art they have been assembling for more than forty-five years, these gifts and promised gifts are an essential component of the National Gallery's holdings of contemporary art. Selections from the Vogel Collection have been featured in two special exhibitions at the National Gallery: *From Minimal to Conceptual Art: Works from the Dorothy and Herbert Vogel Collection* (1994) and *Christo and Jeanne-Claude in the Vogel Collection* (2002). Moreover the Vogels' gifts play an important role in our permanent collection installations, greatly enriching the National Gallery's representation of the art of our time.

Dorothy and Herbert Vogel have now expanded their largesse exponentially by making this daring and varied resource available not only to vast museum audiences in the nation's capital but as well to museum visitors throughout the country. Their plan to donate fifty works from their collection to each of fifty art institutions in the United States—*The Dorothy and Herbert Vogel Collection: Fifty Works for Fifty States*—evolved during conversations between the Vogels and Ruth Fine, the National Gallery's curator of special projects in modern art. Through this program, the Vogels are donating a total of 2,500 works by 177 artists. They hope their gifts will significantly enhance the representation of contemporary art in all regions of the country, also adding to the renown of those artists for whose work they have a deep and abiding respect.

Ruth Fine has overseen the realization of the Vogels' massive undertaking, and Mary Lee Corlett, research associate in the department of special projects in modern art, has worked tirelessly on all of its organizational aspects with assistance from department colleague Janet Blyberg. Molly Donovan, associate curator of modern and contemporary art, and Judith Brodie, curator of modern prints and drawings, both have long-standing associations with the Vogels and have been immensely helpful as work has progressed.

We are associated in this undertaking with our colleagues at the National En-

dowment for the Arts (NEA) and the Institute of Museum and Library Services (IMLS), whose chairman and director, Dana Gioia and Anne-Imelda Radice respectively, have joined with us to carry out the Vogels' dream. Through this catalogue, supported by the NEA, and the Web site (**www.vogel50x50.org**), supported by the IMLS, the collectors are able simultaneously to keep their treasures together as a shared presence and make them accessible to widely dispersed audiences. *The Dorothy and Herbert Vogel Collection: Fifty Works for Fifty States* initiative is a model of donor generosity. The National Gallery of Art is delighted to be working with Dorothy and Herbert Vogel in placing works from their landmark collection in museums throughout the country.

Earl A. Powell III
Director
National Gallery of Art

A Word from Dorothy Vogel

WE BEGAN COLLECTING VERY EARLY IN OUR MARRIAGE, in 1962. While Herb had an art background, I did not, and I learned from him. In fact, my first art lesson was at the National Gallery of Art when we came to Washington on our honeymoon.

In 1987 we returned to the National Gallery on our twenty-fifth wedding anniversary, and we looked up Jack Cowart, the National Gallery's head of twentieth-century art at the time. It was because of him we gave many works to the National Gallery in 1991. Since then we have had two exhibitions there: *From Minimal to Conceptual Art: Works from the Dorothy and Herbert Vogel Collection* and *Christo and Jeanne-Claude in the Vogel Collection*. Other works from our collection frequently have been installed as part of the museum's permanent collection.

Over these several years when our works were being catalogued at the National Gallery, it became apparent that the collection is so expansive that no single museum would be able to research and exhibit all of it to its full potential. In order for more of the works to be seen and for the many facets of the collection to be most fully re-vealed, we realized that it would have to be divided among several institutions. With this *Fifty Works for Fifty States* project, we can bring together a huge portion of the collection. Although physically the works will be in fifty locations, there is the added bonus that they will be visible to many people, especially those who cannot travel. Hopefully they will enjoy the experience of looking at these works from our collection and will be inspired.

Before our association with the National Gallery, we had many exhibitions from our collection in sixteen states, coast to coast, and four foreign countries. Because we have experienced the pleasure of displaying our art widely, we like the idea of continu-ing to share our collection throughout the United States this way.

While this book gives an idea of the number of artists in the collection, it does not reflect the depth of their work, and not all of our artists are represented in the project. The related *Fifty Works for Fifty States* Web site will bring together informa-tion about all of the 2,500 works that have been donated to museums as part of the project. In addition to other works that we have given to the National Gallery of Art,

we still have art at home, and while we are not interested in adding new artists, we are still collecting.

We want to thank Earl A Powell III, director, and Alan Shestack, deputy director of the National Gallery, for their support of this project from the very beginning; Dana Gioia, chairman, and Robert Frankel, director, museum and visual arts, of the National Endowment for the Arts, for making this publication possible; Anne-Imelda Radice, director, and Marsha L. Semmel, deputy director for museums and director for strategic partnerships, of the Institute of Museum and Library Services, for their support of the shipping and transporting of the works being given to the fifty institutions, as well as the related Web site.

Our thanks also go to Ruth Fine, National Gallery curator of special projects in modern art, who had the idea for this project, for all she has done to execute it. Mary Lee Corlett, the department's research associate, has attended to every detail, undertaking a tremendous amount of work which she did very accurately with loving care. Research assistant Janet Blyberg also has been helpful in many ways, as were two summer interns, Edward Puchner and Ted Gioia. We also thank Elizabeth A. Croog, general counsel for the National Gallery of Art; Julian Saenz, on her staff; and Jane Gregory Rubin, our long-time lawyer and advisor, for overseeing the legal aspects of these gifts.

Others at the National Gallery with whom we personally have worked on the project over the years and whom we would like to thank include several members of the conservation staff, especially Jay Krueger (paintings), but also Shelley Sturman (objects), Kimberly Schenck (drawings), Connie McCabe (photographs), Julia Burke (textiles), and Hugh Phibbs (matting and framing); in the registrar's office, Sally Freitag, and Gary Webber, who has made many trips to our New York apartment to help transfer our works to Washington. Lyle Peterzell did the extraordinary photography for this catalogue, and we appreciate his enthusiasm for working on the project. The many other people at the National Gallery who contributed to the success of *The Dorothy and Herbert Vogel Collection: Fifty Works for Fifty States* project are noted in Mr. Powell's foreword to this book and Ms. Fine's acknowledgments.

Most importantly, Herb and I want to dedicate this book to all the artists whose generosity and encouragement enabled us to assemble this collection. It is with great pride and pleasure that we give their works from our collection to fifty museums throughout the United States.

Acknowledgments

THE DOROTHY AND HERBERT VOGEL COLLECTION: Fifty Works for Fifty States project has evolved over several years and has drawn an enormous number of participants into its fold. Our greatest appreciation is to Dorothy and Herbert Vogel, for their generosity in sharing their collection with museum-goers throughout the United States, and for sharing their memories, their knowledge, their friendship, and their collection with all of us at the National Gallery of Art.

We are likewise indebted to the 177 artists whose works are included in the gifts documented in this book. We are grateful to them for their creativity and for their generosity in taking the time to respond to our inquiries about their art. We owe extended thanks to those who were called upon many times, especially Edda Renouf, Pat Steir, and Richard Tuttle. We also thank the artists' dealers, estate overseers, and other representatives for information they have provided to us.

At the National Endowment for the Arts, Chairman Dana Gioia suggested the creation of this book. His imagination and encouragement added greatly to the overall success of the project, as did the support of Robert Frankel, director of museums and visual arts; Karen Elias, acting general counsel; and Don Ball, editor. At the Institute of Museum and Library Services (IMLS), Anne-Imelda Radice, director, and Marsha Semmel, deputy director for museums and director for strategic partnerships, expanded the scope of the project to include a groundbreaking Web site. We appreciate their creative input along the way, as well as the contributions of Nancy Weiss, IMLS general counsel.

At the National Gallery of Art, we are grateful to Earl A. Powell III, director; Alan Shestack, deputy director; Elizabeth A. Croog, secretary and general counsel, and Julian Saenz, associate general counsel; and Dave Rada, comptroller in the treasurer's office. I am immensely grateful to two of my departmental colleagues, Mary Lee Corlett, who facilitated every aspect of this immense project with constant dedication and grace; and Janet Blyberg, who was called upon frequently to assist with a wide variety of tasks. Curatorial colleagues Judith Brodie, Carlotta Owens, Charles Ritchie, and Amy Johnston in the department of modern prints and drawings, and Molly Donovan, Verónica Betancourt, and Jennifer Roberts in the department of

modern and contemporary art worked with us at every stage of this project.

For sharing their expertise in preservation and conservation, we thank Hugh Phibbs, Jay Krueger, Kimberly Schenk, Marian Dirda, Connie McCabe, Katy May, and Simona Cristanetti. Sally Freitag, chief registrar, has provided crucial assistance, along with her extraordinary staff of registrars and art handlers, particularly Susan Finkel, whose support in the form of computer searches and downloads was invaluable, Lehua Fisher, and Gary Webber. We also thank Anne Halpern, in the department of curatorial records, whose assistance has also been immensely helpful.

In the department of imaging and visual services we are grateful to Alan Newman and his staff, including Robert Grove, Lorene Emerson, Peter Dueker, Katherine Mayo, and Lyle Peterzell, who returned to the National Gallery for two months to photograph works in the Vogel Collection for this catalogue and for use in the Web site developed for the project (**www.vogel50x50.org**), for which oversight we are grateful to Joanna Champagne and John Gordy in the publishing and Web office. Judy Metro, editor in chief, has likewise been extremely helpful in our work, as has Nancy Deiss in the deputy director's office.

And for their advice and assistance in all matters related to *The Dorothy and Herbert Vogel Collection: Fifty Works for Fifty States*, we are grateful to the National Gallery's chief information officer, Deborah Ziska, as well as staff members Anabeth Guthrie and Steve Konick.

Former National Gallery of Art colleagues Jack Cowart and Laura Coyle offered memories that have aided our work, for which we are most appreciative.

Ruth Fine
Curator of Special Projects in Modern Art
National Gallery of Art, Washington

Building a Collection:
"Every Spare Moment of the Day"[1]

Ruth Fine

THE RENOWNED ART COLLECTION assembled since 1962 by Dorothy and Herbert Vogel has been called "one of the most remarkable American collections formed in [the twentieth] century, one that covers most of the important developments in contemporary art."[2] Two civil servants by profession with no independent financial means, the Vogels have acquired some four thousand objects, primarily drawings. In the early years of their collecting journey, the Vogels provided moral and modest financial support to a number of relatively unknown artists who subsequently would receive international acclaim. Among them are Robert Barry (plates 101 and 113), Sol LeWitt (plate 186), Edda Renouf (plates 56 and 128), and Richard Tuttle (plates 4, 28, 38, 72, and 124), with all of whom the Vogels became close friends. By the 1970s, when the work of these and other artists represented in the Vogel Collection became widely exhibited and recognized by the international art press, Dorothy and Herbert likewise were acknowledged for their early, prescient attention to their work.

As is the case for many collectors, the Vogels started with no intention of building "a collection" per se, but rather to acquire works they admired, with which they wanted to live. The art community's awareness of the limited funds the couple could devote to these acquisitions brought the Vogels considerable admiration, as did their enthusiastic response to a range of contemporary practices, which included work many collectors found difficult to appreciate—new forms employing non-traditional materials such as latex, string, and Styrofoam. Most frequently referred to as collectors of minimal and conceptual art, the Vogels have always had a more expansive reach. They

collected art rooted in abstract expressionism, as exemplified by Michael Goldberg (plates 83 and 194) and Charles Clough (plates 73 and 133); innovative post-minimalist approaches, as seen in the art of Richard Francisco (plates 10 and 182) and Pat Steir (plates 48 and 67); and diverse figurative directions, such as that embraced by Will Barnet (plates 57 and 165) and Mark Kostabe (plate 87), among others.

Since 1975 a dozen exhibitions featuring various aspects of the Vogel Collection have been organized. They are documented in the catalogues that are recorded in this volume's bibliography. These exhibitions generated interest from several museums, eventually prodding the couple to give form to their long-standing intention to place their treasures in a public institution. In 1992 the National Gallery of Art (NGA) in Washington, DC, announced an agreement with the Vogels that established the gallery's stewardship of their collection. Since that date 1,100 paintings, objects, drawings, photographs, prints, and illustrated books have entered the NGA collection or have been designated as promised gifts. During this same period, owing to the Vogels ongoing purchases and the gifts they receive from artists, their collection has doubled in size from some 2,400 works originally brought to Washington, already too many to be reasonably placed in any one institution, to approximately 4,000 objects. Thus the Vogels have worked closely with NGA staff to develop *The Dorothy and Herbert Vogel Collection: Fifty Works for Fifty States*, a program to facilitate gifts of fifty works to one museum in each of the fifty United States.[3] The project has received essential support from the National Endowment for the Arts and the Institute of Museum and Library Services.

SHAPING THE COLLECTION

FIGURE 1: *Dorothy and Herbert Vogel on their wedding day, January 14, 1962.*

In January 1962, twenty-six-year-old Dorothy Faye Hoffman married Herbert Vogel, thirteen years her senior (figure 1). The small synagogue ceremony took place in Dorothy's home town of Elmira, New York, where her father was a stationary merchant and her mother, by then deceased, had been a homemaker. The bride had no particular interest in the visual arts, but rather was focused on classical music and theater. To this day the living stage remains a high priority for her, and, on most Wednesday afternoons from September through June, Dorothy is to be found in the vicinity of 42nd and Broadway attending a matinee. Other ongoing interests include watching ice skating and reading fiction, especially mysteries. By contrast, Herbert's deep immersion in painting and drawing already was in place at the time of their mar-

riage. According to Dorothy, "art is Herby's only interest, except for animals."[4] He immediately set out to share these twin passions with his new wife. She was an eager participant.

His father a tailor, his mother a homemaker, Herbert Vogel (Herb to most of his friends) had grown up in Harlem, on 100th Street between 5th and Madison Avenues, and later on 105th Street. As an adult, he clerked for the United States Postal Service, assigned to several different Manhattan branches until he retired in 1979. Starting in the mid-1950s Herb also took classes in art history at the New York University (NYU) Institute of Fine Arts. Among his teachers were Max Friedländer, Robert Goldwater, and Erwin Panofsky. These brilliant scholars provided him a historical framework for the art-based adventure he and Dorothy began during their honeymoon in Washington, DC, where the National Gallery of Art became the setting for her introduction to old master paintings.

Before his marriage, Herb had frequented the early havens of the so-called abstract expressionists, including Greenwich Village's Cedar Tavern and the artists' club, and he also had journeyed to the Provincetown, Massachusetts, artists' community. He still speaks with special warmth about his association with Franz Kline and David Smith. By the close of the fifties, Herb was painting nights and weekends in a work space he set up in the Bronx apartment where he was living in 1960 when he met Dorothy, a librarian for the Brooklyn Public Library system with bachelor's and master's degrees in library science from Syracuse University and the University of Denver respectively.[5] (She retired in 1990.)

Dorothy's association with Herb introduced her to the practice of painting as well as the study of art history. Shortly after their marriage, the couple rented a studio at 41 Union Square, and Dorothy, like Herb, took weekly painting and drawing classes at NYU. After work and on weekends they developed their budding talents as abstract painters. Dorothy's hard-edged style presented a strong contrast to Herb's colorful expressionism. In addition to the time in their studio, they devoted part of each weekend to prowling New York art galleries, then a far smaller world than now. Dorothy stated, "It was 57th Street, and then up Madison and the 70s, mainly."[6] They started with visits to venues that had been established by the end of the 1950s, including Grace Borgenicht, Sidney Janis, Tibor de Nagy, Betty Parsons (an artist herself [see plate 16]), Poindexter, Stable, and Zabriskie. But they quickly expanded their range and kept abreast of shows at Bykert, Leo Castelli, Paula Cooper, Virginia

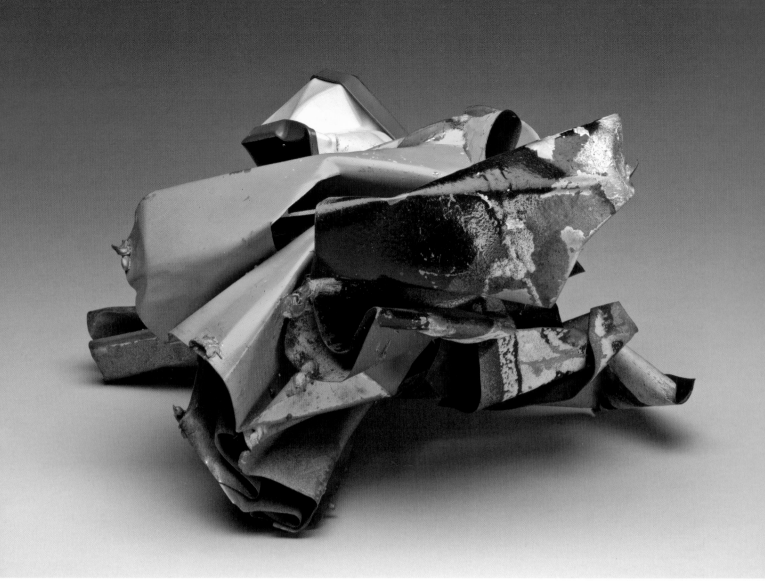

FIGURE 2: *John Chamberlain*, Untitled, *1962, crushed car metal on wood base, National Gallery of Art, Dorothy and Herbert Vogel Collection.*

Dwan, Rosa Esman, Fischbach, Green, OK Harris, Kornblee, and Holly Solomon.[7] "In the beginning it was more looking than buying," Dorothy remembered. "I was just learning and Herby was the one who thought of perhaps buying."[8] They occasionally visit galleries today, but for the past decade the Vogels have tended to learn about new art and artists directly from artist friends.

Herb made a few art purchases before he married Dorothy, among the earliest of which was an untitled painted wood wall piece by Giuseppi Napoli (plate 167). To celebrate their engagement the Vogels jointly selected one of Pablo Picasso's ceramic vases; and their initial purchase as a married couple, just one month after the event, was an untitled crushed-car metal sculpture by John Chamberlain (figure 2), now in the National Gallery of Art's collection.[9] Its selection marked Dorothy's first visit to an artist's studio. Chamberlain was far less well known than he subsequently would become, and in 1975 Suzanne Delehanty, then director of Philadelphia's Institute of Contemporary

Art (ICA), applauded this as a most daring acquisition for so early a date.[10] The Vogels installed their few purchases and Herb's paintings in the living room of what had been Dorothy's Brooklyn apartment, into which Herb settled after their marriage.

Within a year, the couple moved across the East River to an interim Manhattan space, and by the close of 1963 they were living in the Upper East Side one-bedroom apartment they inhabit to this day. Two months into their marriage they adopted their first cat, and since have shared their lives with as many as seven exotic breeds simultaneously, including flame point Himalayan, Siamese, Manx, Abyssinian, and Rex. (See John Salt's *Untitled (Vogel Living Room Drawn from Memory)*, 1972, plate 140.) Several of the cats have been named for nineteenth- and twentieth-century artists such as Cézanne, Renoir, and Whistler, because either the cat's appearance or personality reminded the Vogels of its namesake's work. Their menagerie over the years also has included some twenty turtles from around the world and a diverse community of tropical fish (figure 3).

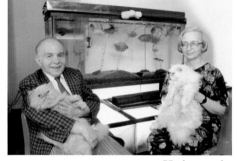

FIGURE 3: *Herbert and Dorothy Vogel with cats, in front of fish and turtle tanks, 1992.*

From the start, the Vogels were committed to having art function as an active and engaging presence in their lives: "We had a lot of flexibility and we didn't buy a lot of big furniture that would interfere with the collection. We did not buy, for instance, mirrors [to] compete with the art work."[11] Their furniture consisted of multipurpose pieces, such as a sofa constructed of flat wooden panels on and against which pillows would be arranged for seating. These horizontal and vertical panels also could function as tables and backdrops, respectively, for small sculpture; and a narrow shelf atop the headboard of their bed was similarly employed (figure 4). Their apartment essentially became an art gallery, with one wall each devoted to Dorothy and Herb's abstract paintings. According to Dorothy, "our obsession was really our own work, in addition to having our jobs. And then we just started buying other artists' work…. I think I got more enthused about collecting than I was about painting…. And you know, collecting is not easy, it's a lot of hard work, too."[12]

After about three years of dividing their weekends between studio work and gallery visits, Dorothy and Herb realized that practicing art required more substantial dedication and time than they cared to commit. They also were finding more immediate pleasure and long-term gratification in the hours they spent looking at other artists' work than in those they devoted to creating their own. So in 1965 the Vogels gave up the Union Square studio and began "[to put] together, through passion and

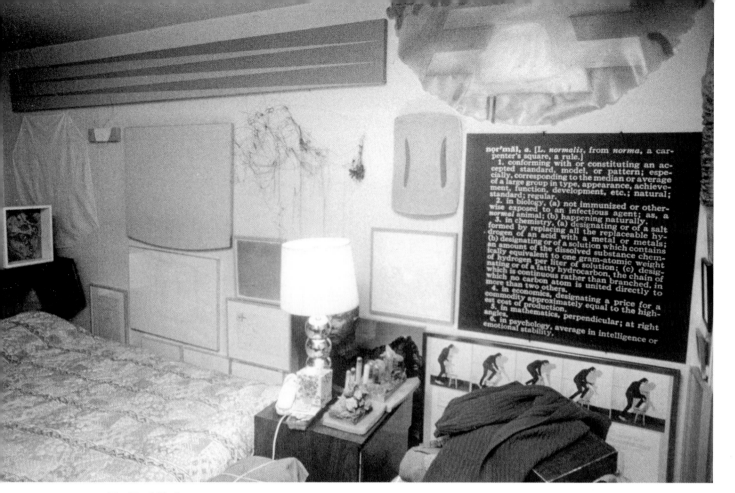

FIGURE 4: *The Vogels' bedroom with works by Leo Valledor, Gary Stephan, Richard Tuttle, Robert Mangold, Alan Saret, Ron Gorchov, Joseph Kosuth, Vito Acconci, Joseph Beuys, and Peter Hutchinson, among others, c. 1975.*

trust in their own judgment, an extraordinary collection," to quote the artist Richard Nonas (plates 148 and 176).[13]

Herb's salary (and subsequently his pension) served as the couple's resource for art acquisitions, and Dorothy's was directed to more pedestrian living expenses like rent, subway fare, and food. She recently commented that "I paid the bills and Herby was the mad collector who bought the art."[14] Their limited means and space mandated parameters for what they would buy. They learned a crushing lesson early: having acquired a vertical sculpture by Sol LeWitt, they discovered it was too tall to stand in their living room. They subsequently exchanged it for a horizontal piece, *Floor Structure Black*, 1965.[15] And LeWitt made a smaller version of the vertical work for them. Drawings soon became the Vogels' focus, eventually making up approximately three-quarters of their collection, which in great measure is "a record of ideas rather than an assembly of objects," as it includes many studies for large scale and environmental works.[16]

When the Vogels started their journey they were part of a relatively small community of people interested in looking at and collecting contemporary art, but the number of participants has grown radically since 1962. This becomes evident when comparing the occurrence of international art expositions now with then (when the

Venice Biennale was one of very few); and by considering the expanding number of art journals over these years, as well as the increase in their listings for galleries and for exhibition reviews. (The two journals Herb has consistently read are *Art News* and *Art in America*.) A primary signifier of the Vogels' prescience as collectors is their early passion for drawings, which were of considerably less interest to the collecting community in 1962 than now. But even today drawings tend to appeal to a particular kind of collector only—one who prizes the intellectual challenges and visceral pleasures possible at the origins of the artistic process over a more finished presentation.[17]

Given their essential focus on drawings, the Vogels have nonetheless tried to acquire examples of every aspect of "their" artists' practices, works that reveal development over time. Martin Johnson's art, for example, is represented in the collection by paintings, sculptures, and works on paper that incorporate collage and photography (plates 86 and 142). And according to Barry, "looking through the things [the Vogels have] purchased over the years gives a sense of the way my work has developed…. They have many smaller, more intimate pieces—the personal things artists don't always show in a gallery. I like that quality and that sense of adventure…. I remember Sol LeWitt saying to me, 'I think [the Vogels] have the best collection in the country.'"[18]

The Vogels credit the directions in which their collection moved to their friendships with artists, in particular Dan Graham (plate 98) and LeWitt. For approximately one year around 1965, Graham managed the Daniels Gallery which Dorothy and Herb frequented to look at art and also to engage in conversation. Subsequent to the gallery's closing, the Vogels and Graham continued to get together, often sharing dinner. The essential subject of their discussions was the emergence of new art forms, especially the work of Donald Judd and Robert Morris. When the Vogels decided to purchase a LeWitt sculpture after the closing of his first solo show, held at Daniels in 1965, the gallery was about to cease operation. So Graham suggested they contact the artist and conduct the transaction directly, which they did. LeWitt had met Herb before, "in the late fifties. [He] was painting at the time. He was interested in seeing my work, so I invited him to my studio. He was then as he is now—enthusiastic."[19] The friendship thrived and, during the last decades of LeWitt's life, he and Herb spoke by telephone virtually every Saturday morning, except when the artist was abroad. Similarly Herb has maintained frequent contact, often by telephone, with several other artists, especially Tuttle (figure 5). The couple's collection of his art is unparalleled.[20]

The Vogels had purchased a painting by Will Insley (plate 37) from the Stable

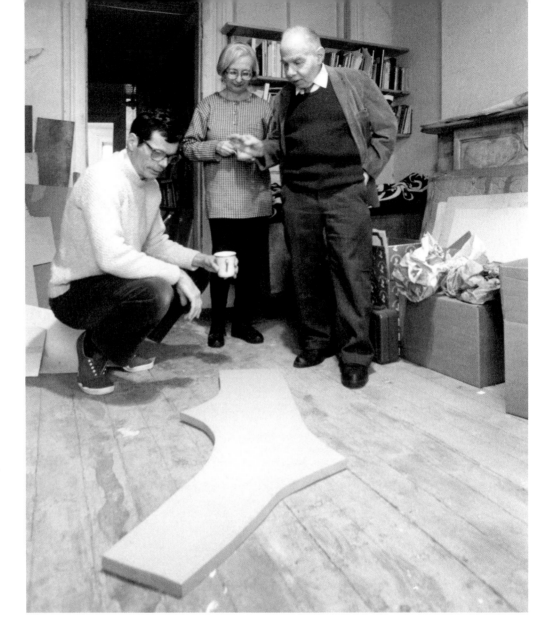

FIGURE 5: *The Vogels with Richard Tuttle in his New York studio, early 1980s.*

Gallery shortly before the LeWitt acquisition, but their serious collecting started with that August 1965 studio purchase, which also was LeWitt's first sale of his art.[21] He delivered the sculpture to the Vogels' apartment with the help of his artist friend, Robert Mangold (plate 31), who owned an automobile. Shortly thereafter he and Sylvia Plimack Mangold (plate 170) would be counted among the Vogels's growing community of artist friends.

Dorothy and Herb love to talk directly with artists, and they often reiterate how these conversations are essential not only to their understanding of individuals' oeuvres, but also to the expansion of their broader aesthetic appreciation and knowledge of the field. An avid collector himself, LeWitt's interests, like Graham's, were immensely influential on the Vogels, who always responded to his suggestions of exhibitions they should see. An important one was Seth Siegelaub's now legendary

"January Show," where they first encountered the work of Barry, Douglas Heubler, Joseph Kosuth, and Lawrence Weiner (plate 12).[22]

At the start of the seventies the Vogels gave up European travel to enlarge their art-buying budget.[23] They were being invited to virtually every contemporary art opening at New York galleries and to important museum celebrations as well. Always together and notably small in stature (both barely reach five feet tall), the Vogels were recognizable and stood out in any crowd. At times Herb delighted "in showing up at openings exuberently 'clashed,' as he puts it, in plaid pants and a houndstooth overcoat."[24] Now that Dorothy is in her early seventies and Herb in his mid-eighties, they have slowed down somewhat, but in their heyday of some thirty-five years, they went to as many as twenty-five shows a week, where they would often encounter artists.

It is common for artists to work in galleries to support their creative work early in their careers, and in addition to Graham at Daniels, the Vogels met Lynda Benglis (plates 65 and 85) when she was working at Bykert, and William McWillie Chambers (plate 129) and Peggy Cyphers (plate 158) when they worked for Grace Borgenicht and John Weber, respectively. Following LeWitt, it became commonplace for artists to introduce their artist friends to these enthusiastic collectors; and the Vogels, of course, would be eager to make studio visits to those artists whose work they knew and admired.[25] Years after they met Nonas at his 1971 show at 112 Green Street, an alternative exhibition space, the artist reported that "[Herb] comes to visit me once a month, he's consistent. The collection is a real commitment for them, the works are their children, their pride." Nonas also mentioned the Vogels' comments as early as 1981 about placing their art in a public institution; he thus viewed his presence in the collection as "a big responsibility…[part of] a record of American art during these twenty years."[26]

The Vogels have focused on artists working in New York City, where studio visits could be an essential part of their collecting experience.[27] European and American artists living elsewhere that are represented in the collection generally visited New York (or were briefly based there), met the Vogels and saw their collection, and subsequently brought work to show them. In addition to buying works directly from artists and galleries, the Vogels often bid at benefit auctions supporting charities, political causes, and arts organizations.

Not intending to make a political statement of any kind, but by buying art they

FIGURE 6: *The Vogels with Pat Steir in her New York studio, April 4, 2008.*

admire Dorothy and Herb have assembled an impressive collection of art by women.[28] Edda Renouf and Pat Steir, both of whose work the couple collects in depth, have spoken enthusiastically about their studio visits, and the strength, in particular, of Herb's "eye." Renouf described first looking at her paintings with them in the 1970s this way: "They took their time...looking at my works with full attention [which was] very inspiring to me and the beginning of our long-lasting friendship based above all on our mutual devotion and understanding of art."[29] Steir (figure 6), who also met the Vogels in the 1970s, recently commented that for them collecting "became much more than a hobby, it is a profession. It is extraordinary they could see so well."[30]

The couple has, together, chosen everything in the collection apart from artists' gifts and occasional exceptions when Herb (the more inveterate studio visitor) selects a work in Dorothy's absence. Their judgment is complementary, each agreeing that the other is better at selecting a particular kind of art. As they describe it, the breakdown reflects their youthful painting styles: Herb is in the forefront when selecting more flamboyant post-minimalist art, for example by Lucio Pozzi (plates 54 and 123), with Dorothy more keen when considering work of a conceptual and minimal orientation, especially by LeWitt.

Dorothy's librarian background undoubtedly nourishes her commitment to maintaining documentary files on artists represented in the collection (and many who are not). She assiduously collects and organizes exhibition announcements and clips journal and newspaper articles, including solo and group show reviews. Housed at

the Archives of American Art (AAA) in Washington, DC, this rich resource is peppered with personal correspondence. [31] And in addition to postcards enhanced with sketches that have been accessioned by the NGA, the rest of the Vogels' postcards from artists are housed in the NGA Archives and currently number approximately 160 pieces, many of which likewise are annotated with drawings.

Dorothy and Herb's 1981 "Collection of Thoughts on the Vogel Collection" in the *4 x 7 Selections from the Vogel Collection* exhibition catalogue beautifully articulates how the couple's lives are defined by their collecting:

> Collecting is not just buying art works but it is also the whole experience of being part of the art world. It means going to artists' studios, openings, galleries, and museums, and seeing, reading, talking, and thinking about art every spare moment of the day. It means rushing through dinner to go to an opening, continually filling out loan forms, clipping articles from newspapers and magazines for our archives, constantly meeting new people, strangers stopping us in the street because we met them years ago at a lecture or an opening, missing a movie or a play because there is no time, getting up early on Sunday morning because there is no time, and having to schedule supermarket visits or else we would have no food in the house. Our life is indeed hectic, but we love it. We are constantly seeking new art and artists and have so far been able to find and collect it…. It is most gratifying to be a part of the art world of our time, to inspire some artists, collectors and curators.[32]

THE COLLECTION GOES PUBLIC

Around 1970, increasing numbers of artists started asking the Vogels to see the collection. Renouf remembered that "it was immediately clear to me that for the Vogels, their apartment was not only for them to live in; it was for housing what was most essential and important in their lives—the art works.[33] Once people started visiting them to see the collection, they would tell others, so within a very short period of time, there were many visitors, who might join the Vogels for dinner, first at home, and then at local German or Chinese restaurants.

Knowledge of the collection quickly spread, leading to visits from international museum professionals—from Europe at first, particularly Belgium, Germany, and Holland. "When curators come from Europe they visit the Museum of Modern Art, the Whitney, and the Vogels' apartment," Nonas reported.[34] Despite this interest from foreign curators, apart from individual works, the Vogel Collection was not exhibited abroad until 1987 when *Beyond the Picture: Works by Robert Barry, Sol LeWitt, Rob-*

ert Mangold, Richard Tuttle from the Collection, Dorothy & Herbert Vogel, New York, opened at the Kunsthalle, Bielefeld, Germany. On this side of the Atlantic, however, the collection was brought to public view more than a decade earlier.

From mid-April through mid-May 1975, the first Vogel Collection exhibition was installed in Manhattan at The Clocktower gallery (figure 7). *Selections from the Collection of Dorothy and Herbert Vogel* initiated a *Collectors of the Seventies* series at this SoHo exhibition space sponsored by the Institute for Art and Urban Resources.[35] According to the accompanying catalogue, the show was selected and installed by Dorothy and Herb. It focused on the minimal and conceptual aspects of the collection and included one work by each of forty-two artists, among them Stephen Antonakos (plates 49 and 185), David Rabinowitch (plate 55), and Ruth Vollmer

FIGURE 7: *Dorothy and Herbert Vogel at The Clocktower with a drawing by Philip Pearlstein behind them, 1975.*

(plate 104). A statement by Alanna Heiss, the institute's president, referred to the Vogels as "underground figures in the New York art world for years [who] have been collecting brilliantly and obsessively since 1962."[36] Later that year, a larger but similarly focused show, *Painting, Drawing and Sculpture of the '60s and the '70s from the Dorothy and Herbert Vogel Collection*, organized by Philadelphia's ICA, included more than 200 of approximately 500 works then in the collection. Delehanty praised the collection in the catalogue as "an excellent educational resource for the study of aesthetic activities during the last decade." And in a April 21, 1975 letter to the Vogels, Jack Boulton, director of the Contemporary Arts Center in Cincinnati, Ohio, to which the ICA show traveled, praised them for exemplary "scholarly stewardship toward building a collection."[37]

In an effort to correct the already commonly held misconception that the Vogel Collection consists entirely of the minimal and conceptual art included in The Clocktower and ICA shows, in 1977 Bret Waller, director of the University of Michigan Museum of Art, selected a more diverse group of artists for *Works from the Collection of Dorothy and Herbert Vogel*, including, John Torreano (plate 80) and Judy Rifka (plate 44), among others of a post-minimalist orientation. Nevertheless, even today, the public continues to associate the Vogel Collection with minimal and conceptual art.

Exhibitions continued through the 1980s, including the *20th Anniversary Exhibition of the Vogel Collection*, organized in 1982 by the Brainerd Art Gallery at the State University College of Arts and Science in Potsdam, New York. It also marked the twentieth anniversary of the couple's marriage, and was accompanied by a handsome catalogue designed by Barry. *Drawings from the Collection of Dorothy and Herbert Vogel*, at the University of Arkansas at Little Rock in 1986, celebrated the works on paper in the collection, and the catalogue included individual brief essays about every artist in the show. It was the most substantial publication about the collection to that date. The decade closed with *From the Collection of Dorothy and Herbert Vogel*, organized in Dorothy's hometown of Elmira in 1988 by the Arnot Art Museum, which traveled to four additional venues through 1989. By this time the Vogels and their collection had been featured in many mass media publications, including *New York* and *People*.[38] And they were frequent participants in lecture series and panel discussions about collecting contemporary art.

A dramatic change to the Vogels' apartment was slowly taking place. When

drawings that had been framed for public presentation were returned at the close of these several exhibitions, the sheets took up much more space than previously, when they were stored unframed in folders and boxes. As the 1970s turned into the 1980s the Vogels had no choice but to maintain part of their collection in exhibition shipping crates, which gradually displaced their furniture. Eventually their apartment was transformed from its function as an art gallery to that of an art warehouse. This circumstance, plus their advancing ages, caused Dorothy and Herb to think more seriously about a permanent home for their treasures.

GIFTS TO THE NATION I:
THE NATIONAL GALLERY OF ART, WASHINGTON

Over the years, major institutions such as New York's Solomon R. Guggenheim Museum had expressed interest in acquiring the Vogel Collection.[39] The fit never seemed quite right to Dorothy and Herb, however, until Jack Cowart, then curator of twentieth-century art at the NGA, initiated a conversation about the National Gallery's expanding representation of contemporary art. As curator at the Wadsworth Atheneum in the early 1970s, Cowart had followed minimal and conceptual art through LeWitt, Carl Andre, Morris, and Lucy Lippard, and he certainly was aware of the Vogels and their collection before he actually met them, probably in the late 1970s.[40] Both Cowart and the Vogels remember talking to each other at a Museum of Modern Art luncheon in the mid-1980s, around the time the museum reopened after renovation. Cowart suggests he first visited the Vogel's apartment around 1986. The following year, when they were finalizing their twenty-fifth anniversary celebration—a return visit to their honeymoon city—Dorothy and Herb scheduled an appointment with Cowart. He enthusiastically introduced them to the workings of the NGA and to colleagues engaged with contemporary art.[41] Further conversations about the NGA as a possible home for the collection ensued. Two things that made the National Gallery attractive to the Vogels were the free admission to everyone at all times and a policy against deaccessioning objects (other than duplicate prints) that are accepted into the collection.

When the Vogels visited the NGA in 1962, the East Building had yet to be designed. Apart from a selection of prints and drawings, contemporary artists essentially were represented in the NGA collection by artists of Picasso's generation. Alive, but quite advanced in years, their art bore no relationship to that of the young radicals the

Vogels were starting to collect. This circumstance changed drastically when the East Building opened in 1978, after which contemporary art maintained a siable place in the NGA's embrace. By the time the aquisition of the Vogel Collection was under discussion, exhibition and collecting practices at the National Gallery had expanded to include a substantial representation of art from the later twentieth century. Nevertheless, the Vogels' interests presented the potential for a massive departure from previous concerns, which primarily had focused on the abstract expressionist generation.

As the conversation about a relationship between the Vogels and the NGA progressed, it became clear that it was not possible to view more than a small fraction of the collection. While paintings and drawings covered their apartment walls, and objects were suspended from ceilings and resting on every available flat surface (figure 8), much of the collection was buried. According to Cowart, "There was this mountain of wrapped art. Crates on top of crates on top of boxes. The actual apartment had reduced itself to maybe 15 square feet. You had these tantalizing glimpses of things—a Donald Judd sculpture or a Michael Lucero ceramic piece."[42] For the collection to be seen in its entirety, the art had to be transferred either to a warehouse or to the National Gallery itself, and the latter was determined to be the best solution.

In late summer 1990, two staff members from the NGA registrar's office, Anne Halpern and Gary Webber, made a reconnaissance trip to the Vogels' apartment (figure 9). They calculated that it would require five truck shipments to bring the collection to Washington—and it did. [43] More than 2,400 works of art were transferred in September and October, followed by many months of intense activity on the part of Cowart and several assistants—as well as staff from multiple departments—working to unpack, check in, and provide museum-appropriate housing for the collection. The Vogels traveled back and forth from New York to provide assistance and information. Laura Coyle, then a member of the twentieth-century art department's staff, remembered how the experience "made me realize that passion, commitment, vision, and

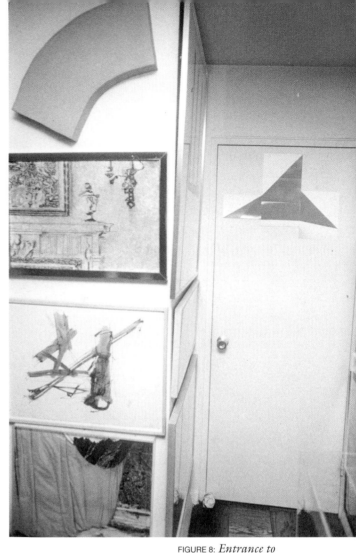

FIGURE 8: *Entrance to the Vogel apartment, c. 1975, with works on display at left (top to bottom) by Richard Tuttle, Richard Artschwager, Mark DeSuvero, and Christo; a work by Judy Rifka is on the door.*

FIGURE 9: *Gary Webber packing art for transfer from the Vogel apartment to Washington, 1992; the collectors are looking on, with Jack Cowart and associate in background.*

the ability to set priorities and make sacrifices are more important than wealth when it comes to building an art collection. Though it never hurts to have money also."[44] Once the art was properly stored in Washington, it was reviewed by everyone involved in NGA collection-building decisions: curatorial staff; J. Carter Brown and Roger Mandell, director and deputy-director at the time; and eventually the trustees.

J. Carter Brown heralded the National Gallery's relationship with the Vogels at a National Press Club lunch on January 7, 1992, and the acquisition was included in a press release two days later. Through gift and partial purchase (the former far outweighing the latter) the NGA had acquired from Dorothy and Herbert Vogel 214 works by Andre, Richard Artschwager, Benglis, John Cage, Christo, Judd, LeWitt, Robert Mangold, Sylvia Plimack Mangold, Joel Shapiro, and Tuttle, and had entered into an agreement that made other works available to the National Gallery. Given the understanding that the collection was too large ever to be accessioned in its entirety, conversations ensued about placing portions of the Vogel's art with other institutions.

The first Vogel Collection exhibition in Washington was organized by Mark Rosenthal (who had succeeded Cowart as curator of twentieth-century art), his associate Molly Donovan, and the present writer. On view in 1994, *From Minimal to Conceptual Art: Works from the Dorothy and Herbert Vogel Collection* highlighted what had remained the best-known aspects of the collection (figure 10). In 2002 Donovan organized *Christo and Jeanne-Claude in the Vogel Collection*. And over the years, many works acquired from the Vogels have been installed in the East Building's perma-

nent collection galleries, including LeWitt's *Wall Drawing No. 681C. A wall divided vertically into four equal squares separated and bordered by black bands. Within each square, bands in one of four directions, each with color ink washes superimposed.*, which has been on view at the entrance to the auditorium almost without interruption since 1993.[45] According to Donovan, "The Vogel Collection not only deepened our holdings of numerous artists' work, but greatly expanded our relationships with those artists as well. In countless cases the National Gallery has built strong ties to the artists in the Vogel Collection as a direct result of the Vogels' beneficence."[46]

The NGA worked closely with other institutions both on individual loan requests, and in support of exhibitions drawn entirely from the Vogel Collection, such as *The Poetry of Form: Richard Tuttle's Drawings from the Vogel Collection* (1992), which opened at the Instituto Valenciano de Arte Moderno, Valencia, Spain, was on view at the Indianapolis Museum of Art (1993), and traveled to the Museum of Fine Art, Santa Fe (1995). *Women Artists in the Vogel Collection* (1998) was organized by Brenau University in Gainesville, Georgia. Both of these exhibitions combined works that are part of the National Gallery's holdings and those that remained on deposit, now to be part of the *Fifty Works for Fifty States* program.

Dorothy and Herb continue to travel to Washington twice a year to meet with NGA staff about a mélange of issues related to the collection, including conservation discussions—primarily with Jay Krueger, senior conservator of modern paintings—and oral history interviews that will be housed in the National Gallery Archives. Before each trip they send a list of works from their collection that they would like to see during their stay, what has become Dorothy and Herb's way to visit works they think of as "old friends." Their recent acquisitions are brought from New York to the NGA on a periodic basis. By the close of 2007, a total of 1,100 works had been acquired by the NGA or designated as promised gifts, and plans for *The Dorothy and Herbert Vogel Collection: Fifty Works for Fifty States* were in place.

GIFTS TO THE NATION PART II:
THE DOROTHY AND HERBERT VOGEL COLLECTION:
FIFTY WORKS FOR FIFTY STATES

As the twentieth century turned into the twenty-first and the Vogel Collection had reached a critical mass of some 4,000 works, Dorothy and Herb were ready to finalize plans for donations to additional museums. A broadly based philanthropic effort

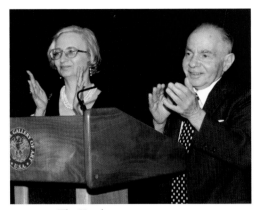

FIGURE 10: *The Vogels at the opening reception of* From Minimal to Conceptual Art: Works from the Dorothy and Herbert Vogel Collection, *May 25, 1994.*

seemed best, one that would offer opportunities for works by the artists they admire to be seen on a regular basis throughout the country. Their decision was to donate fifty works (many of which consist of multiple parts) to the permanent collections of one institution in each of the nation's fifty states. Titled *The Dorothy and Herbert Vogel Collection: Fifty Works for Fifty States*, the project provides for a total donation of 2,500 drawings, paintings, objects, prints, and photographs by 177 artists.

The Vogels' plan is modeled on Samuel H. Kress's vision of making his entire collection of old master paintings and sculptures available to the public, for which purpose the Kress Foundation was chartered in 1929. When the NGA opened in 1941, 375 paintings and 18 sculptures from the Kress Collection were on view. Like the Vogel Collection, the Kress Collection continued to grow, and by 1961 when the Kress Foundation's gifts were completed, paintings and sculptures had been distributed to forty-four institutions throughout the United States, including twenty-three colleges and universities, plus the NGA.[47] The Vogels hope their national program will enable museums to exhibit work by contemporary artists they otherwise might not have been able to acquire, just as the Kress Foundation's gifts enables them to showcase earlier masters.

Dorothy and Herb used a range of personal criteria to determine institutions to which they would offer gifts. Some had exhibited aspects of the collection or had invited the Vogels as speakers; others were staffed by professionals the couple had worked with over the years, or were in cities that had meaning to one or the other of them, like Buffalo, where Dorothy earned her bachelor's degree. For some states they based their decisions on research that identified institutions with a demonstrated interest in contemporary art.

The enthusiasm of Dana Gioia, NEA chairman, generated the idea for this publication, and Anne-Imelda Radice, director of the IMLS, with equal vigor, offered to fund the dissemination costs of the project.[48] Radice also suggested the development with IMLS support of a groundbreaking educational Web site to document the project: **www.vogel50x50.org**. The site links the fifty institutions across the country in a major collaborative undertaking that at the outset echoes the content of this book. But each institution will have the option over time to expand its segment of the site, adding new data about the works in its gift. In that way the site eventually will be able

to carry a complete record of *The Dorothy and Herbert Vogel Collection: Fifty Works for Fifty States* initiative.

"Insight, Persistence & Daring: The Dorothy and Herbert Vogel Story" is the apt title of a recent piece about the Vogels' collecting practice.[49] But a more rigorous version of that story is told in a feature-length documentary film, *Herb and Dorothy*, produced and directed by Megumi Sasaki, that is in its final production stage as this book goes to press.[50] Any full description of the couple must convey their capacity for friendship. It is apparent from the many works of art they have received as gifts from artists to mark birthdays, anniversaries, and other special events, many of them bearing affectionate inscriptions. Friendships are further documented in the Vogel Collection archives at the AAA and the NGA, where letters, notes, and postcards from artists and their spouses (and occasionally their children) mention wonderful dinner parties at the couple's apartment, thank them for their support, and report on the writers' travels, often emphasizing art they encountered that particularly excited them. All of this, taken together, offers a picture of Dorothy and Herb as a gregarious couple who embrace artists and their clans as family.

The Vogels' warm and daring *modus operandi* is also apparent to viewers of the collection who have never actually met Dorothy or Herb, like Lyle Peterzell, who photographed the art for this volume. He commented:

> I was only vaguely aware of the Vogel's as major modern collectors…going into this project. I don't think anything could have prepared me for the variety and intensity of the art…. It became apparent after a few days of shooting that the pieces were having an impact on me…. the common thread seemed to be that, although these were serious works of art, they came from a free-spirited, calm, and joyful place. It was hard to not feel good just being around them, and leave feeling uplifted at the end of the day.[51]

Long admired for the distinctive nature of the collection they assembled over forty-five years, and for their many supportive efforts on behalf of artists, Dorothy and Herbert Vogel were counted among the world's top art collectors in several *Art News* annual listings, and they are included in James Stourton's recent text, *Great Collectors of our Time: Art Collecting Since 1945*.[52] *The Dorothy and Herbert Vogel Collection: Fifty Works for Fifty States* is an initiative of creative generosity that undoubtedly would also place the Vogels on any proposed list of the world's top art benefactors, celebrated and influential participants in the arena of contemporary art.

POST SCRIPT

The National Gallery of Art's April 2008 press release about *The Dorothy and Herbert Vogel Collection: Fifty Works for Fifty States* listed the first ten museums to which the Vogels were making donations from their collection. Its publication in the art press immediately generated a flurry of requests from museum staff throughout the country, eager to become part of the project. By then, however, the Vogels already had determined the additional forty institutions, but had yet to contact them, engaged as they were in the process of finalizing object lists to include in the letters offering their gift.

As this book goes to press all fifty institutions have accepted the Vogels' generous gift offer and the distribution of the works of art to museums is underway. Exhibitions including these gifts are planned, selectively in upcoming shows of recent acquisitions (in advance of exhibiting the gift as a whole), as well as in special exhibitions featuring the entire gift. "Sharing it Out" by Louise Nicholson in the July 2008 issue of *Apollo* quotes Dorothy summing up the *Fifty Works for Fifty States* project as "50 different entities but still our collection, brought together by a website."[53] And also this book. Reinforcing the connectedness of the collection, communications already are taking place between recipient museums; and curatorial staff are in contact with artists whose work is included in the collection, eager to learn more about the art they received. Thus, the vision of *The Dorothy and Herbert Vogel Collection: Fifty Works for Fifty States* project as a way of keeping the Vogel Collection together while also sharing it throughout the country is taking shape.

Additionally, *Herb and Dorothy*, the 85-minute documentary film directed by Sasaki, which includes lengthy interviews with the couple and several of their artist-friends, was previewed in June 2008 at the Silverdocs film festival in Silver Spring, Maryland. Following two showings (one in a packed 400-seat auditorium), the film received the Audience Award for the festival's most popular feature-length presentation. Dorothy and Herb, who attended the festivities, were given standing ovations from the audiences at the end of each viewing. Sasaki closed the film with an announcement of *The Dorothy and Herbert Vogel Collection: Fifty Works for Fifty States* project, sparking questions and comments during the discussion periods following the viewings that were equally attentive to the couple's generous gifts to museums throughout the country as they were to Sasaki's extraordinarily warm and cogent rendition of the Vogels' focused life as collectors.

NOTES

[1] The title quotation is from Dorothy and Herbert Vogel, "A Collection of Thoughts on the Vogel Collection," *4 x 7 Selections from the Vogel Collection* [exh. cat.:William Paterson College Ben Shahn Gallery] (Wayne, New Jersey, 1981), unpaginated. Typographical errors and misspellings in the published text have been corrected with approval from the Vogels.

[2] Edward J. Sozanski, "The Simple Collectors," *The Philadelphia Inquirer* (July 26, 1994), E1.

[3] Edward Wyatt, "An Art Donor Opts to Hold on to His Collection," *The New York Times* (January 8, 2008), B1, reports that Eli Broad announced his intention to maintain his collection in a foundation that will make loans to museums, preferring the works be on view in a range of institutions rather than owned by and held in storage at one. The Vogels' goal is similar, but they hope to achieve it by placing ownership and responsibility for the art in the hands of multiple institutions.

[4] Dorothy Vogel in a tape-recorded interview by the author on January 29, 2001. An interview with Herbert also was made that day. The Vogels describe this as the first time each of them was interviewed individually. Additional individual interviews were recorded on June 20, 2001, along with a joint interview on June 2, 2003, for the National Gallery of Art Archives Oral History Program. Subsequent endnotes reference these interviews as DV followed by the interview date. Other data in this essay is based on conversations with one or both of the Vogels over the past eighteen years, in person, by telephone, and via e-mail. The accuracy of my memory and undated notes have been confirmed by the collectors.

[5] The Vogels met at a social for vacationers at Tamiment, a resort in the Pocono Mountains that Dorothy had visited. Herb had not, but he read about the event in the *New York Post* and thought it would be a good place to meet people. He was right.

[6] DV, June 20, 2001.

[7] In addition to those identified in the text by their eponymous gallery names, Klauss Kertess, director of Bykert Gallery from 1968 through 1975, and Richard Bellamy at Green Gallery were helpful and influential in these early years of the Vogels' collecting.

[8] DV, e-mail to author, April 14, 2008.

[9] Accession number 2007.6.96.

[10] Suzanne Delehanty, "Foreword," *Painting, Drawing and Sculpture of the '60s and the '70s from the Dorothy and Herbert Vogel Collection* [exh. cat., Institute of Contemporary Art, University of Pennsylvania](Philadelphia, 1975), 3.

[11] DV, June 20, 2001.

[12] DV, June 20, 2001.

[13] Nonas in *4 x 7 Selections from the Vogel Collection*.

[14] DV, telephone conversation with author, April 11, 2008.

[15] Accession number 1991.241.53.

[16] Delahanty, Foreword, 4.

[17] Werner H. and Sarah-Ann Kramarsky formed a major drawings collection during a similar time frame as the Vogels. They, too, have donated or promised much of it to museums. See Amy Eshoo, ed. *560 Broadway: A New York Drawings Collection at Work, 1991-2006*, New York, New Haven, and London, 2008. Kramarsky's Fifth Floor Foundation is establishing a Web site highlighting the importance of drawings: www.aboutdrawing.org.

[18] Barry in *4 x 7 Selections from the Vogel Collection*, unpaginated.

[19] LeWitt in *4 x 7 Selections from the Vogel Collection*, unpaginated.

[20] The Vogels gifts of Tuttle's art to the NGA number almost 300 works, and they are donating multiple works by him to every museum in the *Fifty Works for Fifty States* project.

[21] It was an untitled sculpture, painted gold. LeWitt later asked the Vogels to exchange it for a more recent work (described earlier, which would not stand up in their apartment). They have since regretted agreeing to that exchange, all the more so because LeWitt eventually destroyed the gold-painted work.

[22] The show was held at 1100 Madison Avenue from January 5–31, 1969. There is a catalogue.

[23] They traveled abroad for pleasure in 1963, 1965, and 1970, devoting much of their time to museum visits. Subsequently all of their travel to Europe was related to exhibitions drawn from their collection and Tuttle's solo shows.

[24] Sara Rimer, "Collecting Priceless Art, Just for the Love of It," *The New York Times* (February 11, 1992).

[25] The Vogels report that they do not make studio visits to artists whose work is unknown to them, thereby avoiding encounters in which they find the work to be of no interest.

[26] Nonas in *4 x 7 Selections from the Vogel Collection*, unpaginated.

[27] Some artists who prefer collectors not visit their studios requested anonymity in reporting that this circumstance essentially ended their association with the Vogels.

[28] See *Women Artists in the Vogel Collection* (exh. cat., Brenau University)[Gainesville 1998].

[29] Renouf, e-mail to author, January 15, 2008.

[30] Quoted by Jacqueline Trescott in "Avant-Garde Art Collection to Be Split Among All 50 States," *The Washington Post* (April 11, 2008), C4.

[31] The Dorothy and Herbert Vogel Papers, Archives of American Art, Smithsonian Institution (AAA) include personal letters and published materials related to most artists represented in the collection and others who are not.

[32] Dorothy and Herbert Vogel, "A Collection of Thoughts on the Vogel Collection," in *4 x 7 Selections from the Vogel Collection*, unpaginated.

[33] Renouf, letter to author, January 15, 2008.

[34] Nonas in *4 x 7 Selections from the Vogel Collection*, unpaginated.

[35] The Clocktower gallery opened in 1973 in the penthouse of the old New York Life Insurance Building at 346 Broadway, between Leonard and Lafayette Streets. Several artists the Vogels admired had solo exhibitions there prior to the exhibition from their collection. The couple's advocacy for artists whose work they collect has included their insistence that exhibitions from their collection be documented by publications, however modest, to make the artists better known.

[36] The title page of the exhibition checklist describes *Collectors of the Seventies* as "A series of presentations about collectors of contemporary art." Heiss' introductory statement describes the project as illustrating "a diverse approach to collecting, from buying drawings to sponsoring projects."

[37] Vogel Papers, AAA. Other exhibitions mentioned in this essay also traveled beyond the organizing institution as recorded in the bibliography.

[38] Anthony Haden-Guest, "A New Art-World Legend: Good-by, Bob and Ethel; Hullo, Dorothy and Herb!" *New York* (April 28, 1975), 46-48; and Harriet Shapiro, "Using Modest Means, the Vogels Build a Major Collection," *People* (September 8, 1986), 59-65.

[39] In an October 26, 1976 letter, Thomas M. Messer, the Guggenheim's director, makes mention of tentative discussions regarding the possibility of the collection eventually coming to that museum, Vogel Papers, AAA.

[40] Cowart, e-mail to author, January 5, 2008.

[41] In a November 11, 1986 note in the Vogel Papers, AAA, Cowart suggests several January dates that would work for a visit to the National Gallery. This writer met the Vogels during this visit.

[42] Rimer, 1992.

[43] Works were brought to Washington by Atlantic Storage on September 5, 11, 12, 18, and October 17. We are grateful to the detailed notes and splendid memory of Anne Halpern for data related to the transfer. Mary Suzor was the National Gallery's acting chief registrar at the time.

[44] Coyle, e-mail to author, April 15, 2008.

[45] Accession number 1993.41.1

[46] Donovan e-mail to author, April 13, 2008

[47] I am grateful to Maygene Daniels, chief of National Gallery Archives, for providing data about the Foundation's gifts.

[48] Robert Frankel, director of museums and visual arts at the NEA, and Marsha Semmel, deputy director for museums and director for strategic partnerships at the IMLS, orchestrated the project for their agencies.

[49] The segment is in Estelle Ellis, Caroline Seebohm, and Christopher Simon Sykes, *At Home with Art: How Art Lovers Live with and Care for their Treasures* (New York, 1999), 80-83. In *Emily Hall Tremaine: Collector on the Cusp* (Meriden, Connecticut, and Hanover, New Hampshire, 2001), 2, Kathleen L. Housley names "great collectors of modern and contemporary art" of the Tremaines' generation: "Peggy Guggenheim, several members of the Rockefeller family, Raymond and Patsy Nasher, John and Dominique de Menil, Herbert and Dorothy Vogel, Stanley Marsh, Edgar Kaufman, Victor and Sally Ganz, and Robert and Ethel Scull."

[50] *Herb and Dorothy* premiered at SILVERDOCS Film Festival, June 16–23, 2008, Silver Spring, Maryland.

[51] Peterzell, e-mail to author, April 18, 2008.

[52] London, 2007, 156-158, under the category "New York Modernists" which also includes Victor and Sally Ganz and Agnes Gund.

[53] Louise Nicholson, "Sharing It Out," *Apollo* 168 (July/August 2008), 56-59.

Books and Articles

"The ARTnews 200. [The World's 200 Top Collectors]" *ARTnews* 95 (Summer 1996), 122.

Barnett, Catherine. "A Package Deal: With Very Little Money But Lots of Determination, The Vogels Have Put Together an Incredible Collection of Art." *Art & Antiques* (Summer 1986), 39-41.

Berman, Avis. "Papers and Documents Received." *Archives of American Art Journal* 42 no. 1/2 (2002), 50-5.

Cembalest, Robin. "We're Giving It to the Whole Country." *ARTnews* 91 (March 1992), 34-5.

Cox, Meg. "Postal Clerk and Wife Amass Art Collection in New York Flat." *Wall Street Journal*, January 30, 1986, 1, 20.

D'Arcy, David. "The Unlikely Medici: A Pair of Art Fans Assemble What May Be the 'Premier Collection' of Its Type." *Los Angeles Times*, January 16, 1992, F1, F8, F9.

Donovan, Molly. "Minimal to Conceptual: The Dorothy and Herbert Vogel Collection." *American Art Review* 6 (October-November 1994).

Ellis, Estelle, Caroline Seebohm, Christopher Simon Sykes. "Insight, Persistence & Daring: The Dorothy & Herbert Vogel Story." In *At Home with Art: How Art Lovers Live with and Care for Their Treasures.* New York: Clarkson Potter/Publishers, 1999, 80-83.

Flack, Michael. "The Vogel Collection: A Sense of Ordered Purposefulness." *Drawing* 18 (Spring 1997), 97-100.

Gardner, Paul. "Look! It's the Vogels!" *ARTnews* 3 (March 1979), 84-88.

Gardner, Paul. "Mesmerized by Minimalism." *Contemporanea—International Art Magazine* 9 (December 1989), 56-61.

Gardner, Paul. "An Extraordinary Gift of Art from Ordinary People." *Smithsonian* 7 (October 1992), 124-26, 128, 130, 132.

Gardner, Paul. "Good Hands, Good Eyes." *ARTnews* 96 (December 1997), 26.

Haden-Guest, Anthony. "A New Art-World Legend: Good-by, Bob and Ethel; Hullo, Dorothy and Herb!" *New York* (April 28, 1975), 46-48.

Hemphill, Chris. "The Vogels: Minimal Collectors." *Interview* 5 (May 1974), 19.

Lewis, Jo Ann. "National Gallery's Cache Advantage: Vogels Promise Vanguard Collection." *The Washington Post*, January 8, 1992, C1, C3.

Mandell, Jonathan. "Maximum Minimalism." *New York Newsday: Part II*, January 23, 1992, 60, 61, 89.

Rimer, Sara. "Collecting Priceless Art, Just for the Love of It." *New York Times*, February 11, 1992, A1, B4.

Ryan, Michael. "Trust Your Eye." *Parade Magazine* (April 12, 2002), 10-11.

Shapiro, Harriet. "Using Modest Means, the Vogels Build a Major Collection." *People* (September 8, 1986), 59-65.

Simmons, Kenna. "The Collective Eye." *Horizon* 8 (October 1988), 14-16.

Stourton, James. "Dorothy and Herb Vogel." In *Great Collectors of Our Time: Art Collecting Since 1945*. London: Scala Publishers Ltd., 2007, 156-58.

Vogel, Carol. "National is Pledged 2,000-Work Collection." *New York Times*, January 8, 1992, C13.

Exhibition Catalogues

4 X 7: Selections from the Vogel Collection. Ben Shahn Gallery, William Paterson College, Wayne, New Jersey, October 10 – November 11, 1981.

20th Anniversary Exhibition of the Vogel Collection. Brainerd Art Gallery, State University, College of Arts and Science, Potsdam, New York, October 1 – December 1, 1982: Gallery of Art, University of Northern Iowa, Cedar Falls, [erroneously published as Cedar Rapids] Iowa, April 5 – May 5, 1983.

Beyond the Picture: Works by Robert Barry, Sol LeWitt, Robert Mangold, Richard Tuttle from the collection Dorothy & Herbert Vogel, New York. Kunsthalle Bielefeld, May 3 – July 5, 1987.

Christo and Jeanne-Claude in the Vogel Collection. National Gallery of Art, Washington, February 3 – June 23, 2002. Essay by Molly Donovan.

Drawings from the Collection of Dorothy and Herbert Vogel, Department Art Galleries, The University of Arkansas at Little Rock, September 7 – November 16, 1986; The University of Alabama Moody Gallery of Art, University, February 2 – February 27, 1987; The Pennsylvania State University Museum of Art, University Park, March 15 – May 10, 1987.

From the Collection of Dorothy and Herbert Vogel, Arnot Art Museum, Elmira, October 15 – December 31, 1988; Grand Rapids Art Museum, January 27 – March 19, 1989; Terra Museum of American Art, Chicago, April 8 – June 4, 1989; Laumeier Sculpture Park, St. Louis, June 18 – August 13, 1989; Art Museum at Florida International University, Miami, September 15 – November 10, 1989.

From Minimal to Conceptual Art: Works from The Dorothy and Herbert Vogel Collection. National Gallery of Art, Washington, May 29 – November 27, 1994. With Essay by John T. Paoletti. Interview with the Vogels by Ruth Fine.

Painting, Drawing and Sculpture of the '60s and the '70s from the Dorothy and Herbert Vogel Collection. Institute of Contemporary Art, University of Pennsylvania, Philadelphia, October 7 – November 18, 1975; The Contemporary Arts Center, Cincinnati, December 17, 1975 – February 15, 1976.

The Poetry of Form: Richard Tuttle, Drawings from the Vogel Collection. Instituto Valenciano de Arte Moderno, June 25 – August 30, 1992 and at the Indianapolis Museum of Art, October 2 – November 21, 1993. [traveled to Museum of Fine Arts, Santa Fe, New Mexico, 1995]

Selections from the Collection of Dorothy and Herbert Vogel, The Clocktower, The Institute for Art and Urban Resources, New York, April 19 – May 17, 1975. (Part I of "Collectors of the Seventies: A Series of Presentations about Collectors of Contemporary Art.")

Women Artists in the Vogel Collection. Brenau University, Gainesville, Georgia, February 5 – April 5, 1998. With Essays by Molly Donovan and Ruth Fine.

Works from the Collection of Dorothy and Herbert Vogel. The University of Michigan Museum of Art, Ann Arbor, November 11, 1977 – January 1, 1978.

Fifty Works for Fifty States

Museum Gifts

NOTE TO THE READER

Listings of museum gifts are organized in alphabetical order by state.

The following information is supplied for each museum section:

1. An alphabetical list of the artists whose work is included in that state's gift
2. Illustrations of four works from each gift accompanied by basic catalogue information as known:
 • artist's name
 • artist's nationality, dates
 • object title, date
 • medium
 • size in inches, height before width before depth

At least one work is illustrated by every artist represented in the *Dorothy and Herbert Vogel Collection: Fifty Works for Fifty States* initiative.

ALABAMA

Birmingham Museum of Art

BIRMINGHAM

ERIC AMOUYAL • WILL BARNET • ROBERT BARRY • MICHAEL CLARK (CLARK FOX) • CHARLES CLOUGH
RICHARD FRANCISCO • MICHAEL GOLDBERG • DON HAZLITT • MARTIN JOHNSON • STEVE KEISTER
MARK KOSTABI • CHERYL LAEMMLE • MICHAEL LUCERO • ROBERT MANGOLD • ALLAN MCCOLLUM
RICHARD NONAS • LUCIO POZZI • DAVID RABINOWITCH • DAVID REED • EDDA RENOUF
RICHARD STANKIEWICZ • DARYL TRIVIERI

PLATE 1
Eric Amouyal
Israeli, born 1962
Seeds: New York #2, 1998
acrylic on canvas
17 1/16 x 15 1/8 in.

PLATE 2
Allan McCollum

American, born 1944

***For Presentation and Display:
Ideal Setting by Louise Lawler and
Allan McCollum***, 1984

black and white photographic print on
Kodak paper

10 x 8 in.

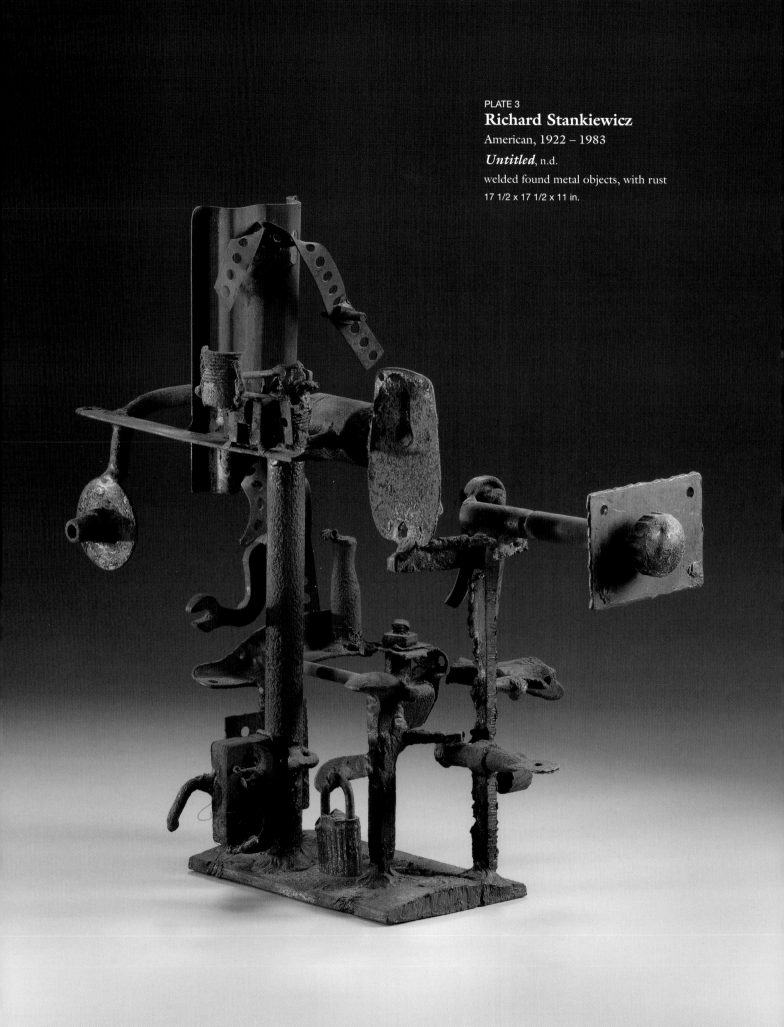

PLATE 4

Richard Tuttle

American, born 1941

Ball Drawing, 1969

graphite on paper

11 7/8 x 8 7/8 in.

ALASKA

University of Alaska Museum of the North

ROBERT BARRY • ANN CHERNOW • CHARLES CLOUGH • JOEL FISHER • RICHARD FRANCISCO
DON HAZLITT • JENE HIGHSTEIN • STEWART HITCH • PATRICK IRELAND (BRIAN O'DOHERTY) • BILL JENSEN
STEPHEN KALTENBACH • STEVE KEISTER • ALAIN KIRILI • MARK KOSTABI • WENDY LEHMAN
MICHAEL LUCERO • JOSEPH NECHVATAL • RICHARD NONAS • LUCIO POZZI • EDDA RENOUF • JUDY RIFKA
JUDITH SHEA • LORI TASCHLER • DARYL TRIVIERI • RICHARD TUTTLE

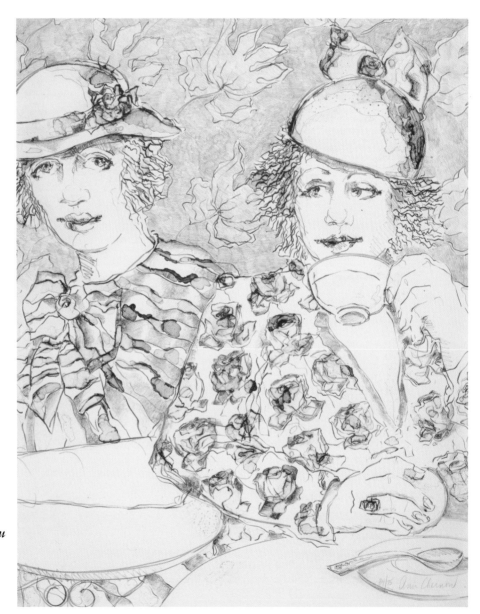

PLATE 5
Ann Chernow

American, born 1936

I Get Along Without You Very Well, 1979

lithograph on paper
edition: 34/75

27 3/8 x 21 in.

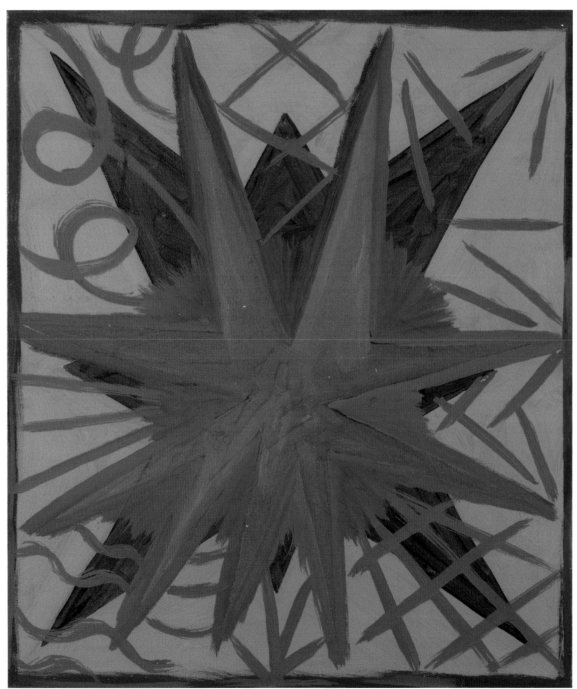

PLATE 6

Stewart Hitch

American, 1940 – 2002

Schenevus, 1982

oil on canvas

36 x 30 in.

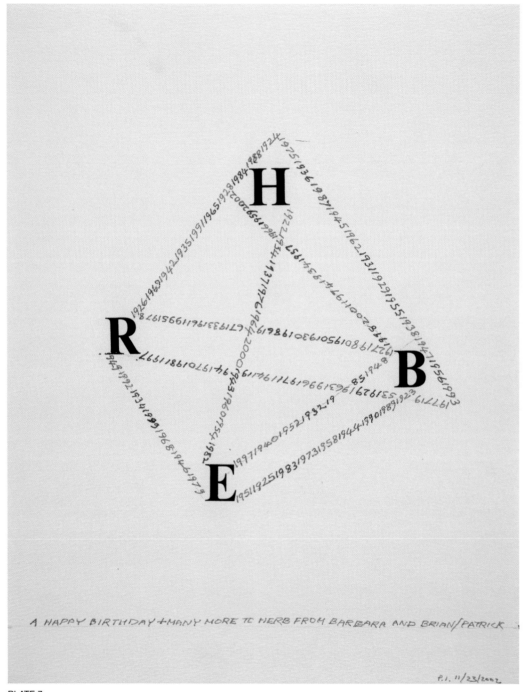

A HAPPY BIRTHDAY + MANY MORE TO HERB FROM BARBARA AND BRIAN/PATRICK

P.I. 11/23/2002

PLATE 7

Patrick Ireland (1972 – 2008)
aka Brian O'Doherty

American, born 1934

Untitled, 2002

colored ink with press type and graphite on paper

11 15/16 X 9 in.

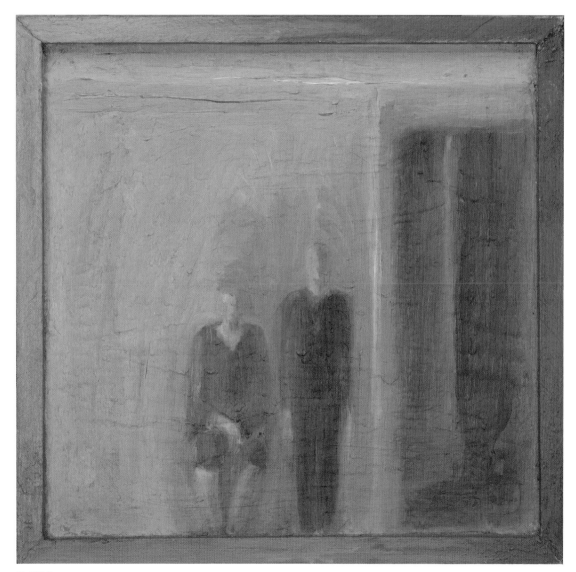

PLATE 8

Lori Taschler

American, born 1959

Untitled, 1984

oil on canvas with painted wood frame

14 x 14 in.
frame: 15 1/2 x 15 1/2 in.

ARIZONA

Phoenix Art Museum

PHOENIX

STEPHEN ANTONAKOS • RICHARD ANUSZKIEWICZ • WILL BARNET • ROBERT BARRY • LYNDA BENGLIS
LOREN CALAWAY • MICHAEL CLARK (CLARK FOX) • CHARLES CLOUGH • RICHARD FRANCISCO
MICHAEL GOLDBERG • DON HAZLITT • JENE HIGHSTEIN • STEWART HITCH • MARTIN JOHNSON
STEVE KEISTER • MARK KOSTABI • CHERYL LAEMMLE • MICHAEL LUCERO • ROBERT MANGOLD
ANDY MANN • RICHARD NONAS • LUCIO POZZI • DAVID REED • EDDA RENOUF • EDWARD RENOUF
DARYL TRIVIERI • RICHARD TUTTLE • LAWRENCE WEINER

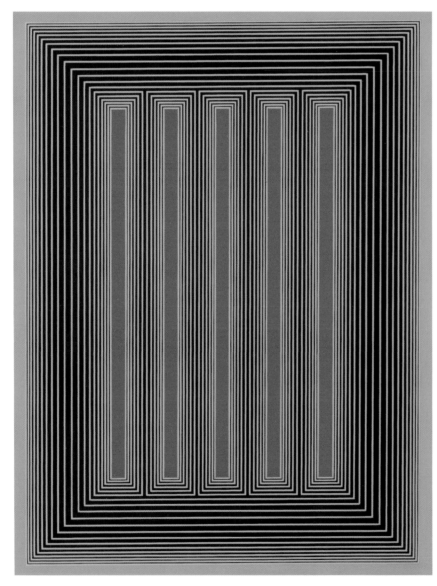

PLATE 9
Richard Anuszkiewicz
American, born 1930
Temple of Red with Orange, 1983
acrylic on wood panel
31 x 23 in.

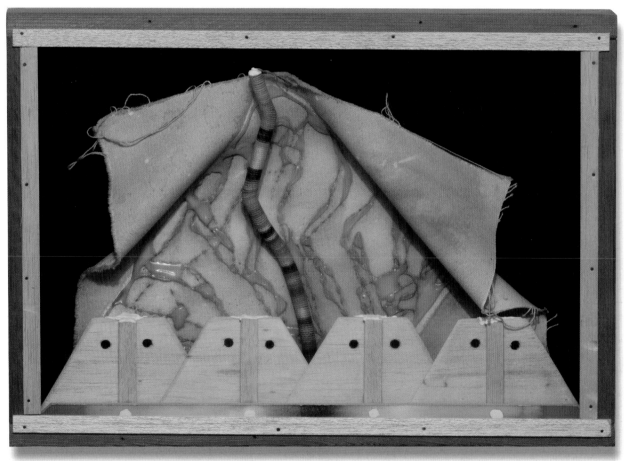

PLATE 10
Richard Francisco

American, born 1942

Studio Garden, 1976

paint, balsa wood, canvas, glue, string
in a wood, glass-covered box

13 x 18 1/4 x 3 in.

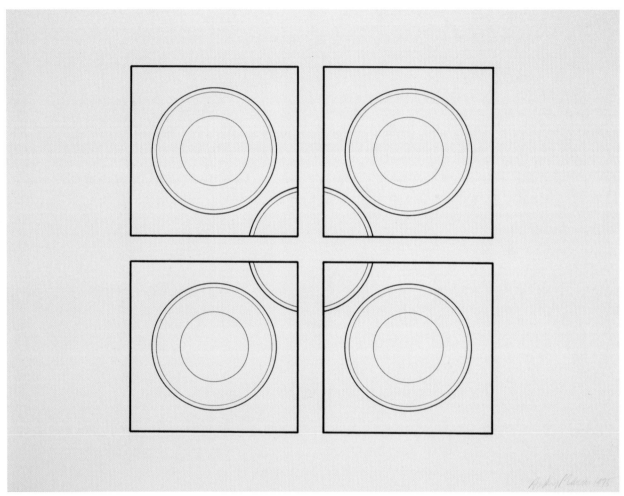

PLATE 11
Andy Mann
American, 1949 – 2001

X Matrix, 1975
ink on paper
11 x 13 15/16 in.

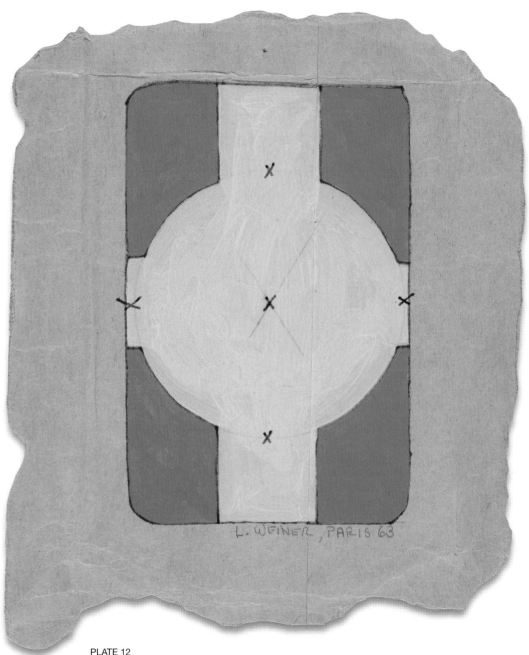

PLATE 12
Lawrence Weiner
American, born 1940

Paris, 1963

gouache, ink, and graphite on torn
portion of manila envelope

6 1/4 x 5 1/4 in. (irregular)

ARKANSAS

The Arkansas Arts Center

LITTLE ROCK

WILLIAM ANASTASI • WILL BARNET • ROBERT BARRY • LYNDA BENGLIS • MICHAEL CLARK (CLARK FOX)
CHARLES CLOUGH • ROBERT DURAN • RICHARD FRANCISCO • CHARLES GAINES • MICHAEL GOLDBERG
JENE HIGHSTEIN • MARTIN JOHNSON • STEVE KEISTER • MARK KOSTABI • CHERYL LAEMMLE
MICHAEL LUCERO • ROBERT MANGOLD • RICHARD NONAS • BETTY PARSONS • LUCIO POZZI
EDDA RENOUF • DARYL TRIVIERI • RICHARD TUTTLE

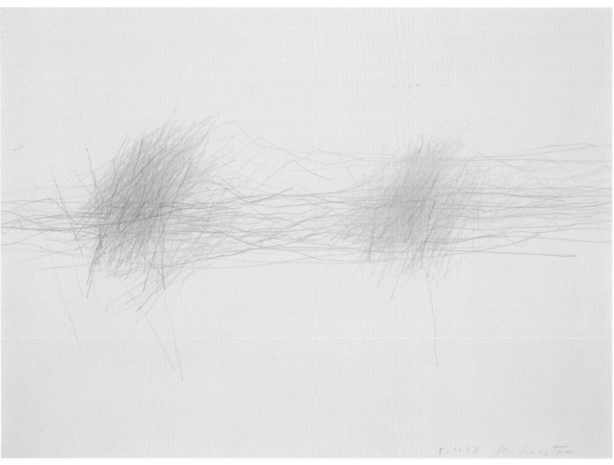

PLATE 13
William Anastasi
American, born 1933
Subway Drawing, 1978
graphite on paper
9 1/16 x 12 1/4 in.

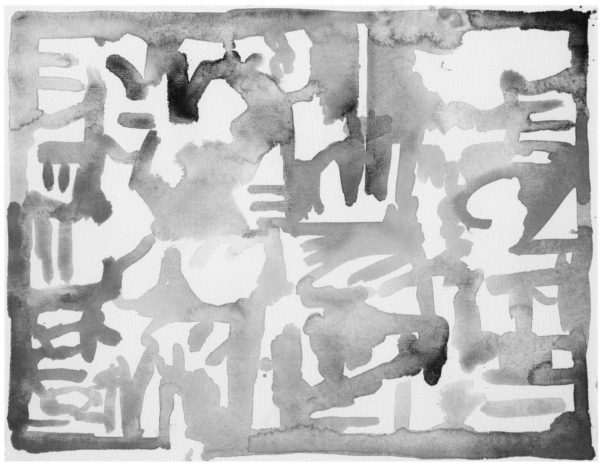

PLATE 14
Robert Duran
American, born 1938
Untitled, 1970
watercolor on paper
8 7/8 x 11 1/2 in.

PLATE 15
Charles Gaines
American, born 1944

Walnut Tree Orchard Set L, 1976

one black and white photograph, drymounted,
and two drawings in ink on paper

photo: 19 7/8 x 15 7/8 in.
photo mount: 21 7/8 x 18 in.
each drawing: 22 x 17 15/16 in.

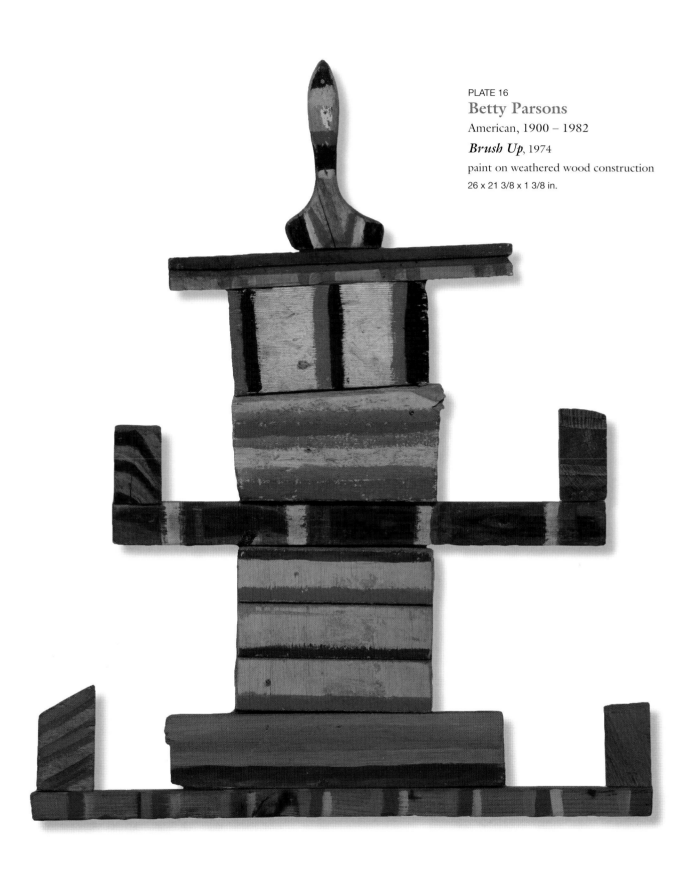

PLATE 16
Betty Parsons
American, 1900 – 1982

Brush Up, 1974
paint on weathered wood construction
26 x 21 3/8 x 1 3/8 in.

CALIFORNIA

The Museum of Contemporary Art, Los Angeles

LOS ANGELES

WILLIAM ANASTASI • CARL ANDRE • STEPHEN ANTONAKOS • ROBERT BARRY • LYNDA BENGLIS
CHARLES CLOUGH • RICHARD FRANCISCO • MICHAEL GOLDBERG • DAN GRAHAM • JOAN JONAS
STEVE KEISTER • MARK KOSTABI • MICHAEL LUCERO • RICHARD NONAS • NAM JUNE PAIK • LUCIO POZZI
EDDA RENOUF • ALAN SARET • DARYL TRIVIERI • RICHARD TUTTLE

PLATE 17
Carl Andre
American, born 1935
Untitled, n.d.
ink (rubber stamp) on paper
8 1/2 x 8 9/16 in.

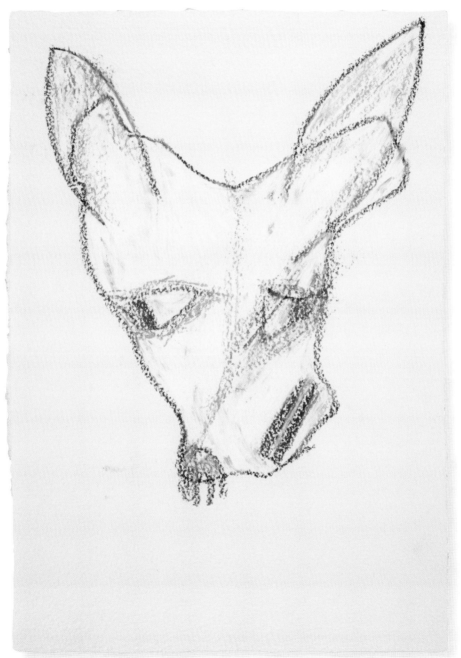

PLATE 18
Joan Jonas
American, born 1936

Dog/Decoy, 1996

oil pastel on paper

16 3/8 x 11 1/8 in.

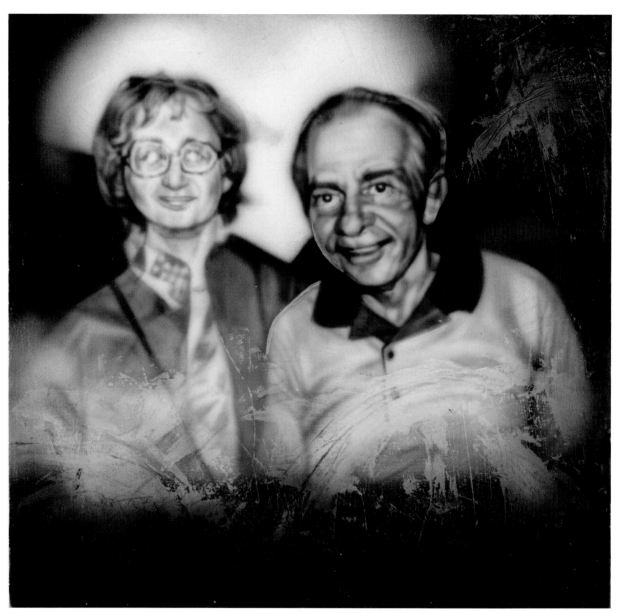

PLATE 19

Daryl Trivieri

American, born 1957

Portrait of Herb and Dorothy, 1988

acrylic on canvas

22 1/4 x 22 3/8 in.

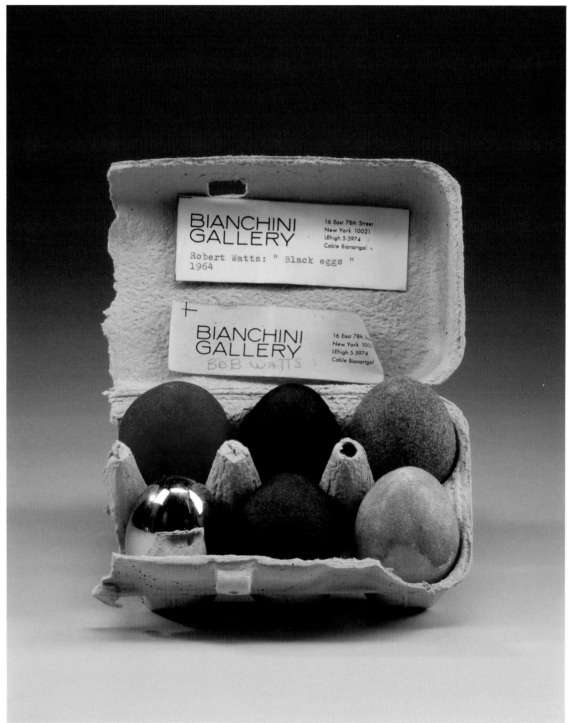

PLATE 20

Robert Marshall Watts

American, 1923 – 1988

Untitled (Assorted Eggs from American Supermarket), 1964

six chrome-plated and flocked eggs

each: 2 1/4 x 1 3/4 in.

COLORADO
Colorado Springs Fine Arts Center

COLORADO SPRINGS

WILL BARNET • ROBERT BARRY • LOREN CALAWAY • MICHAEL CLARK (CLARK FOX) • CHARLES CLOUGH
RICHARD FRANCISCO • ADAM FUSS • MICHAEL GOLDBERG • DON HAZLITT • JENE HIGHSTEIN
MARTIN JOHNSON • STEVE KEISTER • MARK KOSTABI • CHERYL LAEMMLE • JILL LEVINE
MICHAEL LUCERO • SYLVIA PLIMACK MANGOLD • RICHARD NONAS • LUCIO POZZI • EDDA RENOUF
DARYL TRIVIERI • RICHARD TUTTLE

PLATE 21
Michael Clark
American, born 1946

Dorothy, 1983-1985

construction, acrylic on wood,
mirror, with collage

13 1/4 x 13 1/4 x 2 in.

PLATE 22
Adam Fuss
British, born 1961

Untitled, 1997

manipulated photograph
edition: 61/100

10 x 12 in.

PLATE 23
Don Hazlitt
American, born 1948

Sunset, 1989
mixed media on board with painted frame
20 x 20 3/4 in.

PLATE 24

Michael Lucero

American, born 1953

***Untitled (Standing Figure
with Spotlights)***, 1979

wax crayon with incised lines on paper

31 x 22 1/8 in.

CONNECTICUT

Yale University Art Gallery

NEW HAVEN

WILL BARNET • ROBERT BARRY • LOREN CALAWAY • PETER CAMPUS • CHARLES CLOUGH • LOIS DODD
RICHARD FRANCISCO • MICHAEL GOLDBERG • DON HAZLITT • MARTIN JOHNSON • STEVE KEISTER
MARK KOSTABI • CHERYL LAEMMLE • MICHAEL LUCERO • SYLVIA PLIMACK MANGOLD • RICHARD NONAS
NAM JUNE PAIK • LUCIO POZZI • EDDA RENOUF • EDWARD RENOUF • STEPHEN ROSENTHAL
LORI TASCHLER • DARYL TRIVIERI • RICHARD TUTTLE

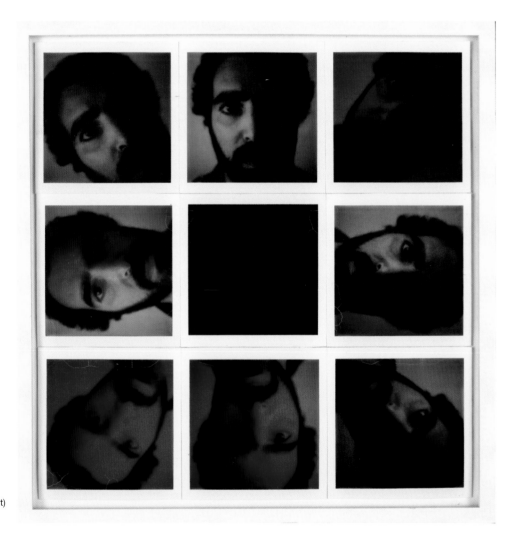

PLATE 25
Peter Campus
American, born 1937

Untitled, 1974

9 color Polaroids,
mounted and framed

mount: 11 x 10 1/2 in. (sight)
frame: 12 x 11 1/2 in.

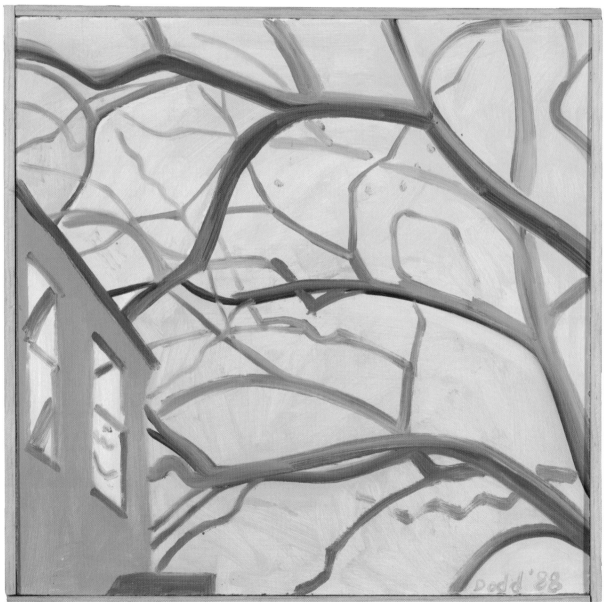

PLATE 26
Lois Dodd

American, born 1927

Butternut Branches, 1988

oil on masonite

11 7/8 x 11 7/8 in.
frame: 12 7/16 x 12 3/8 in.

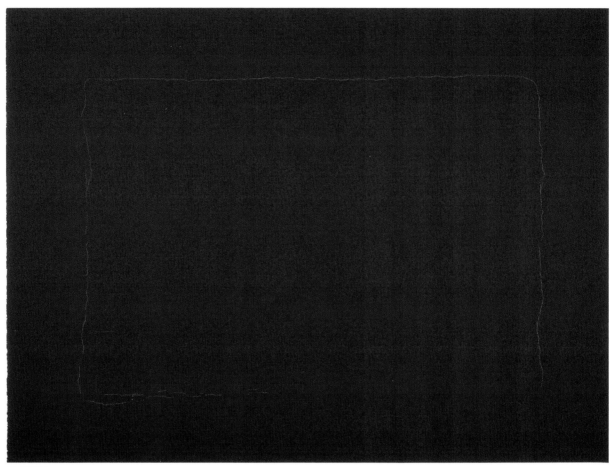

PLATE 27
Nam June Paik
American (born Korea), 1932 – 2006
Untitled, 1973
colored pencil on black paper
19 x 25 1/4 in.

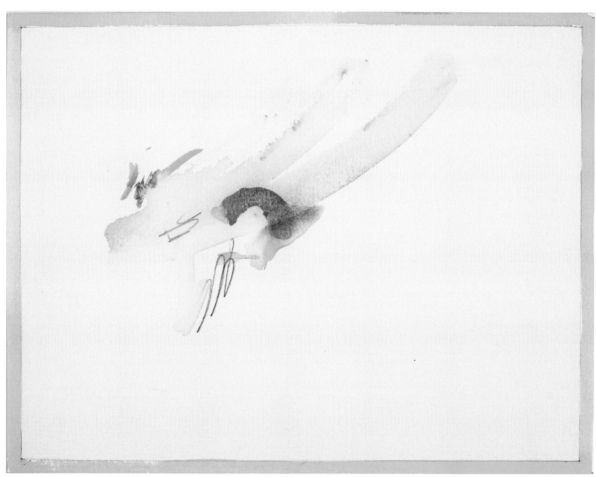

PLATE 28
Richard Tuttle
American, born 1941

Dorothy's Birthday Present, 1991

graphite and watercolor on paper, framed

10 1/8 x 12 3/4 in.

DELAWARE

Delaware Art Museum

WILMINGTON

STEPHEN ANTONAKOS • WILL BARNET • ROBERT BARRY • LYNDA BENGLIS • LOREN CALAWAY
MICHAEL CLARK (CLARK FOX) • CHARLES CLOUGH • KATHLEEN COOKE • RICHARD FRANCISCO
DON HAZLITT • STEWART HITCH • TOM HOLLAND • MARTIN JOHNSON • RONNIE LANDFIELD
ROBERT MANGOLD • LUCIO POZZI • EDDA RENOUF • JUDY RIFKA • PAT STEIR • DONALD SULTAN
DARYL TRIVIERI • RICHARD TUTTLE • JOE ZUCKER

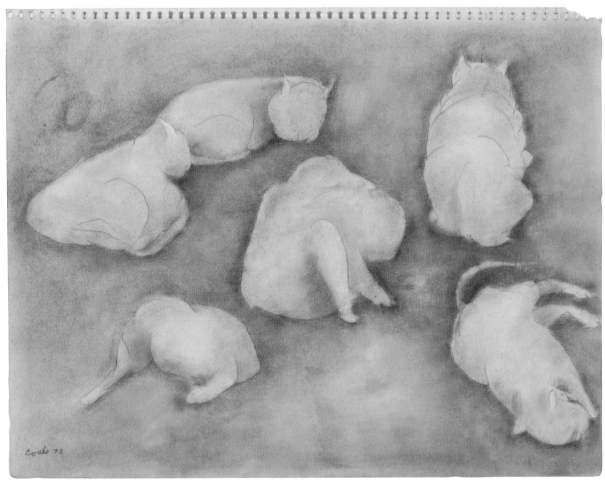

PLATE 29
Kathleen Cooke
American (born Ireland), 1908 – 1978

Untitled, 1972

pastel and graphite on paper

11 x 14 in.

PLATE 30

Tom Holland

American, born 1936

Untitled #1, 1971

collage with staples and acrylic on paper

12 x 28 in.

PLATE 31
Robert Mangold
American, born 1937

Violet/Black Zone Study, 1996

acrylic, charcoal, and graphite on
3 attached sheets of paper

overall: 30 1/4 x 66 7/8 in.

PLATE 32
Joe Zucker

American, born 1941

Candle, 1976

cotton, rhoplex, and acrylic on canvas
stretched over plywood

diameter: 18 3/4 in. (irregular)

FLORIDA
Miami Art Museum

MIAMI

WILL BARNET • ROBERT BARRY • MICHAEL CLARK (CLARK FOX) • CHARLES CLOUGH • JOEL FISHER
RICHARD FRANCISCO • MICHAEL GOLDBERG • DON HAZLITT • JENE HIGHSTEIN • RALPH HUMPHREY
MARTIN JOHNSON • STEVE KEISTER • MARK KOSTABI • CHERYL LAEMMLE • MICHAEL LUCERO
SYLVIA PLIMACK MANGOLD • ANDY MANN • WILLIAM MOREHOUSE • RICHARD NONAS • LUCIO POZZI
EDDA RENOUF • EDWARD RENOUF • ROBERT STANLEY • DONALD SULTAN • DARYL TRIVIERI
RICHARD TUTTLE

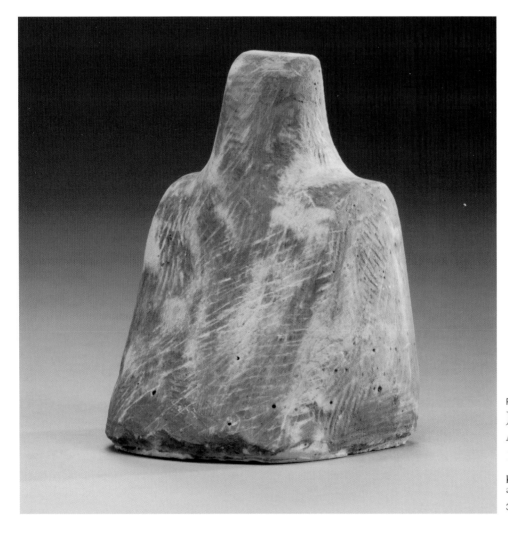

PLATE 33
Joel Fisher
American, born 1947
Untitled, 1992
painted plaster with surface
abrasions and incisions
3 7/8 x 2 3/4 x 3 in.

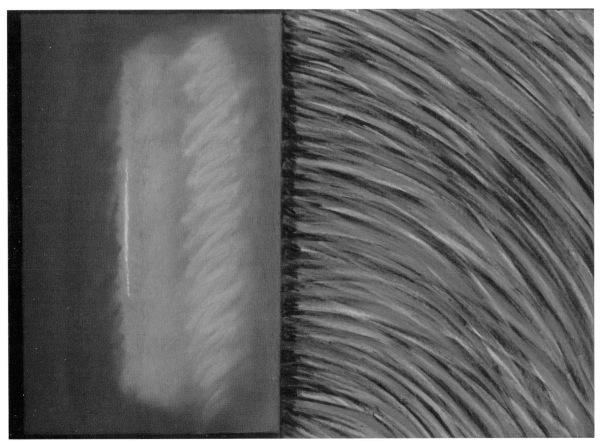

PLATE 34
William Morehouse
American, 1929 – 1993

Untitled, 1981

pastel on black paper

22 1/8 x 30 in.

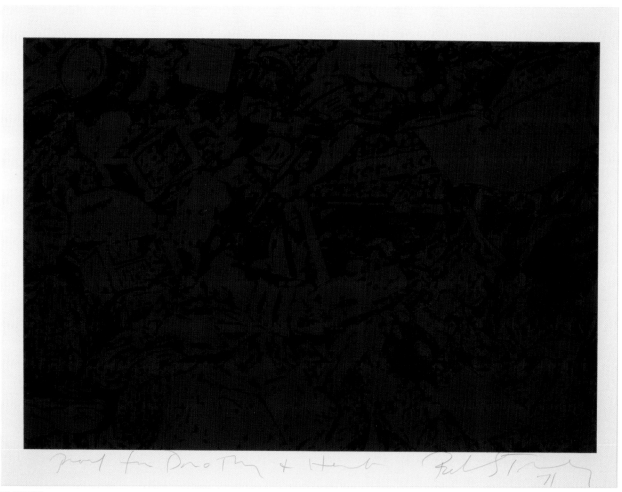

PLATE 35
Robert Stanley

American, 1932 – 1997

Crackerjack, 1971

screenprint on paper
artist's proof

14 x 17 15/16 in.

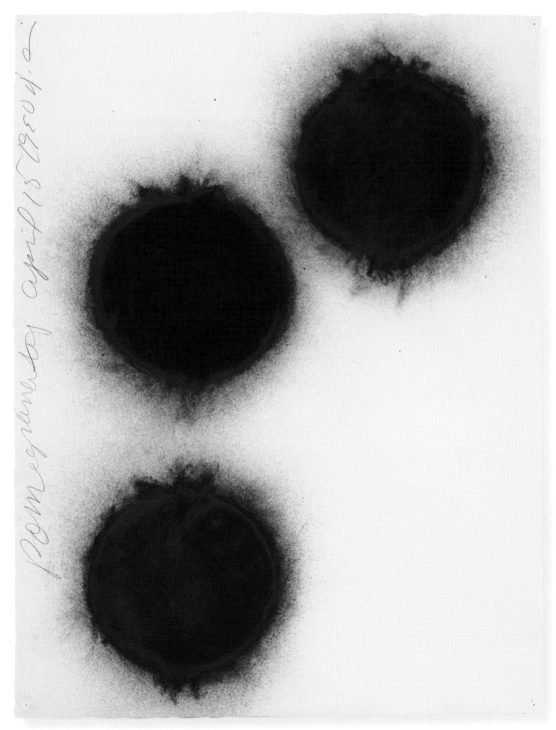

PLATE 36

Donald Sultan

American, born 1951

Pomegranates, 1990

graphite and charcoal on paper

39 1/8 x 29 3/8 in.

GEORGIA
The High Museum of Art
ATLANTA

WILLIAM ANASTASI • STEPHEN ANTONAKOS • WILL BARNET • ROBERT BARRY • LYNDA BENGLIS
LOREN CALAWAY • MICHAEL CLARK (CLARK FOX) • CHARLES CLOUGH • RICHARD FRANCISCO
MICHAEL GOLDBERG • RODNEY ALAN GREENBLAT • JENE HIGHSTEIN • STEWART HITCH • WILL INSLEY
STEVE KEISTER • RONNIE LANDFIELD • LUCIO POZZI • EDDA RENOUF • ALAN SARET • DARYL TRIVIERI
RICHARD TUTTLE • URSULA VON RYDINGSVARD • THORNTON WILLIS • BETTY WOODMAN

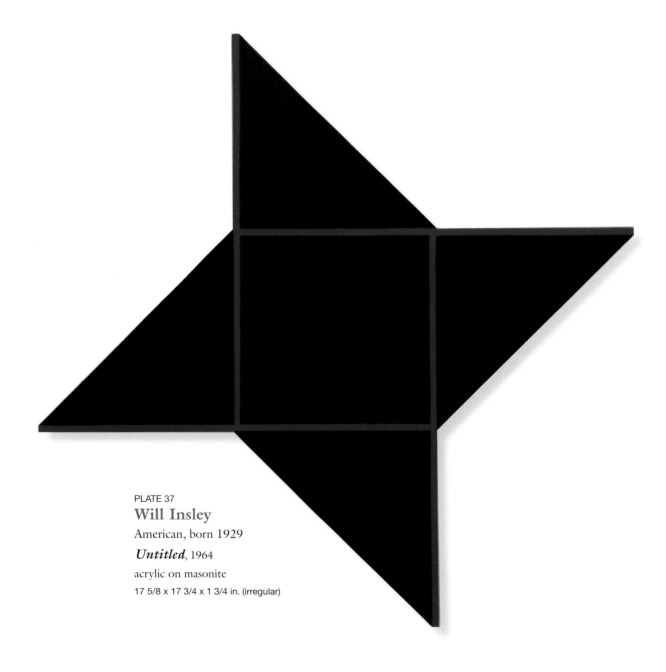

PLATE 37
Will Insley
American, born 1929
Untitled, 1964
acrylic on masonite
17 5/8 x 17 3/4 x 1 3/4 in. (irregular)

PLATE 38
Richard Tuttle
American, born 1941

***Two Black Dots with a Space
In Between***, 1973

ink and graphite on paper

13 7/8 x 11 in.

PLATE 39

Ursula von Rydingsvard

American (born Germany), born 1942

Light Drawing 2/7/81 12 Noon, 1981

charcoal on paper

29 x 23 in.

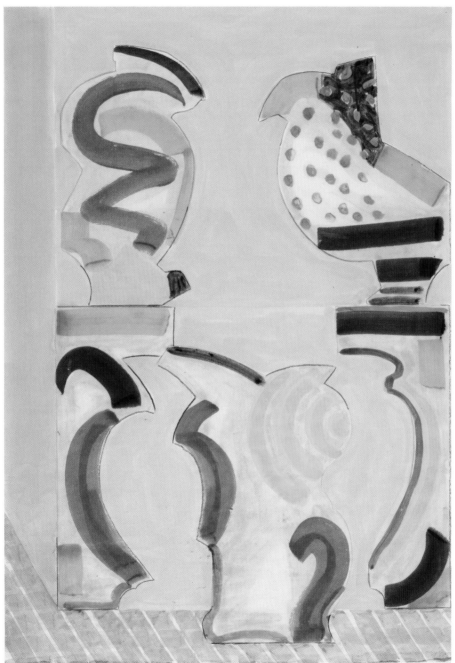

PLATE 40

Betty Woodman

American, born 1930

Garden Corner, 1999

clay, wax, dye and crayon on
Thai Mulberry paper

36 3/4 x 25 1/8 in.

HAWAII

Honolulu Academy of Arts

HONOLULU

ROBERT BARRY • CHARLES CLOUGH • CLAUDIA DE MONTE • RICHARD FRANCISCO • DON HAZLITT
JENE HIGHSTEIN • BILL JENSEN • JOAN JONAS • STEVE KEISTER • ALAIN KIRILI • MARK KOSTABI
WENDY LEHMAN • MICHAEL LUCERO • JOSEPH NECHVATAL • RICHARD NONAS • JOEL PERLMAN
LUCIO POZZI • DAVID REED • EDDA RENOUF • JUDY RIFKA • BARBARA SCHWARTZ • LORI TASCHLER
DARYL TRIVIERI • RICHARD TUTTLE • RUTH VOLLMER

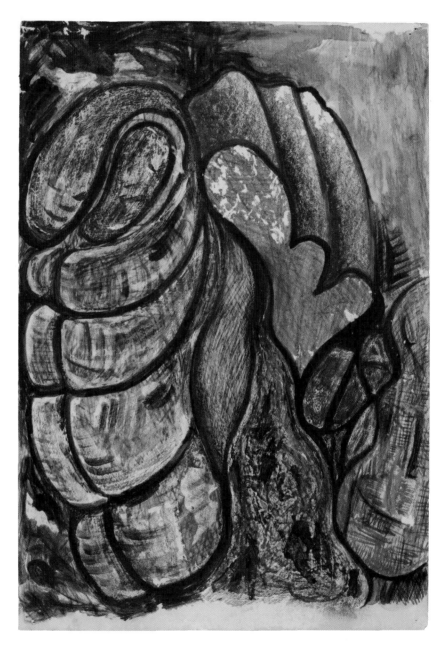

PLATE 41
Bill Jensen
American, born 1945
Untitled, 1986
colored pencil, ink and
white-out on paper
9 1/16 x 6 1/8 in.

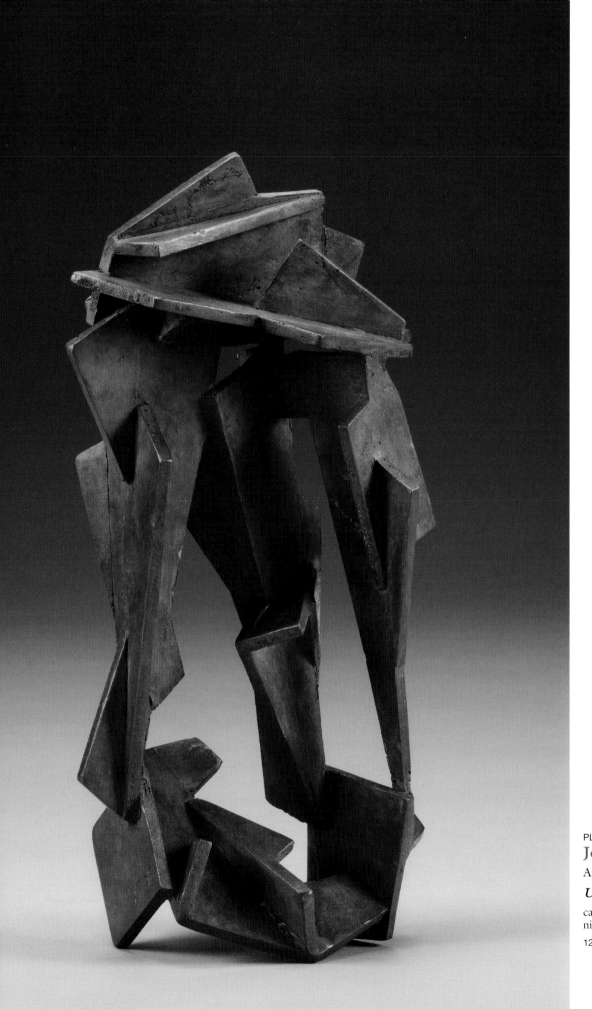

PLATE 42
Joel Perlman
American, born 1943
Untitled, 1995
cast bronze, silver
nitrate patina
12 x 6 1/2 x 4 in.

PLATE 43

David Reed

American, born 1946

Working Drawing for #508, 2004

graphite and ink on graph paper

11 x 17 in.

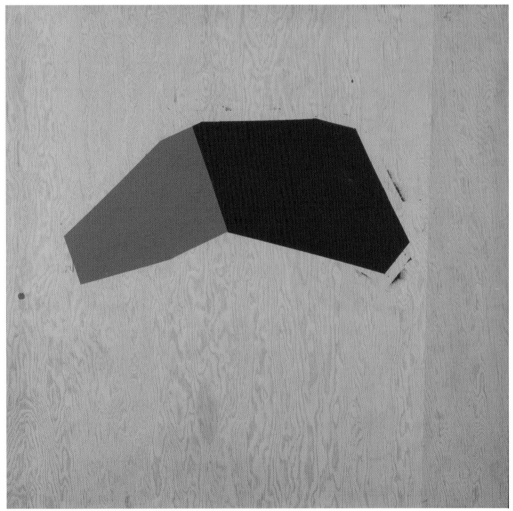

PLATE 44
Judy Rifka
American, born 1945
Untitled, 1974
acrylic on plywood
48 x 48 in.

IDAHO
Boise Art Museum

BOISE

WILL BARNET • ROBERT BARRY • LOREN CALAWAY • CHARLES CLOUGH • R.M. FISCHER
RICHARD FRANCISCO • MICHAEL GOLDBERG • DON HAZLITT • JENE HIGHSTEIN • BRYAN HUNT
MARTIN JOHNSON • STEVE KEISTER • MARK KOSTABI • RONNIE LANDFIELD • ROY LICHTENSTEIN
MICHAEL LUCERO • FORREST MYERS • RICHARD NONAS • LUCIO POZZI • EDDA RENOUF • EDWARD RENOUF
STEPHEN ROSENTHAL • CHRISTY RUPP • PAT STEIR • DARYL TRIVIERI • RICHARD TUTTLE

PLATE 45
R.M. Fischer
American, born 1947
Doctor's Lamp, 1979
steel, flexible metal tubing, light
bulbs, sockets and wiring
76 x 20 in. (variable)

PLATE 46
Ronnie Landfield
American, born 1947

Untitled, 1998

acrylic on paper

29 15/16 x 22 1/16 in.

PLATE 47
Roy Lichtenstein
American, 1923 – 1997

Turkey Shopping Bag, 1964
screenprint on white paper
shopping bag

23 1/2 x 17 1/16 in. (including handles)

PLATE 48

Pat Steir

American, born 1940

***Little Paynes Gray
Brushstroke on a Paynes
Gray Background***, 2000

oil on canvas

23 1/8 x 23 1/4 in.

ILLINOIS

University Museum, Southern Illinois University

CARBONDALE

STEPHEN ANTONAKOS • WILL BARNET • ROBERT BARRY • LOREN CALAWAY • CHARLES CLOUGH
PEGGY CYPHERS • WILLIAM FARES • RICHARD FRANCISCO • MICHAEL GOLDBERG • DON HAZLITT
JENE HIGHSTEIN • BRYAN HUNT • MARTIN JOHNSON • STEVE KEISTER • MARK KOSTABI • CHERYL LAEMMLE
RONNIE LANDFIELD • MICHAEL LUCERO • FORREST MYERS • RICHARD NONAS • LUCIO POZZI
EDDA RENOUF • EDWARD RENOUF • ALAN SARET • LORI TASCHLER • DARYL TRIVIERI • RICHARD TUTTLE
THORNTON WILLIS

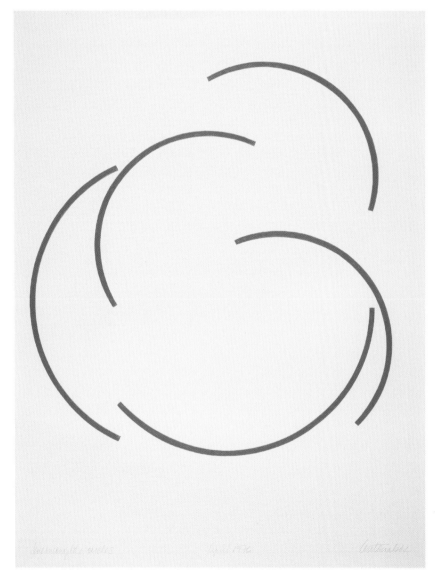

PLATE 49
Stephen Antonakos
American, born 1926
Five Incomplete Circles, 1976
colored pencil on paper
29 15/16 x 22 5/16 in.

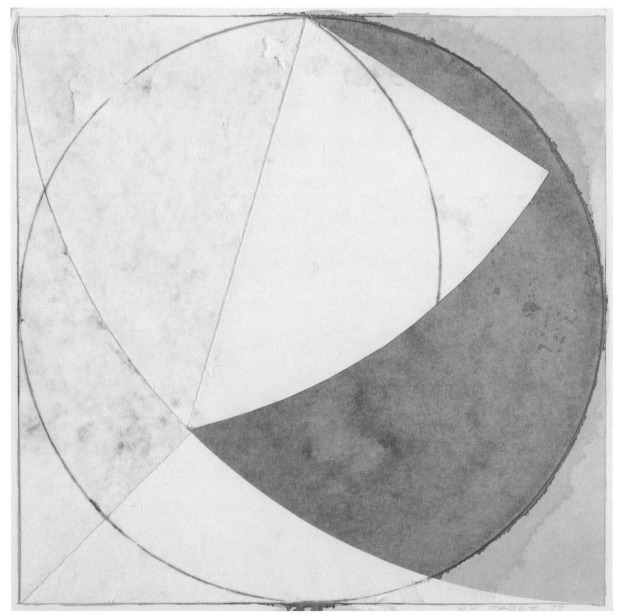

PLATE 50

William Fares

American, born 1942

Untitled, 1977

ink on altered paper

11 x 11 in.

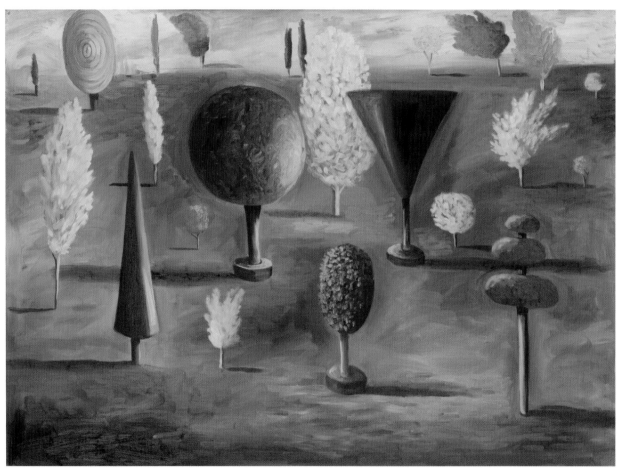

PLATE 51

Cheryl Laemmle

American, born 1947

Specters in the Forest, 1988

oil on canvas

30 1/4 x 40 1/8 in.

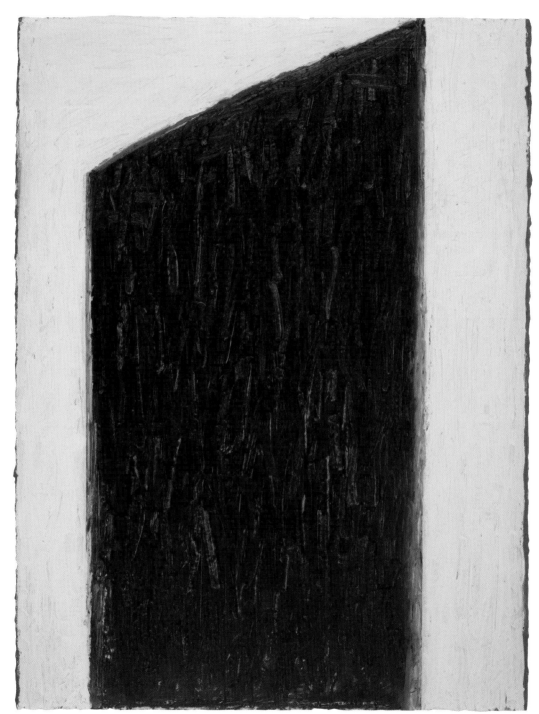

PLATE 52
Thornton Willis
American, born 1936

The Tall Patriot, 1981

oil stick on paper

30 x 22 1/4 in.

INDIANA
IMA–Indianapolis Museum of Art
INDIANAPOLIS

STEPHEN ANTONAKOS • WILL BARNET • ROBERT BARRY • LYNDA BENGLIS • JAMES BISHOP
LOREN CALAWAY • MICHAEL CLARK (CLARK FOX) • CHARLES CLOUGH • RICHARD FRANCISCO
JON GIBSON • MICHAEL GOLDBERG • DON HAZLITT • STEWART HITCH • STEVE KEISTER
RONNIE LANDFIELD • ROBERT MANGOLD • ELIZABETH MURRAY • LUCIO POZZI • DAVID RABINOWITCH
EDDA RENOUF • JUDY RIFKA • DARYL TRIVIERI • RICHARD TUTTLE

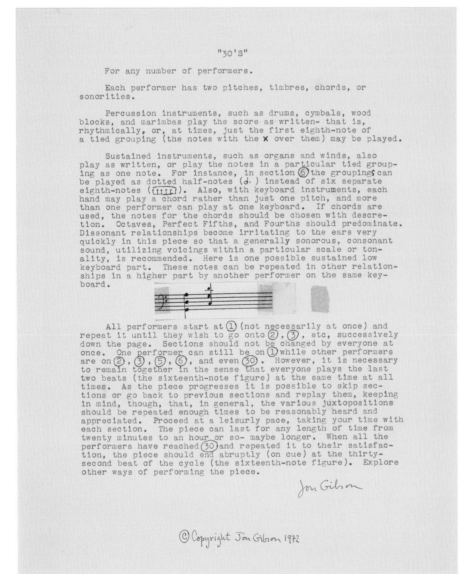

PLATE 53
Jon Gibson
American, born 1940

30's, 1970-72

one of five sheets and three
photocopies: ink and graphite on
graph paper; collage of ink on
musical staff paper, and tape on
bond paper with typescript

each sheet: 8 1/2 x 11 in.

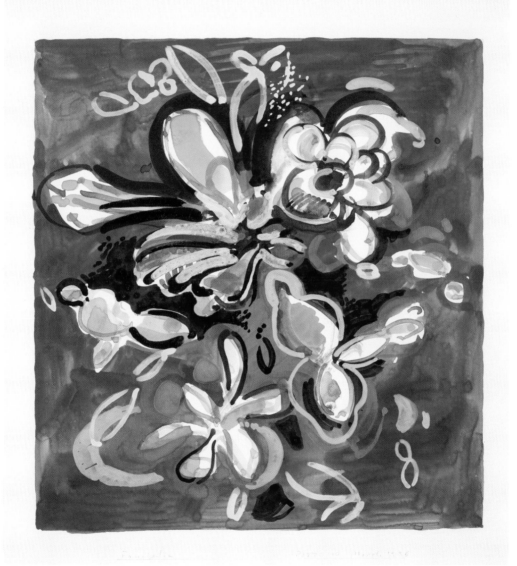

PLATE 54
Lucio Pozzi
American, born 1935
Famiglia, 1996
watercolor on paper
24 x 23 1/16 in.

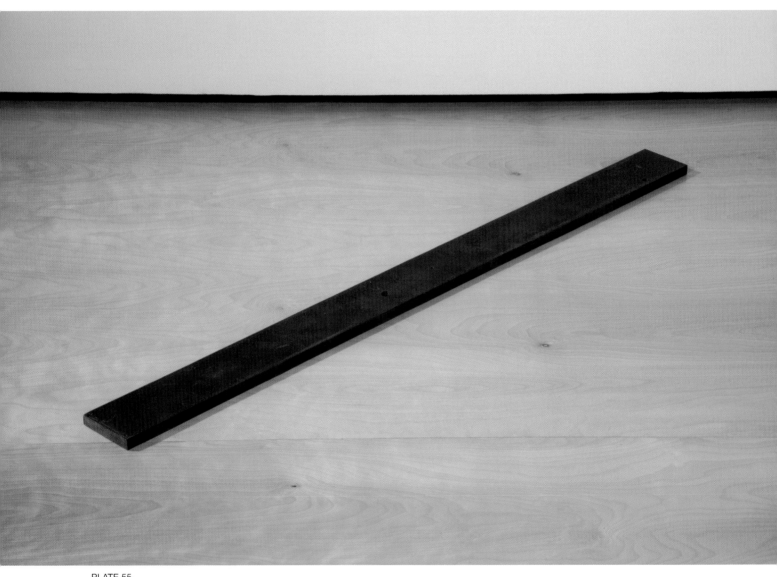

PLATE 55
David Rabinowitch
Canadian, born 1943

Linear Mass in 3 Scales I, 1972

Steel

3/4 x 52 1/4 x 4 in.

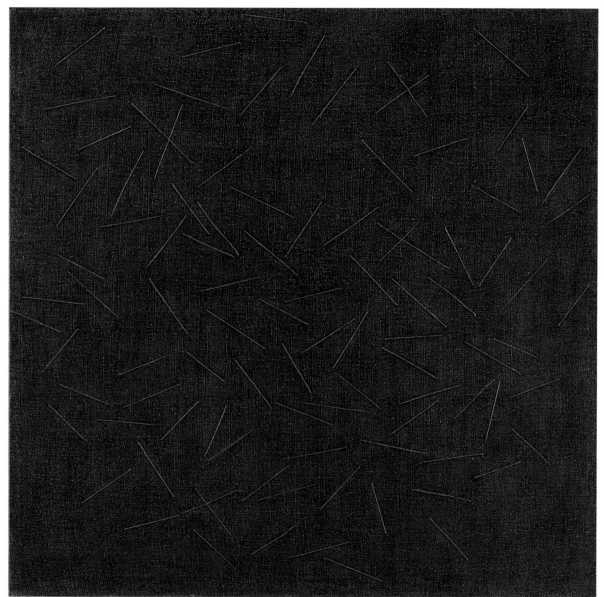

PLATE 56

Edda Renouf

American, born 1943

Wing Piece II, 1980

acrylic on linen

39 1/2 x 39 1/2 in.

IOWA
Cedar Rapids Museum of Art
CEDAR RAPIDS

STEPHEN ANTONAKOS • WILL BARNET • ROBERT BARRY • JOSEPH BEUYS • LOREN CALAWAY
CHARLES CLOUGH • PEGGY CYPHERS • RICHARD FRANCISCO • MICHAEL GOLDBERG • DON HAZLITT
PETER HUTCHINSON • MARTIN JOHNSON • STEVE KEISTER • MARK KOSTABI • RONNIE LANDFIELD
ANNETTE LEMIEUX • MICHAEL LUCERO • JOSEPH NECHVATAL • RICHARD NONAS • LUCIO POZZI
EDDA RENOUF • EDWARD RENOUF • KEITH SONNIER • DARYL TRIVIERI • RICHARD TUTTLE

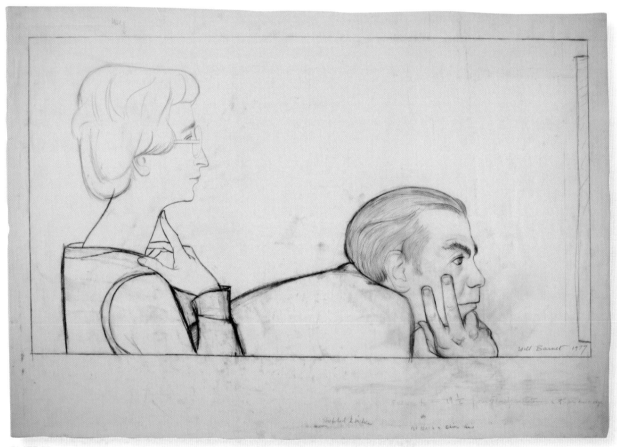

PLATE 57
Will Barnet
American, born 1911

Study for the Vogels (Herb with hands on chin), 1977

graphite and charcoal on vellum
tracing paper

29 15/16 x 42 in. (irregular)

PLATE 58

Joseph Beuys

German, 1921 – 1986

Noiseless Blackboard Eraser, 1974

felt blackboard eraser (two), each with printed
and stamped paper label, with marker

each: 2 x 5 x 1 in.

PLATE 59

Annette Lemieux

American, born 1957

*Popular Wall Painting
(after Ken)*, 1997

tempera, with graphite, on graph paper

sheet: 8 1/2 x 10 15/16 in.

PLATE 60
Keith Sonnier
American, born 1941
BA - O - BA III, 1976
marker on graph paper
10 5/8 x 8 1/2 in.

KANSAS

Spencer Museum of Art, The University of Kansas

LAWRENCE

WILL BARNET • ROBERT BARRY • LOREN CALAWAY • CHARLES CLOUGH • GENE DAVIS
RICHARD FRANCISCO • MICHAEL GOLDBERG • DON HAZLITT • JENE HIGHSTEIN • PETER HUTCHINSON
MARTIN JOHNSON • STEVE KEISTER • MARK KOSTABI • MICHAEL LUCERO • JOSEPH NECHVATAL
RICHARD NONAS • LUCIO POZZI • EDDA RENOUF • EDWARD RENOUF • PETER SCHUYFF
BARBARA SCHWARTZ • DARYL TRIVIERI • RICHARD TUTTLE • JOSEPH WHITE

PLATE 61
Gene Davis
American, 1920 – 1985

Untitled, 1970
acrylic on canvas, framed
10 x 12 1/8 in.
framed: 10 3/4 x 12 3/4 in.

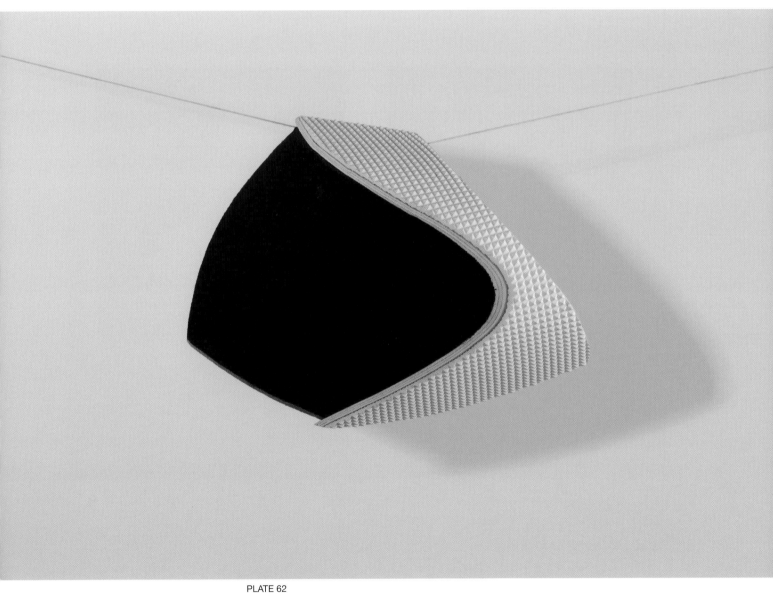

PLATE 62
Steve Keister
American, born 1949

Untitled, 1990

painted masonite, wood, and string

8 x 10 x 7 in. (not including string; variable)

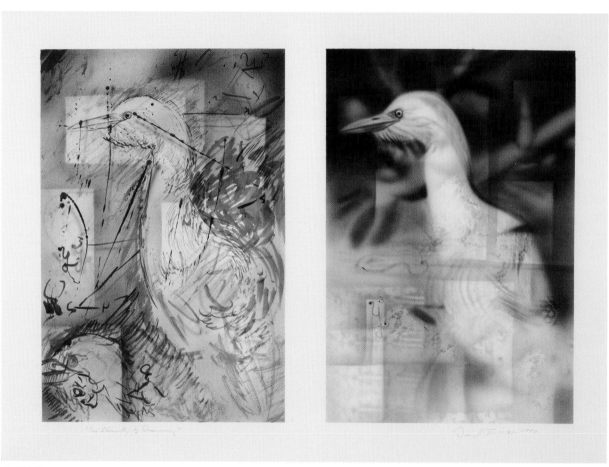

PLATE 63

Daryl Trivieri

American , born 1957

The Elements of Drawing, 1990

airbrush and inkwash on paper

22 1/4 x 30 1/8 in.

THE DRAWING FOR A PAINTING
CALLED THE MANILA ENVELOPE
JOSEPH WHITE

PLATE 64

Joseph White

American, born 1938

Untitled, n.d.

graphite on paper

8 1/2 x 8 1/2 in.

KENTUCKY
The Speed Art Museum
LOUISVILLE

WILL BARNET • ROBERT BARRY • LYNDA BENGLIS • LOREN CALAWAY • MICHAEL CLARK (CLARK FOX)
CHARLES CLOUGH • CLAUDIA DE MONTE • RICHARD FRANCISCO • MICHAEL GOLDBERG • RONALD GORCHOV
PETER HALLEY • JENE HIGHSTEIN • STEWART HITCH • BRYAN HUNT • MARTIN JOHNSON • STEVE KEISTER
ROBERT MANGOLD • RICHARD NONAS • EDDA RENOUF • PAT STEIR • DARYL TRIVIERI • RICHARD TUTTLE
URSULA VON RYDINGSVARD • MARTIN WONG

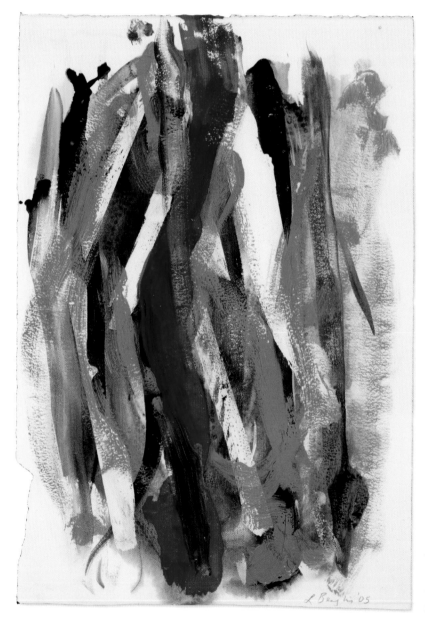

PLATE 65
Lynda Benglis
American, born 1941
Gestural Study, 2005
egg tempera on paper
22 1/2 x 15 1/8 in. (irregular)

PLATE 66

Bryan Hunt

American, born 1947

Quarry Study, 1979

ink on paper

6 5/16 x 9 in. (approx.)

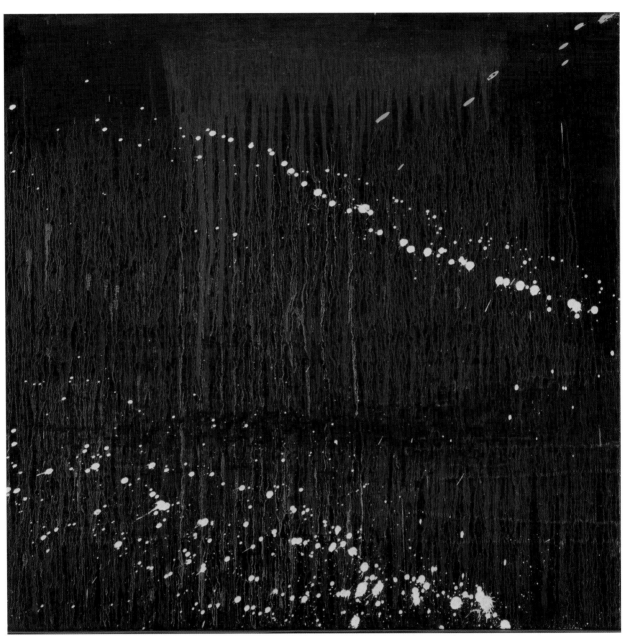

PLATE 67

Pat Steir

American, born 1940

Red Cascade, 1996-97

oil on canvas

30 1/8 x 30 1/8 in.

 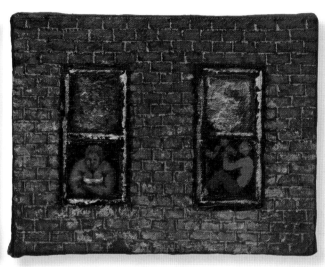

PLATE 68
Martin Wong
American, 1946 – 1999

Untitled, n.d.

oil on canvas, diptych

overall: 7 1/8 x 18 1/4 in.;
each: 7 1/8 x 9 1/8 in.

LOUISIANA
New Orleans Museum of Art

NEW ORLEANS

WILL BARNET • ROBERT BARRY • LYNDA BENGLIS • JAMES BISHOP • LISA BRADLEY • CHARLES CLOUGH
PINCHAS COHEN GAN • RICHARD FRANCISCO • MICHAEL GOLDBERG • JENE HIGHSTEIN • STEWART HITCH
BILL JENSEN • MARK KOSTABI • CHERYL LAEMMLE • RONNIE LANDFIELD • JOHN LATHAM • MICHAEL LUCERO
RICHARD NONAS • LIL PICARD • LUCIO POZZI • EDDA RENOUF • EDWARD RENOUF • BARBARA SCHWARTZ
DARYL TRIVIERI * RICHARD TUTTLE

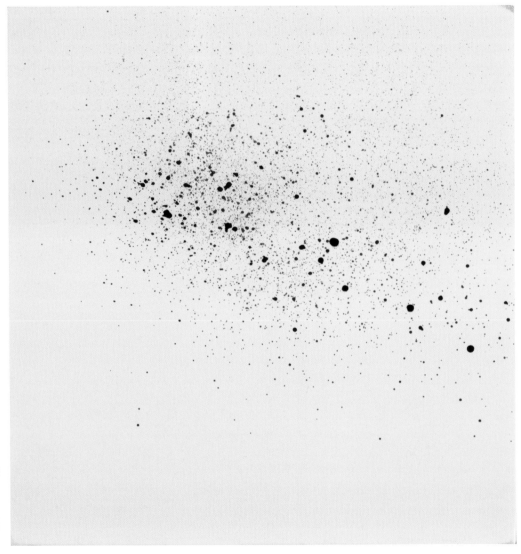

PLATE 69
John Latham
British , 1921 – 2006
*One Second
Drawing*, 1971
enamel on wood panel
8 1/8 x 7 5/8 in.

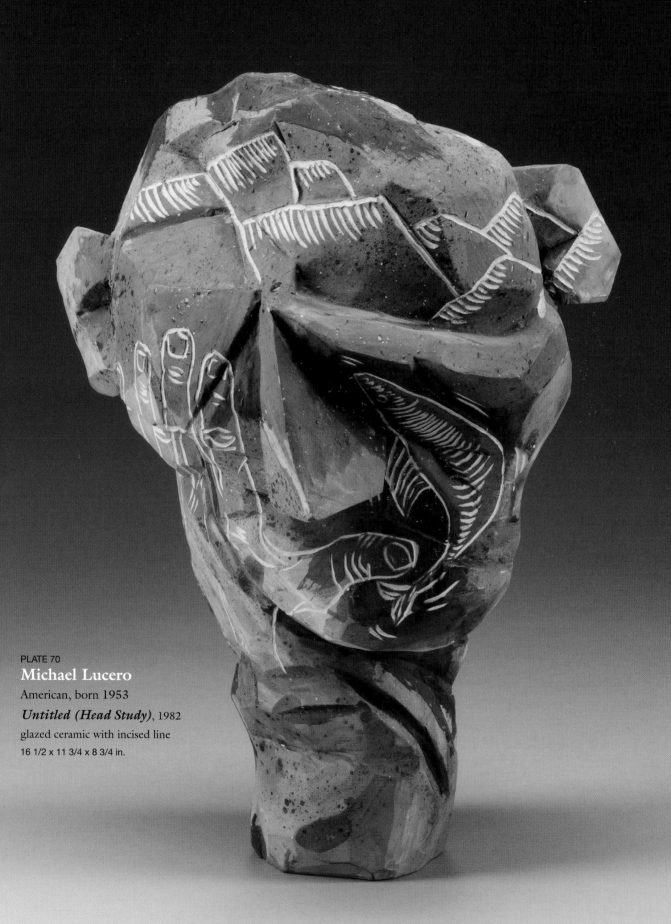

PLATE 70
Michael Lucero
American, born 1953
Untitled (Head Study), 1982
glazed ceramic with incised line
16 1/2 x 11 3/4 x 8 3/4 in.

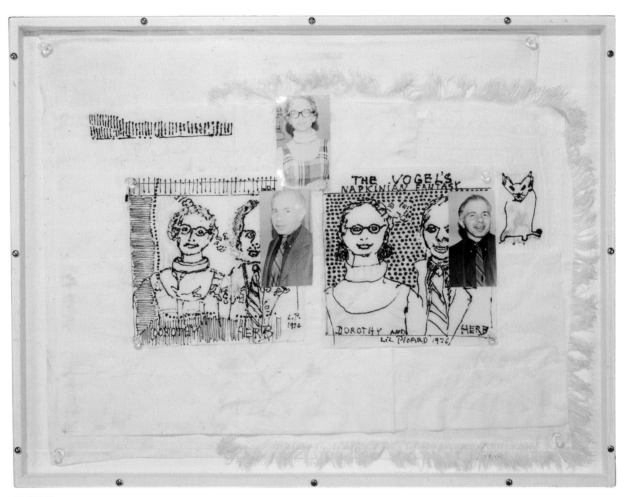

PLATE 71

Lil Picard

German, 1899 – 1994

The Vogel's Napkinian Fantasy, 1976

collage of paper and cloth napkins,
linen placemat, photos, ink, and plastic
push-pins in painted wood and plexiglas box

16 3/4 x 21 3/4 in.

PLATE 72
Richard Tuttle
American, born 1941

Chicago 14, No. 1, 1982

watercolor on lined notebook paper in wood
frame

9 5/8 x 14 1/8 x 1 5/8 in.

MAINE
Portland Museum of Art

PORTLAND

WILL BARNET • ROBERT BARRY • LISA BRADLEY • CHARLES CLOUGH • CLAUDIA DE MONTE
RACKSTRAW DOWNES • RICHARD FRANCISCO • MICHAEL GOLDBERG • DON HAZLITT
PETER HUTCHINSON • MARTIN JOHNSON • STEVE KEISTER • MARK KOSTABI • RONNIE LANDFIELD
MICHAEL LUCERO • ANTONI MIRALDA • JOSEPH NECHVATAL • RICHARD NONAS • LUCIO POZZI
EDDA RENOUF • JUDY RIFKA • BARBARA SCHWARTZ • LORI TASCHLER • DARYL TRIVIERI
RICHARD TUTTLE • TOD WIZON

PLATE 73
Charles Clough
American, born 1951
August Fifteenth, 1985
enamel on panel, framed
23 7/8 x 25 3/8 in.
frame: 24 7/8 x 26 1/4 in.

PLATE 74

Rackstraw Downes

British, born 1939

Disused Weather Station,
Galveston, TX, 1997

graphite on two attached sheets of
gray charcoal paper

7 1/4 x 16 3/4 in.

PLATE 75

Antoni Miralda

Spanish, born 1942

Untitled, 1972

bread, colored and baked, mounted on mat
board, on wood inside plexiglas case

case: 3 3/4 x 12 1/4 x 12 1/4 in.

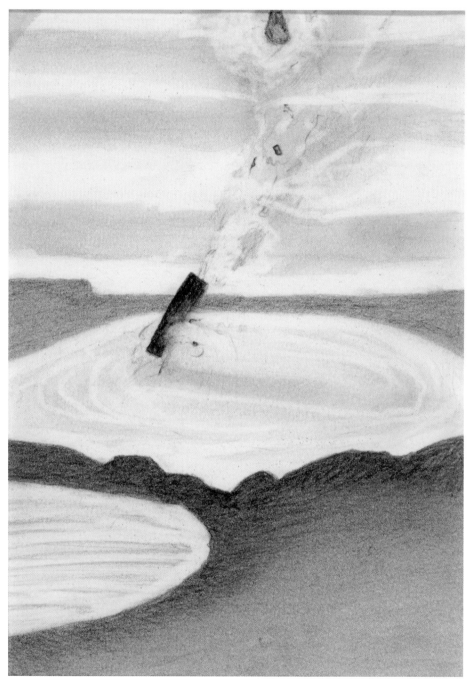

PLATE 76
Tod Wizon
American, born 1952
Untitled, 1979
graphite on paper
5 x 3 7/16 in.

MARYLAND
Academy Art Museum
EASTON

STEPHEN ANTONAKOS • ROBERT BARRY • LISA BRADLEY • ANDRÉ CADÉRÉ • CHARLES CLOUGH
CLAUDIA DE MONTE • RICHARD FRANCISCO • MICHAEL GOLDBERG • DON HAZLITT • PETER HUTCHINSON
MARTIN JOHNSON • STEVE KEISTER • MARK KOSTABI • MOSHE KUPFERMAN • CHERYL LAEMMLE
MICHAEL LUCERO • JOSEPH NECHVATAL • RICHARD NONAS • LUCIO POZZI • EDDA RENOUF • JUDY RIFKA
BARBARA SCHWARTZ • LORNA SIMPSON • LORI TASCHLER • JOHN TORREANO • DARYL TRIVIERI
RICHARD TUTTLE

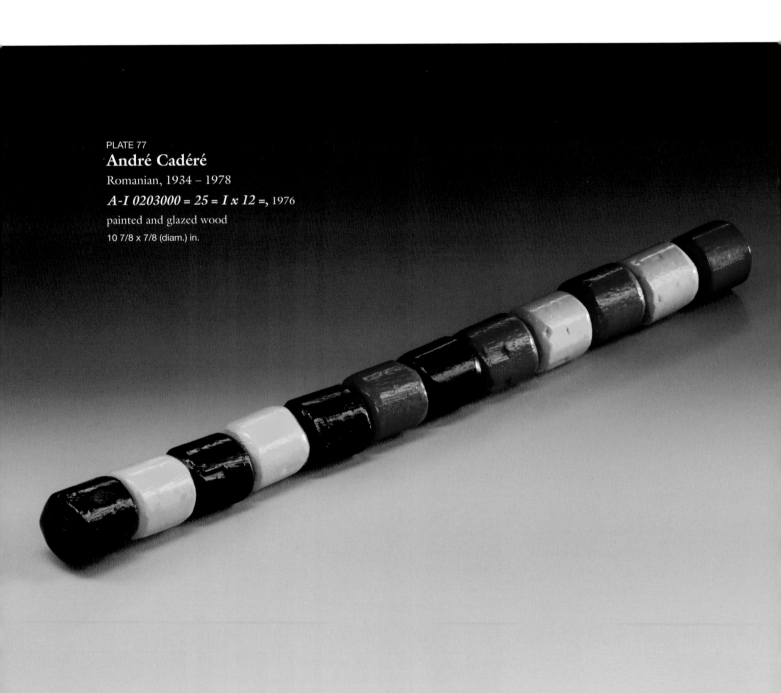

PLATE 77
André Cadéré
Romanian, 1934 – 1978
A-I 0203000 = 25 = I x 12 =, 1976
painted and glazed wood
10 7/8 x 7/8 (diam.) in.

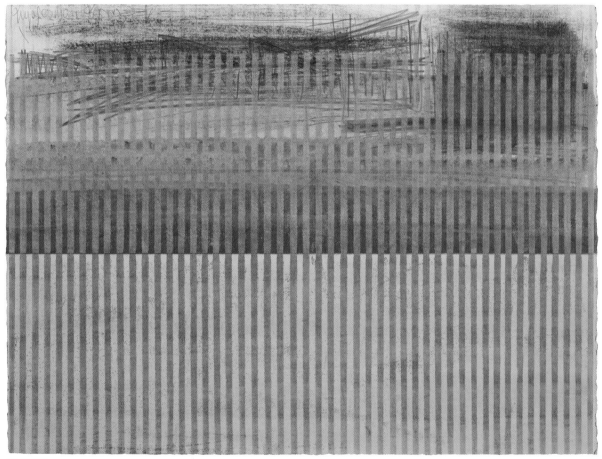

PLATE 78

Moshe Kupferman

Israeli (born Poland), 1926 – 2003

Untitled, 1994

acrylic, graphite and charcoal on paper

19 3/4 x 26 in.

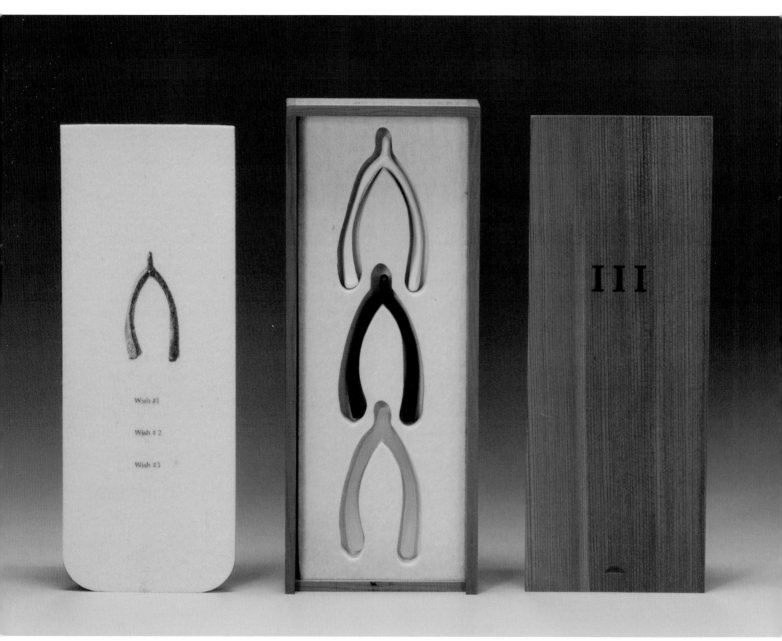

PLATE 79

Lorna Simpson

American, born 1960

***III (Peter Norton Family
Christmas Project)***, 1994

ceramic, rubber, and bronze wishbones
with felt (printed and fitted) in wood box

box: 13 5/8 x 5 3/8 x 2 1/8 in.
each wishbone: 4 1/4 x 2 1/2 x 5/8 in. (approx.)

PLATE 84

David Salle

American, born 1952

Untitled, 1995

ink and Xerography (?) on paper

3 15/16 x 3 15/16 in.

MICHIGAN
The University of Michigan Museum of Art

ANN ARBOR

WILL BARNET • ROBERT BARRY • LYNDA BENGLIS • CHARLES CLOUGH • CLAUDIA DE MONTE
RICHARD FRANCISCO • MICHAEL GOLDBERG • DON HAZLITT • JENE HIGHSTEIN • PETER HUTCHINSON
MARTIN JOHNSON • STEVE KEISTER • MARK KOSTABI • RONNIE LANDFIELD • JILL LEVINE • ROBERT LOBE
MICHAEL LUCERO • JOSEPH NECHVATAL • RICHARD NONAS • LUCIO POZZI • EDDA RENOUF
YINKA SHONIBARE • DARYL TRIVIERI • RICHARD TUTTLE

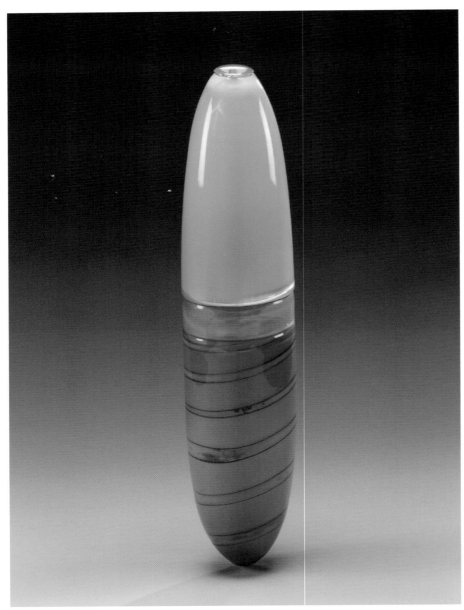

PLATE 85
Lynda Benglis
American, born 1941
Tacpere Maptom, 1985
glass
22 x 5 1/2 (diam.) in.

PLATE 86
Martin Johnson
American, born 1951
Inure Self, 1984
acrylic and thread on canvas
10 x 8 in.

PLATE 87
Mark Kostabi
American, born 1960

Progress of Beauty 3, 1988
ink on paper
11 15/16 x 9 in.

PLATE 88
Yinka Shonibare
British, born 1962
Doll House (Peter Norton Family Christmas Project), 2002

miniature English Victorian townhouse, with furnishings; in cast resin, plastic, wood, paper and fabric

house: 12 3/4 x 8 x 10 5/8 in.

MINNESOTA

Frederick R. Weisman Art Museum, University of Minnesota

MINNEAPOLIS

WILL BARNET • ROBERT BARRY • LISA BRADLEY • CHARLES CLOUGH • CLAUDIA DE MONTE
RICHARD FRANCISCO • MICHAEL GOLDBERG • DON HAZLITT • JENE HIGHSTEIN • PETER HUTCHINSON
MARTIN JOHNSON • STEVE KEISTER • MARK KOSTABI • RONNIE LANDFIELD • MICHAEL LASH
MICHAEL LUCERO • JOSEPH NECHVATAL • RICHARD NONAS • LUCIO POZZI • EDDA RENOUF • JUDY RIFKA
BARBARA SCHWARTZ • ALAN SHIELDS • GARY STEPHAN • LORI TASCHLER • DARYL TRIVIERI
RICHARD TUTTLE

PLATE 89
Claudia de Monte
American, born 1947
Claudia with Snake, 1980
handmade paper (paper mache;
celluclay), acrylic and glitter
13 5/8 x 8 1/2 x 1 1/2 in. (irregular)

PLATE 90

Michael Lash

American, born 1961

Simon's a Sissy, 1988

ball point pen and crayon on mat board

8 3/4 x 11 in. (irregular)

PLATE 91
Alan Shields
American, 1944 – 2005

Untitled, 1972

painted and stitched canvas over
plywood and twine base

19 1/4 x 18 x 21 1/4 in.

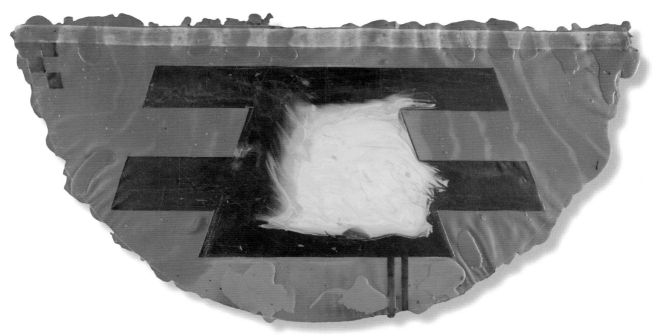

PLATE 92

Gary Stephan

American, born 1942

Untitled, 1969

pigment and polyvinyl chloride
with crayon on verso

25 x 52 1/4 in. (irregular)

MISSISSIPPI

Mississippi Museum of Art

JACKSON

STEPHEN ANTONAKOS • WILL BARNET • ROBERT BARRY • LISA BRADLEY • CHARLES CLOUGH
CLAUDIA DE MONTE • RICHARD FRANCISCO • MICHAEL GOLDBERG • RONALD GORCHOV • DON HAZLITT
JENE HIGHSTEIN • PETER HUTCHINSON • MARTIN JOHNSON • STEVE KEISTER • MARK KOSTABI
RONNIE LANDFIELD • MICHAEL LASH • MICHAEL LUCERO • TAKASHI MURAKAMI • JOSEPH NECHVATAL
RICHARD NONAS • LUCIO POZZI • EDDA RENOUF • CINDY SHERMAN • DARYL TRIVIERI • RICHARD TUTTLE
LYNN UMLAUF

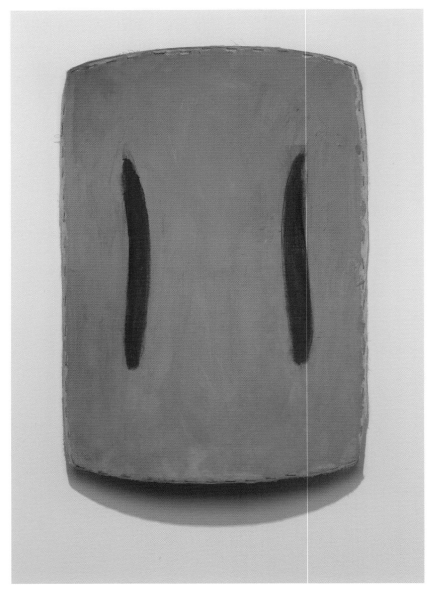

PLATE 93
Ronald Gorchov
American , born 1930
Untitled, 1973
oil on muslin stapled to wood
18 7/8 x 13 x 1 5/8 in.

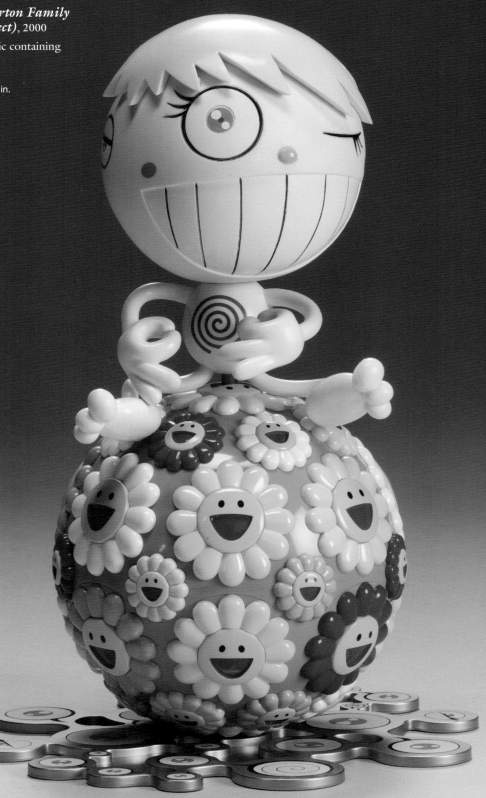

PLATE 94
Takashi Murakami
Japanese, born 1963

Oval (Peter Norton Family Christmas Project), 2000

Polychromed plastic containing a mini-CD
Produced by Cube

10 1/2 x 7 1/2 x 7 1/2 in.

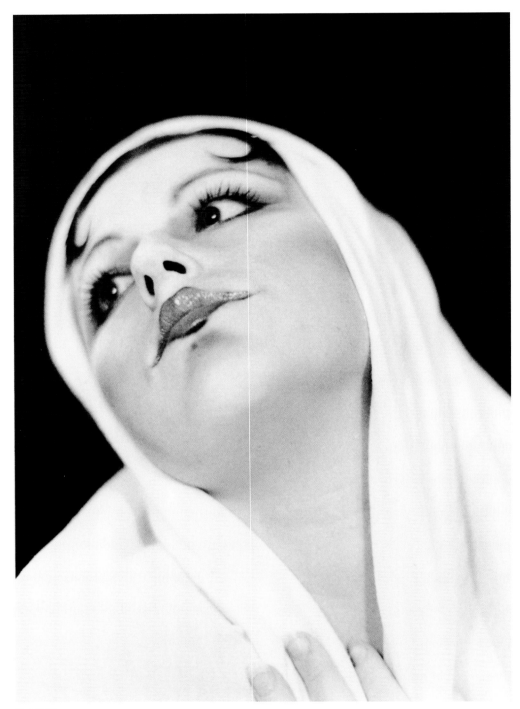

PLATE 95

Cindy Sherman

American, born 1954

Untitled, 1975/97

black and white photograph

10 x 8 in.

PLATE 96

Lynn Umlauf

American, born 1942

Untitled, 1979

pastel on mat board mounted on board

board: 25 x 16 1/2 in. (irregular)
mount: 28 x 22 in.

MISSOURI
Saint Louis Art Museum

ST. LOUIS

STEPHEN ANTONAKOS • WILL BARNET • ROBERT BARRY • LISA BRADLEY • CHARLES CLOUGH
CLAUDIA DE MONTE • RICHARD FRANCISCO • DAN GRAHAM • WILLIAM L. HANEY • JENE HIGHSTEIN
PETER HUTCHINSON • MARTIN JOHNSON • STEVE KEISTER • MARK KOSTABI • MICHAEL LASH
MICHAEL LUCERO • JOSEPH NECHVATAL • RICHARD NONAS • LUCIO POZZI • EDDA RENOUF • JUDY RIFKA
BARBARA SCHWARTZ • HAP TIVEY • DARYL TRIVIERI • RICHARD TUTTLE • LEO VALLEDOR • RUTH VOLLMER

PLATE 97
Lisa Bradley
American, born 1951
Inside Out, n.d.
oil on canvas
40 x 36 in.

Pergola for
Climbing Plants

Non-Slippery
quasi-reflective
Metalic Surface.

2 Way Mirror.

for Laumier Sculpture Park,
St. Louis

1985

PLATE 98
Dan Graham
American, born 1942
***For Laumier Sculpture
Park, St. Louis***, 1985
graphite and ink on paper
17 x 14 in.

PLATE 99
Hap Tivey
American, born 1947

Mirage #4, 1978

aluminum and copper on wood
panel beneath stretched latex

24 3/4 x 15 7/8 x 2 5/8 in.

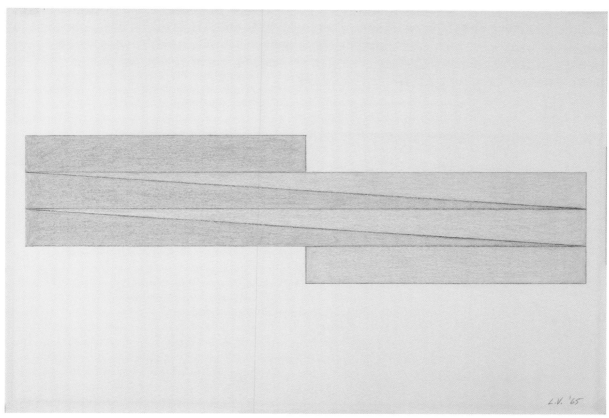

PLATE 100
Leo Valledor
American, 1936 – 1989

Untitled, 1965

graphite and crayon on paper

22 1/16 x 30 in.

MONTANA
Yellowstone Art Museum
BILLINGS

STEPHEN ANTONAKOS • WILL BARNET • ROBERT BARRY • CHARLES CLOUGH • PINCHAS COHEN GAN
CLAUDIA DE MONTE • RICHARD FRANCISCO • MICHAEL GOLDBERG • DON HAZLITT • NEIL JENNEY
MARTIN JOHNSON • STEPHEN KALTENBACH • STEVE KEISTER • MARK KOSTABI • WENDY LEHMAN
MICHAEL LUCERO • JOSEPH NECHVATAL • RICHARD NONAS • LUCIO POZZI • EDDA RENOUF
DARYL TRIVIERI • RICHARD TUTTLE • RUTH VOLLMER

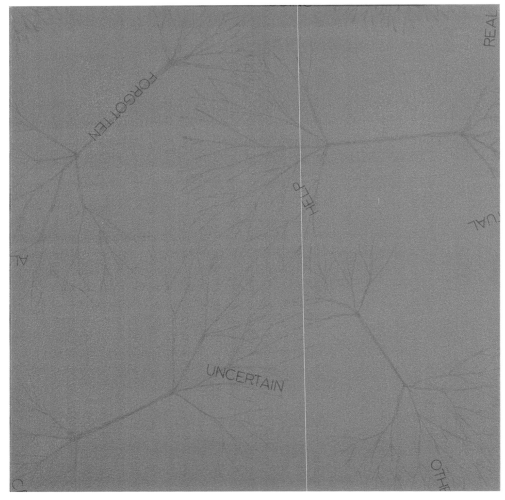

PLATE 101
Robert Barry
American, born 1936
Untitled, 1984
acrylic and gilt paint on canvas
18 x 18 in.

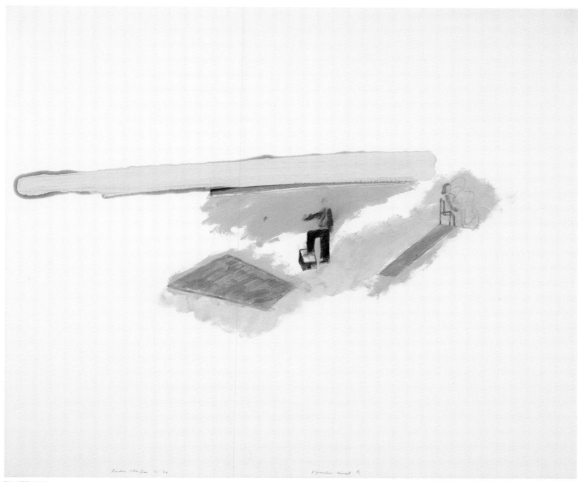

PLATE 102

Pinchas Cohen Gan

American, born 1942

Figurative Circuit N1, 1975-76

graphite, marker, oil, gouache on paper

21 5/8 x 26 11/16 in.

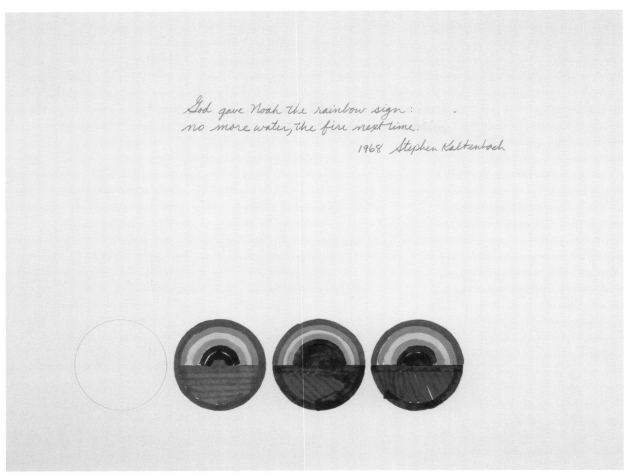

PLATE 103
Stephen Kaltenbach
American, born 1940

God gave Noah the rainbow sign: No More Water, The Fire Next Time, 1968

graphite and marker on paper

17 7/8 x 23 7/8 in.

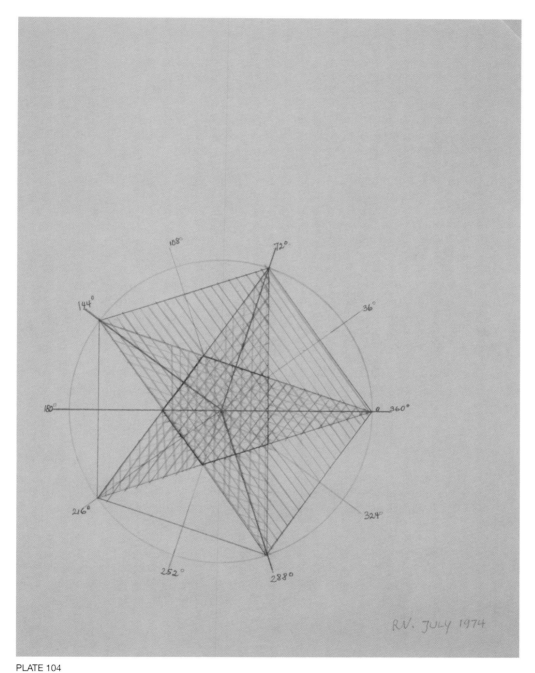

PLATE 104

Ruth Vollmer

American, 1903 – 1982

Pentagon, 1974

colored pencil and graphite on tracing paper

14 x 11 in.

NEBRASKA

Joslyn Art Museum

OMAHA

STEPHEN ANTONAKOS • WILL BARNET • ROBERT BARRY • LYNDA BENGLIS • CHARLES CLOUGH
CLAUDIA DE MONTE • RICHARD FRANCISCO • DON HAZLITT • JENE HIGHSTEIN • PETER HUTCHINSON
MARTIN JOHNSON • STEVE KEISTER • MARK KOSTABI • MICHAEL LASH • MICHAEL LUCERO
JOSEPH NECHVATAL • RICHARD NONAS • LUCIO POZZI • EDDA RENOUF • HANS J_RGEN [H.A.] SCHULT
DARYL TRIVIERI • RICHARD TUTTLE • RICHARD VAN BUREN

PLATE 105
Jene Highstein
American, born 1942

Untitled, 1997

opaque watercolor (bone black
pigment) and graphite on two
attached sheets of graph paper,
with graph paper collage

33 13/16 x 21 7/8 in.

PLATE 106
Jene Highstein
American, born 1942
***Aluminum Casting
of Room with One
Door***, 1997
cast aluminum [edition: A.P]
7 x 6 (diam.) in.

PLATE 107

Hans Jürgen [H.A.] Schult

German, born 1939

Untitled, 1985

screenprint with glitter on poster board

46 3/8 x 30 13/16 in.

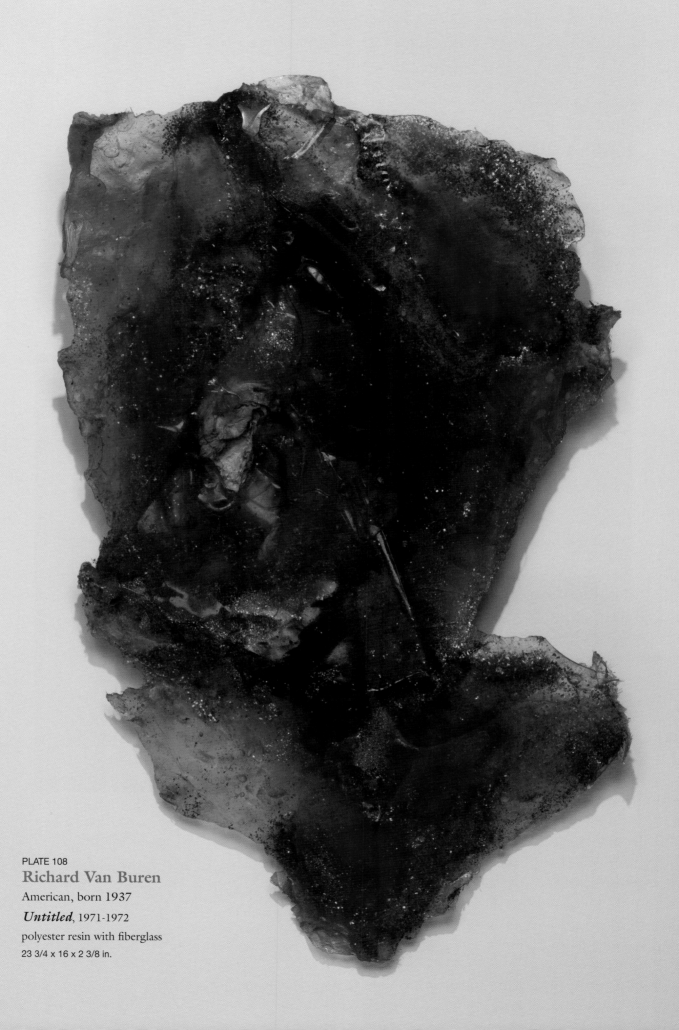

PLATE 108
Richard Van Buren
American, born 1937
Untitled, 1971-1972
polyester resin with fiberglass
23 3/4 x 16 x 2 3/8 in.

NEVADA

Las Vegas Art Museum

LAS VEGAS

STEPHEN ANTONAKOS • ROBERT BARRY • LYNDA BENGLIS • CHARLES CLOUGH • CLAUDIA DE MONTE
RICHARD FRANCISCO • DON HAZLITT • NEIL JENNEY • MARTIN JOHNSON • STEVE KEISTER
MARK KOSTABI • WENDY LEHMAN • MICHAEL LUCERO • JOSEPH NECHVATAL • LUCIO POZZI
EDDA RENOUF • EDWARD RENOUF • F. (FRANK) L. SCHRÖDER • DARYL TRIVIERI • RICHARD TUTTLE
BETTINA WERNER • LARRY ZOX

PLATE 109
Edward Renouf
American, 1906 – 1999

Untitled, 1973

oil on masonite (two panels)

each: 15 x 10 in.

PLATE 110

F. (Frank) L. Schröder

American, born 1950

Automatic Pilot, 1979

ink, marker, and graphite on graph paper

8 1/2 x 10 15/16 in.

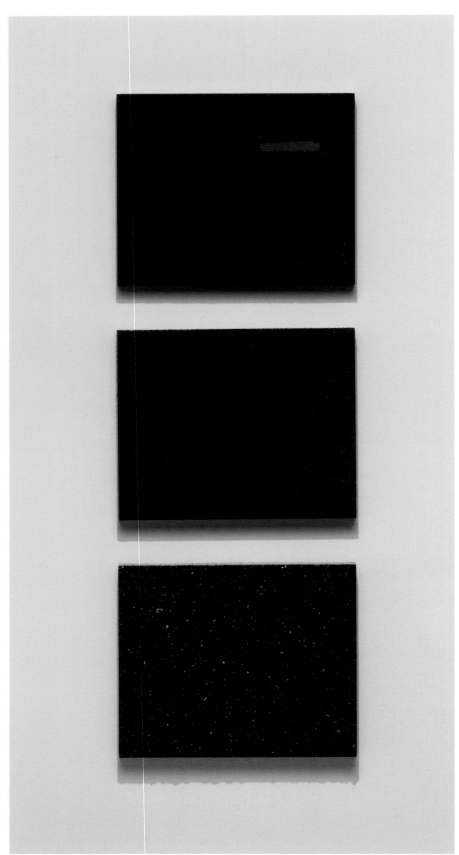

PLATE 111
Bettina Werner

Italian, born 1965

Campi neri di pensiero
(Black Fields of Thought), 1991
salt, resin and pigment on
plastic panels (triptych)
overall: 27 3/4 x 10 1/8 in.
each: 10 1/8 x 8 1/8 in.

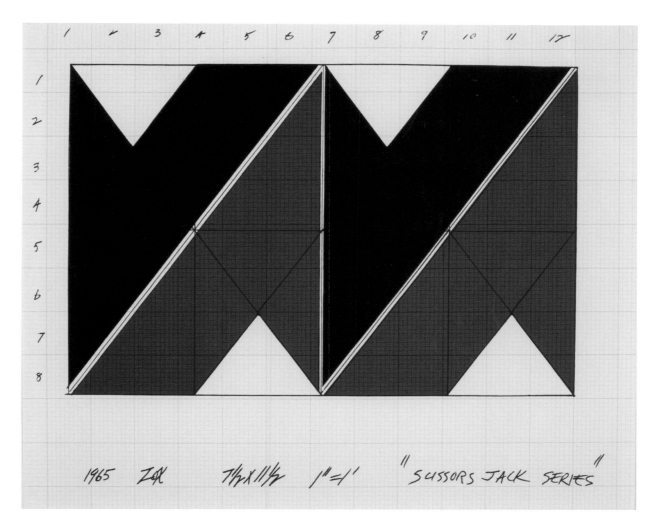

PLATE 112
Larry Zox
American, 1937 – 2006
Scissors Jack Series, 1965
black ink, gouache on graph paper
sheet: 11 1/16 x 13 15/16 in.

NEW HAMPSHIRE
Hood Museum of Art, Dartmouth College
HANOVER

STEPHEN ANTONAKOS • ROBERT BARRY • LYNDA BENGLIS • JOHN CLEM CLARKE • CHARLES CLOUGH
CLAUDIA DE MONTE • RICHARD FRANCISCO • DON HAZLITT • JENE HIGHSTEIN • BILL JENSEN
MARTIN JOHNSON • STEVE KEISTER • MARK KOSTABI • WENDY LEHMAN • MICHAEL LUCERO
JOSEPH NECHVATAL • RICHARD NONAS • LUCIO POZZI • EDDA RENOUF • JUDY RIFKA • DAVID SAWIN
MICHELLE STUART • DARYL TRIVIERI • RICHARD TUTTLE • RUTH VOLLMER

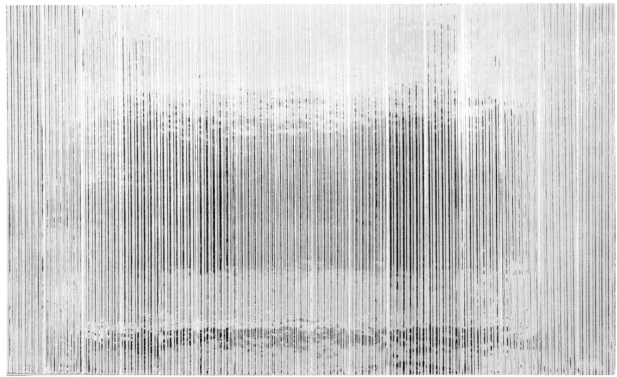

PLATE 113
Robert Barry
American, born 1936
Silver Collage, 1968
metallic strips affixed to board
7 1/2 x 12 1/8 in.

PLATE 114
John Clem Clarke
American, born 1937
Untitled, 1965
acrylic and screenprint
on canvas
55 x 30 3/4 in.

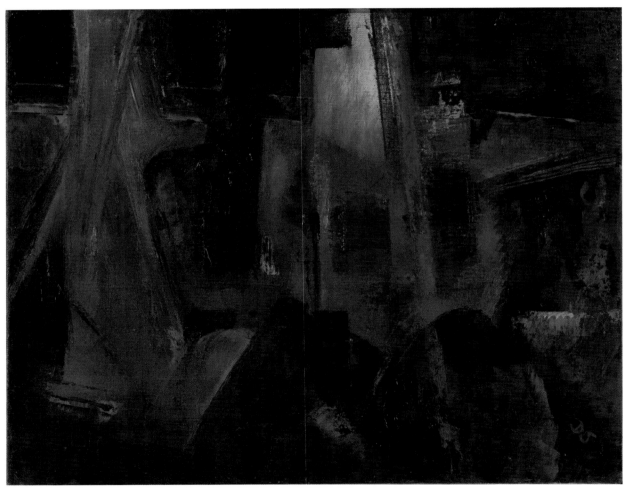

PLATE 115
David Sawin
American, born 1922
Formal Structure, 1953
oil on canvas
14 x 18 in.

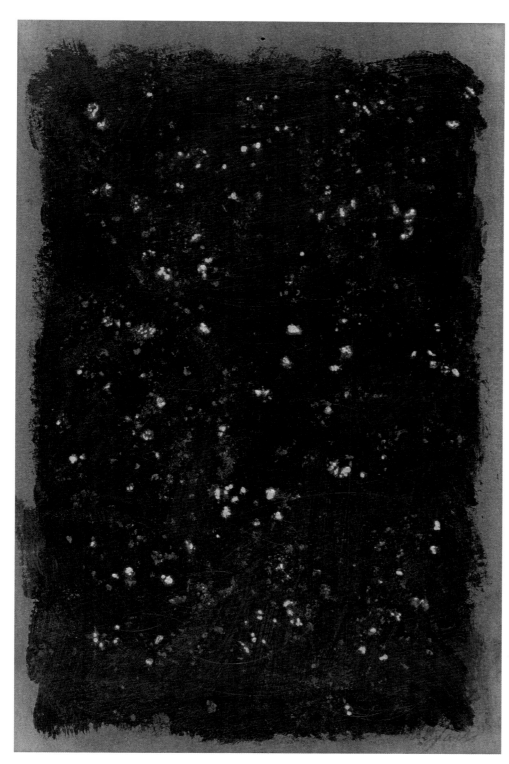

PLATE 116
Michelle Stuart
American, born 1938
July, New Hampshire, 1974
microfine graphite (rubbed), silver paint, with indentations (pounded with rock) on heavyweight canvas paper
9 13/16 x 6 1/2 in.

NEW JERSEY
Montclair Art Museum

MONTCLAIR

STEPHEN ANTONAKOS • WILL BARNET • ROBERT BARRY • LYNDA BENGLIS • RONALD BLADEN
MICHAEL CLARK (CLARK FOX) • CHARLES CLOUGH • STUART DIAMOND • RICHARD FRANCISCO
DON HAZLITT • BRYAN HUNT • BILL JENSEN • MARTIN JOHNSON • ALAIN KIRILI • CHERYL LAEMMLE
MICHAEL LUCERO • RICHARD NONAS • LARRY POONS • LUCIO POZZI • EDDA RENOUF • RODNEY RIPPS
ALAN SARET • BARBARA SCHWARTZ • JUDITH SHEA • DARYL TRIVIERI • RICHARD TUTTLE

PLATE 117
Ronald Bladen
American (born Canada), 1918 – 1988

*Five Studies: 'Black Tower' and four
unknown sculptures*, 1984-85

graphite on paper

22 1/8 x 42 3/8 in.

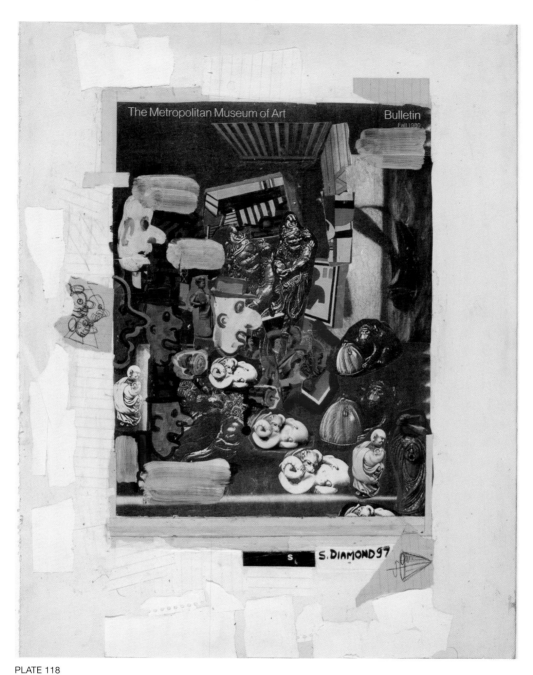

PLATE 118

Stuart Diamond

American, born 1942

Untitled, 1997

collage of various papers, with acrylic,
ink, and tape on paper

sheet: 21 7/8 x 17 in. (approx.)

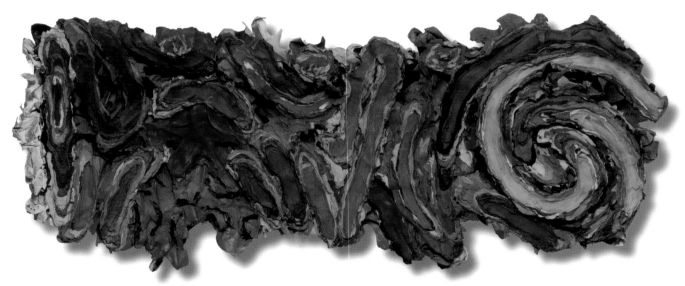

PLATE 119

Rodney Ripps

American, born 1950

Galaxy, 1978

oil paint and wax medium on
cloth on wood

13 x 31 1/4 x 7 in. (irregular)

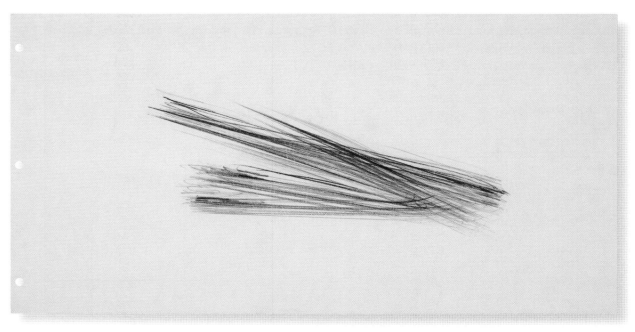

PLATE 120
Alan Saret
American, born 1944

Untitled, 1967
colored pencil and graphite on verso of graph paper
10 15/16 x 22 in.

NEW MEXICO

New Mexico Museum of Art, Museum of New Mexico

SANTA FE

ROBERT BARRY • LYNDA BENGLIS • CHARLES CLOUGH • R.M. FISCHER • RICHARD FRANCISCO
DON HAZLITT • JENE HIGHSTEIN • NEIL JENNEY • BILL JENSEN • JOAN JONAS • STEVE KEISTER
ALAIN KIRILI • MARK KOSTABI • WENDY LEHMAN • MICHAEL LUCERO • JOSEPH NECHVATAL
RICHARD NONAS • KATHERINE PORTER • LUCIO POZZI • EDDA RENOUF • JUDY RIFKA
BARBARA SCHWARTZ • DARYL TRIVIERI • RICHARD TUTTLE

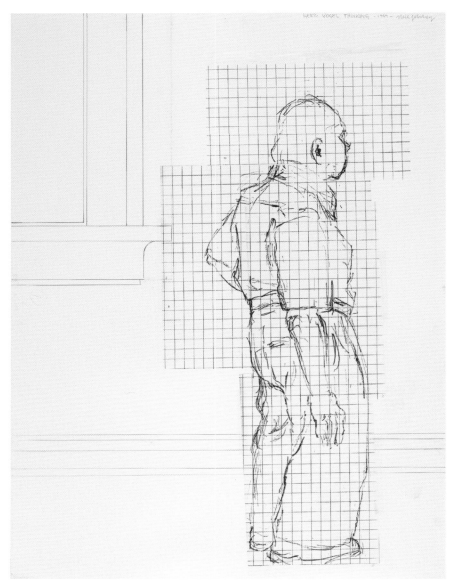

PLATE 121
Neil Jenney
American, born 1945
Herb Vogel Thinking, 1999
Xerox collage and graphite on mat board
47 1/8 x 36 1/8 in.

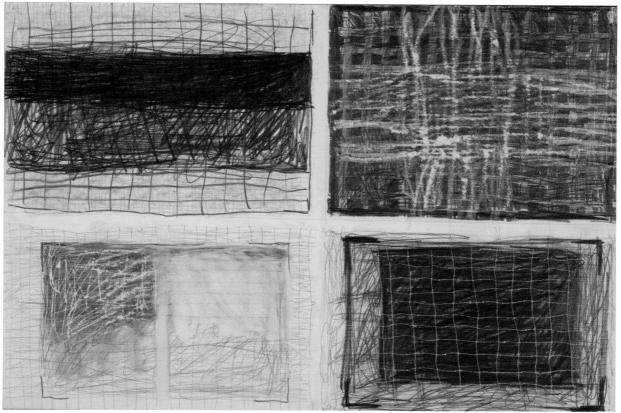

PLATE 122

Katherine Porter

American, born 1941

Untitled, 1974

graphite, colored pencil, and glue, with incised
and scraped lines, on paperboard

12 x 18 in.

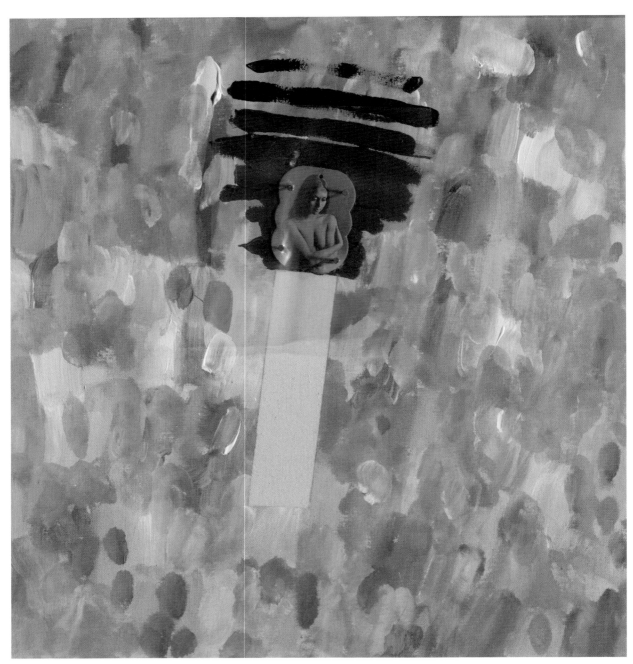

PLATE 123

Lucio Pozzi

American, born 1935

Nude, 1980

acrylic on canvas mounted on wood,
with collage (photograph on board,
nails, plastic)

25 1/8 x 24 x 1 1/4 in.

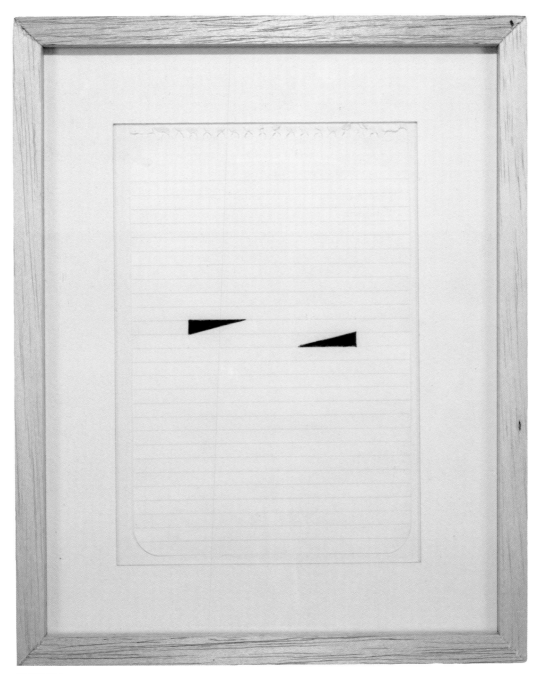

PLATE 124
Richard Tuttle
American, born 1941

Rome Drawing #63, 1974

black felt tip pen on lined notebook
paper, framed

11 9/16 x 9 1/8 in.

NEW YORK

Albright-Knox Art Gallery

BUFFALO

RICHARD ARTSCHWAGER • ROBERT BARRY • LYNDA BENGLIS • CHARLES CLOUGH • KOKI DOKTORI
R.M. FISCHER • RICHARD FRANCISCO • DON HAZLITT • JENE HIGHSTEIN • BILL JENSEN • TOBI KAHN
STEVE KEISTER • ALAIN KIRILI • MARK KOSTABI • WENDY LEHMAN • MICHAEL LUCERO
JOSEPH NECHVATAL • RICHARD NONAS • LARRY POONS • LUCIO POZZI • EDDA RENOUF • JUDY RIFKA
BARBARA SCHWARTZ • DARYL TRIVIERI • RICHARD TUTTLE

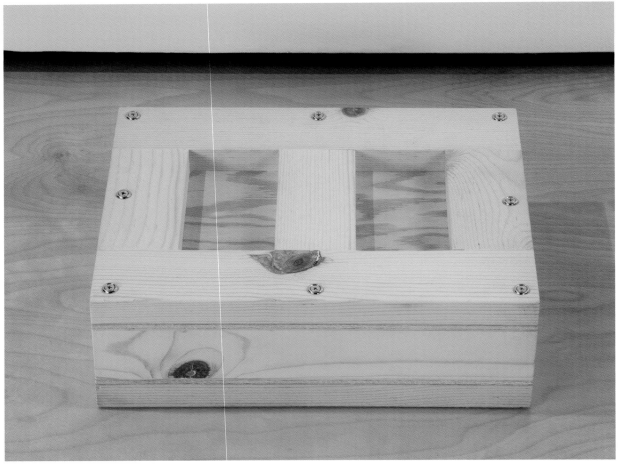

PLATE 125

Richard Artschwager

American, born 1923

Thousand Cubic Inches Prototype, 1996

wood with metal hardware [edition: XXV/XL]

12 1/2 x 15 15/16 x 5 in.

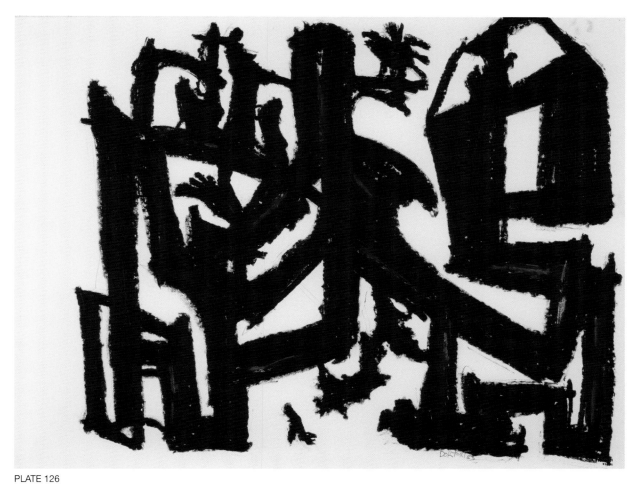

PLATE 126
Koki Doktori
Israeli (?), 1941

On the Run, 1983

oil stick and graphite on paper

22 3/8 x 30 1/16 in.

PLATE 127
Larry Poons
American, born 1937

Untitled, 1967

graphite on graph paper

16 15/16 x 21 15/16 in.

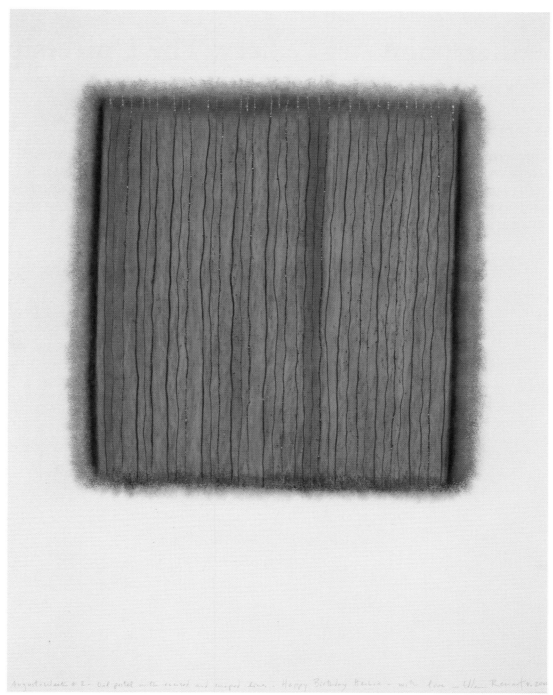

PLATE 128

Edda Renouf

American, born 1943

August-Week 2, 2000

oil pastel with ink, graphite and
incised lines on paper

19 x 15 in.

NORTH CAROLINA

Weatherspoon Art Gallery, The University of North Carolina at Greensboro

GREENSBORO

STEPHEN ANTONAKOS • ROBERT BARRY • LYNDA BENGLIS • MCWILLIE CHAMBERS • CHARLES CLOUGH
RICHARD FRANCISCO • DON HAZLITT • JENE HIGHSTEIN • RALPH IWAMOTO • BILL JENSEN
STEPHEN KALTENBACH • STEVE KEISTER • ALAIN KIRILI • MICHAEL LUCERO • JOSEPH NECHVATAL
RICHARD NONAS • LUCIO POZZI • EDDA RENOUF • JUDY RIFKA • ALEXIS ROCKMAN • LORI TASCHLER
DARYL TRIVIERI • RICHARD TUTTLE • MARIO YRISSARY

PLATE 129
McWillie Chambers

American, born 1951

Untitled woodcuts, n.d., and
S.V. Elissa with Sun, 2000

paper folder, housing eight
woodcuts (4 variations of two
images) of various colors, edition
sizes and papers

sheets: six at 6 x 8 13/16 in.;
four at 8 7/8 x 12 in.;
one at 8 1/2 x 12 1/4 in.
folder dimensions (closed): 13 x 9 3/8 in.

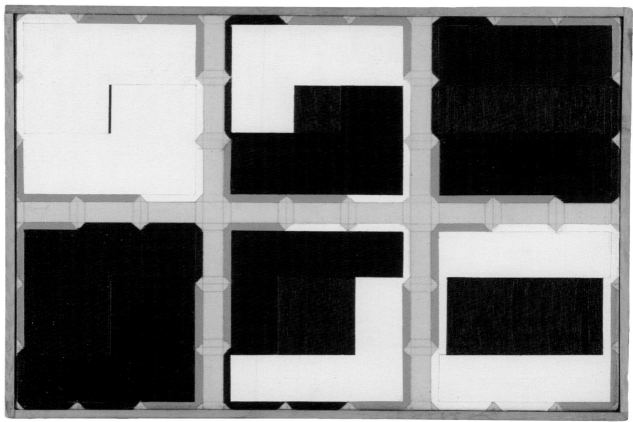

PLATE 130

Ralph Iwamoto

American, born 1927

Study Steps #3, 1977

acrylic on canvas

9 1/2 x 14 1/2 in.
frame: 10 x 15 in.

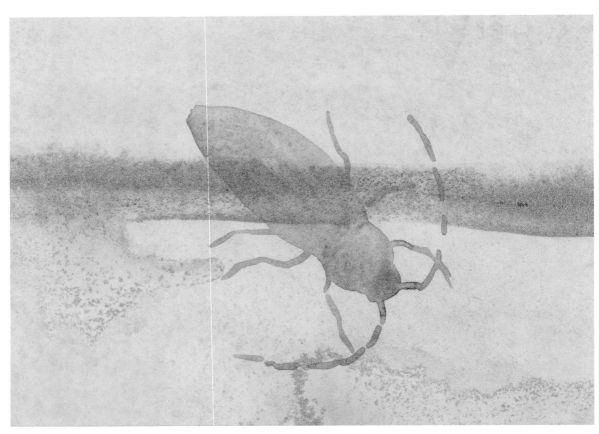

PLATE 131
Alexis Rockman
American, born 1962

Untitled, 1996

watercolor and silver
spray paint on board

4 1/2 x 6 1/4 in.

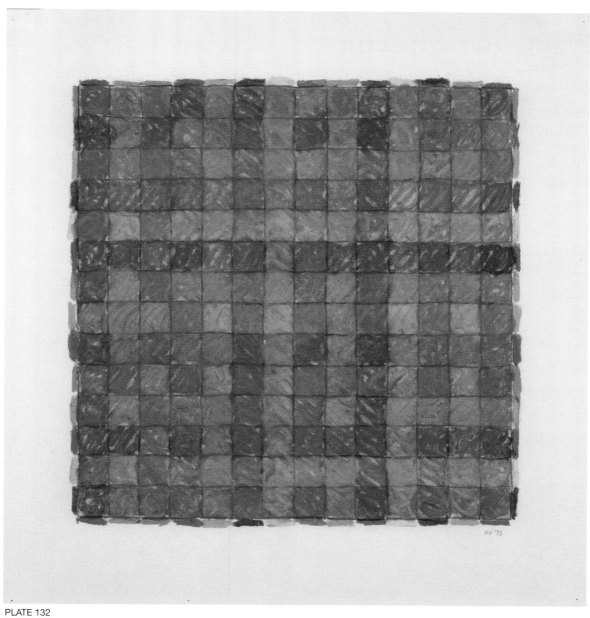

PLATE 132

Mario Yrissary

American, born 1933

Untitled, 1973

crayon, colored pencil, and watercolor on paper

19 7/16 x 19 1/8 in.

NORTH DAKOTA

Plains Art Museum

FARGO

ROBERT BARRY • CHARLES CLOUGH • RICHARD FRANCISCO • DON HAZLITT • JENE HIGHSTEIN
PETER HUTCHINSON • BILL JENSEN • STEVE KEISTER • ALAIN KIRILI • MARK KOSTABI • JILL LEVINE
ROBERT LOBE • MICHAEL LUCERO • JOSEPH NECHVATAL • RICHARD NONAS • LUCIO POZZI
EDDA RENOUF • JUDY RIFKA • PETER SCHUYFF • JUDITH SHEA • LORI TASCHLER • DARYL TRIVIERI
RICHARD TUTTLE • RUTH VOLLMER

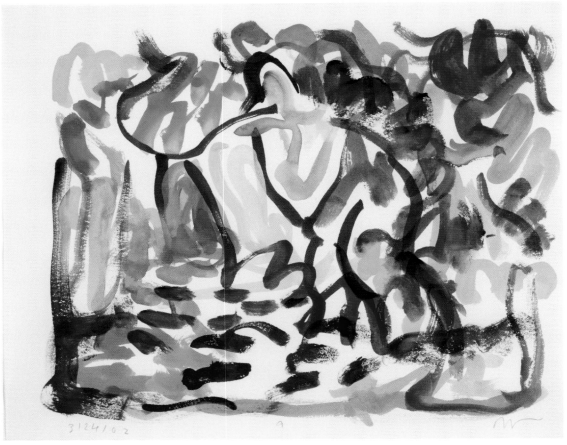

PLATE 133
Charles Clough
American, born 1951
3/24/02, 2002
watercolor on paper, framed
8 1/8 x 11 in. (approx.)

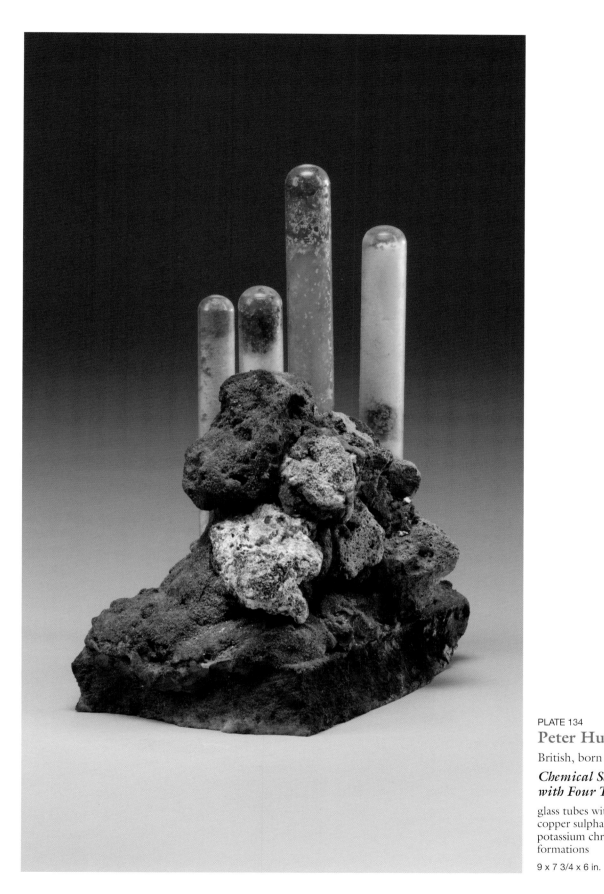

PLATE 134
Peter Hutchinson
British, born 1930
***Chemical Sculpture
with Four Tubes***, 1970

glass tubes with salt,
copper sulphate and
potassium chromate
formations

9 x 7 3/4 x 6 in.

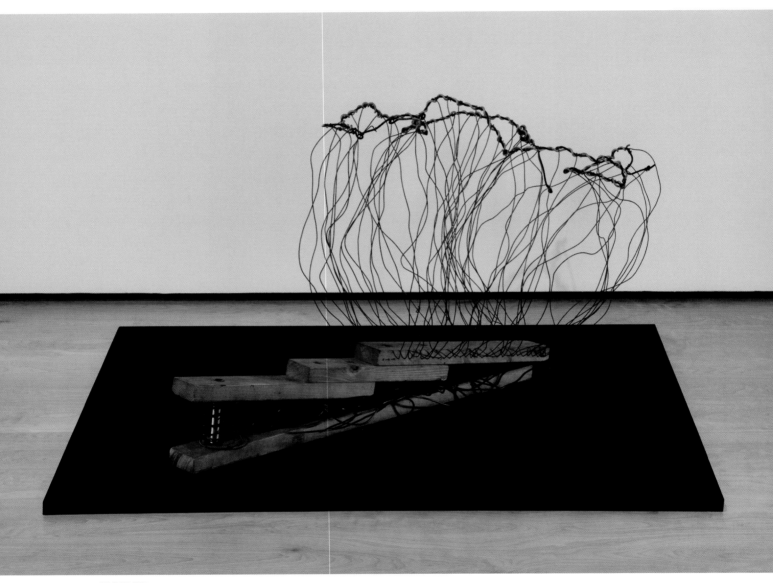

PLATE 135

Robert Lobe

American, born 1945

Untitled, 1969

metal, including steel pipe, coated
spring wire, solder wire, and wood

33 x 60 x 27 in.

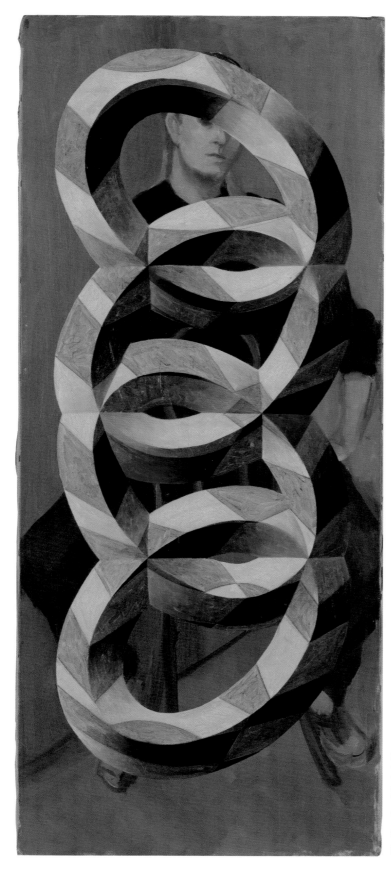

PLATE 136
Peter Schuyff
Dutch, born 1958
Graham, 1998
oil on found canvas
28 1/8 x 12 1/8 in.

OHIO
Akron Art Museum

AKRON

ROBERT BARRY • LYNDA BENGLIS • LOREN CALAWAY • CHARLES CLOUGH • RICHARD FRANCISCO
DON HAZLITT • JENE HIGHSTEIN • DAVID HUNTER • MARTIN JOHNSON • STEVE KEISTER • ALAIN KIRILI
MARK KOSTABI • JILL LEVINE • MICHAEL LUCERO • ROBERT MANGOLD • JOSEPH NECHVATAL
NAM JUNE PAIK • RAYMOND PARKER • LUCIO POZZI • EDDA RENOUF • JUDY RIFKA • JOHN SALT
JUDITH SHEA • LORI TASCHLER • DARYL TRIVIERI • RICHARD TUTTLE

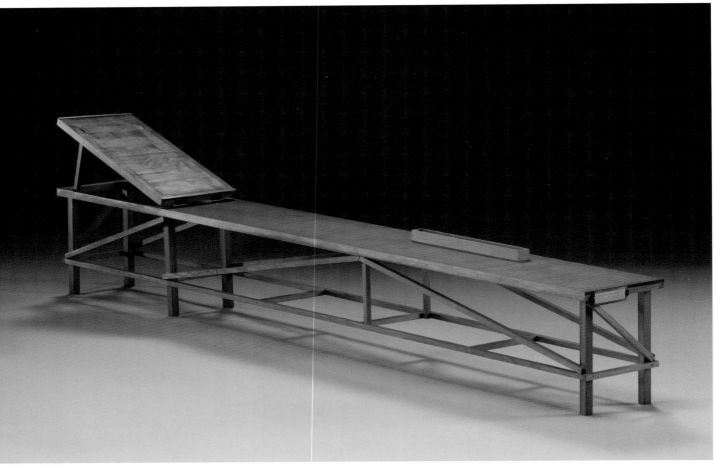

PLATE 137
Loren Calaway
American, born 1950
Untitled, 1979
wood, woven fabric, felted fabric, and
copper-alloy hardware
44 x 5 x 10 in.

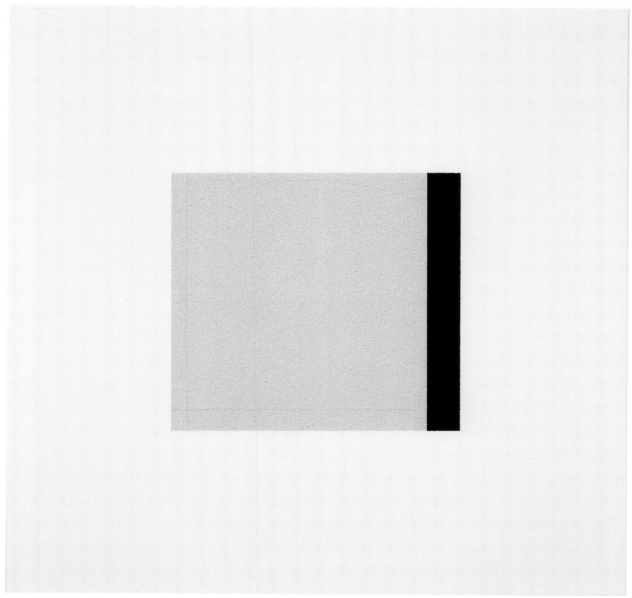

PLATE 138
David Hunter
American, born 1947
Untitled #33, 1997
pigment with binder and graphite on paper
14 1/4 x 15 in.

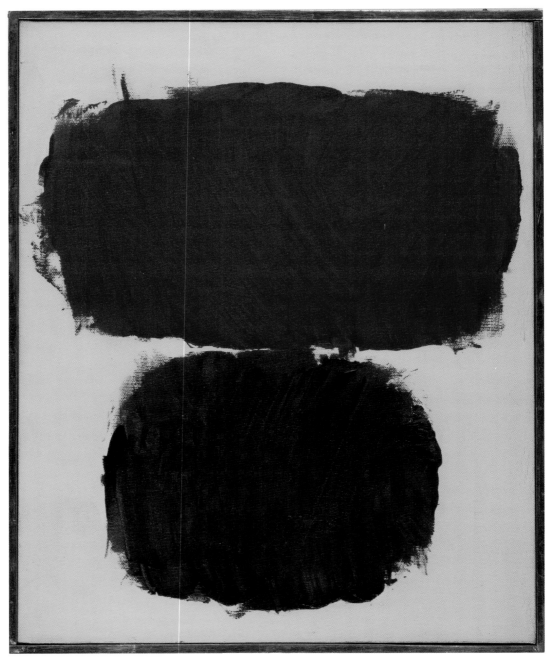

PLATE 139

Raymond Parker

American, 1922 – 1990

Untitled, 1962

oil on canvas, in shadowbox frame

canvas (sight): 16 1/8 x 13 1/4 in.

PLATE 140

John Salt

British, born 1937

Untitled (Vogel living room drawn from memory), 1973

colored pencil, ink, and graphite on paper

sheet (as folded): 3 1/2 x 5 1/8 in.

OKLAHOMA

Oklahoma City Museum of Art

OKLAHOMA CITY

ROBERT BARRY • LYNDA BENGLIS • MICHAEL CLARK (CLARK FOX) • CHARLES CLOUGH
RICHARD FRANCISCO • DON HAZLITT • JENE HIGHSTEIN • RALPH HUMPHREY • MARTIN JOHNSON
STEVE KEISTER • ALAIN KIRILI • MARK KOSTABI • JILL LEVINE • MICHAEL LUCERO • JOSEPH NECHVATAL
HENRY C. PEARSON • LUCIO POZZI • EDDA RENOUF • JUDY RIFKA • JUDITH SHEA • LORI TASCHLER
DARYL TRIVIERI • RICHARD TUTTLE • THORNTON WILLIS • TOD WIZON

PLATE 141
Ralph Humphrey
American, 1932 – 1990

Untitled, 1971

graphite, pastel, acrylic and collage on paper
21 15/16 x 29 3/4 in.

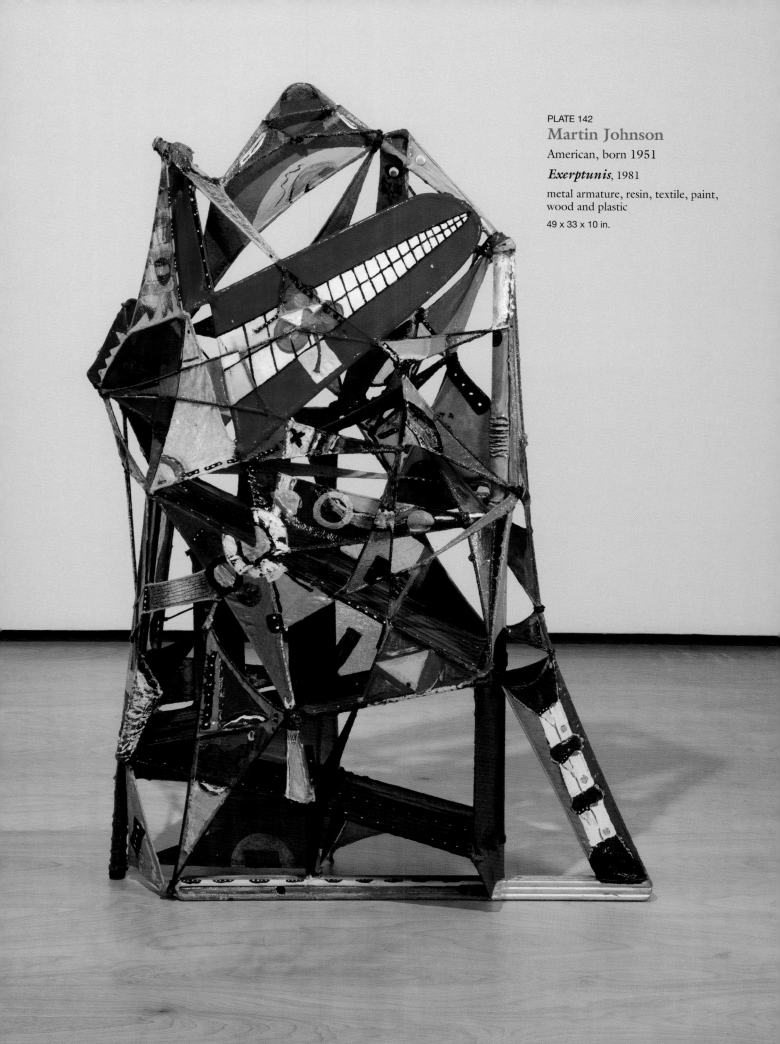

PLATE 142
Martin Johnson
American, born 1951

Exerptunis, 1981

metal armature, resin, textile, paint,
wood and plastic

49 x 33 x 10 in.

PLATE 143

Henry C. Pearson

American, 1914 – 2006

The Aspects of the Case, 1969

ink and watercolor on orange paper

12 x 24 7/8 in.

PLATE 144

Judith Shea

American, born 1948

Untitled, 1991

ink wash, watercolor, graphite,
and copper ink on paper

26 1/8 x 18 7/8 in.

OREGON

Portland Art Museum

PORTLAND

ROBERT BARRY • LYNDA BENGLIS • DIKE BLAIR • RICHMOND BURTON • CHARLES CLOUGH
RICHARD FRANCISCO • DON HAZLITT • JOHN HULTBERG • MARTIN JOHNSON • STEVE KEISTER
ALAIN KIRILI • MARK KOSTABI • MOSHE KUPFERMAN • JILL LEVINE • MICHAEL LUCERO
JOSEPH NECHVATAL • RICHARD NONAS • LUCIO POZZI • EDDA RENOUF • JUDY RIFKA • JUDITH SHEA
HAP TIVEY • DARYL TRIVIERI • RICHARD TUTTLE • THORNTON WILLIS • BETTY WOODMAN

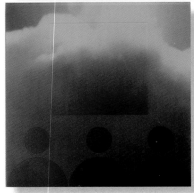

PLATE 145
Dike Blair
American, born 1952

Untitled, 1990

c-print, epoxy on etched
glass mounted on aluminum
strainer, triptych

overall: 54 x 18 in.
each panel: 18 x 18 in.

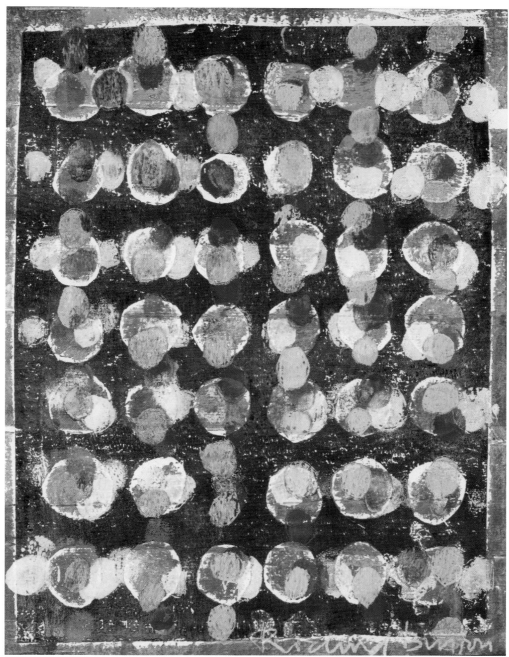

PLATE 146
Richmond Burton
American, born 1960
Untitled, 1997
acrylic on paper
11 x 8 9/16 in.

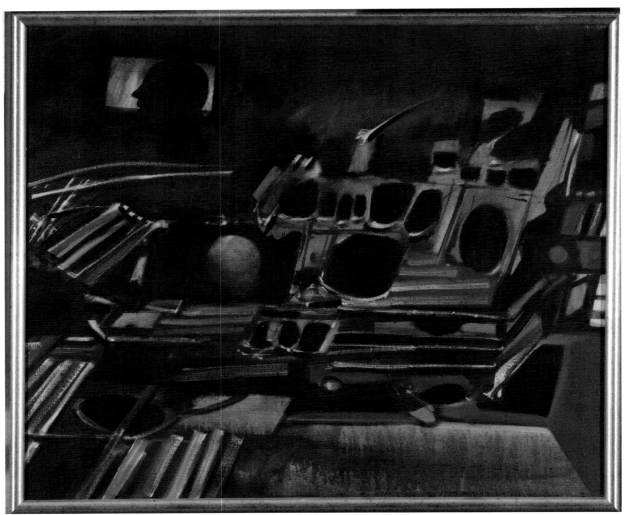

PLATE 147
John Hultberg
American, 1922 – 2005

Suspension 5, 1967

oil on canvas, framed

18 x 22 1/8 in.
frame: 19 3/8 x 23 3/8 in.

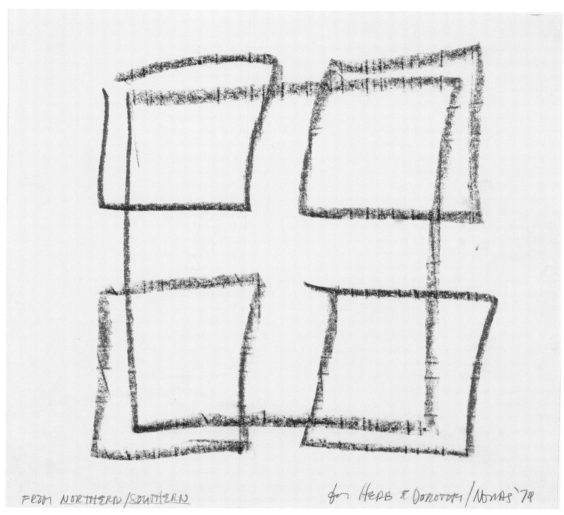

FROM NORTHERN/SOUTHERN for HERB & DOROTHY/NONAS '79

PLATE 148

Richard Nonas

American, born 1936

From Northern/Southern, 1974

graphite on paper

6 7/8 x 7 5/8 in.

PENNSYLVANIA

Pennsylvania Academy of the Fine Arts

PHILADELPHIA

WILL BARNET • ROBERT BARRY • LYNDA BENGLIS • GARY BOWER • LISA BRADLEY • LOREN CALAWAY
CHARLES CLOUGH • RICHARD FRANCISCO • MICHAEL GOLDBERG • DON HAZLITT • JENE HIGHSTEIN
STEWART HITCH • JIM HODGES • MARTIN JOHNSON • TOBI KAHN • STEVE KEISTER • ALAIN KIRILI
MARK KOSTABI • CHERYL LAEMMLE • JILL LEVINE • MICHAEL LUCERO • JOSEPH NECHVATAL
NAM JUNE PAIK • LUCIO POZZI • EDDA RENOUF • JUDY RIFKA • CHRISTY RUPP • ALAN SHIELDS
HAP TIVEY • DARYL TRIVIERI • RICHARD TUTTLE

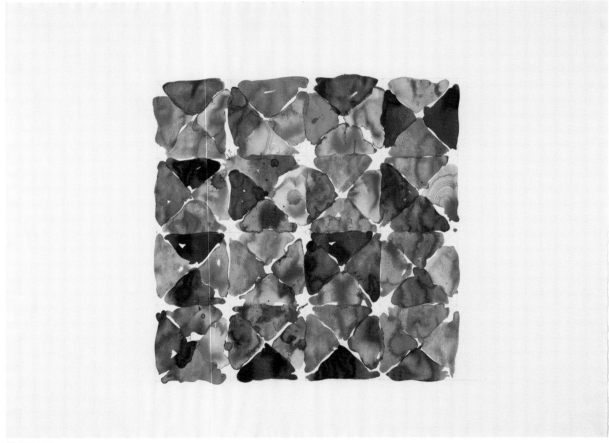

PLATE 149
Gary Bower
American, born 1940

Untitled, 1971

watercolor and graphite on paper
22 1/8 x 30 1/8 in.

PLATE 150

Jim Hodges

American, born 1957

Blanket (Peter Norton Family Christmas Project), 1998

woven wool textile

52 x 72 in.

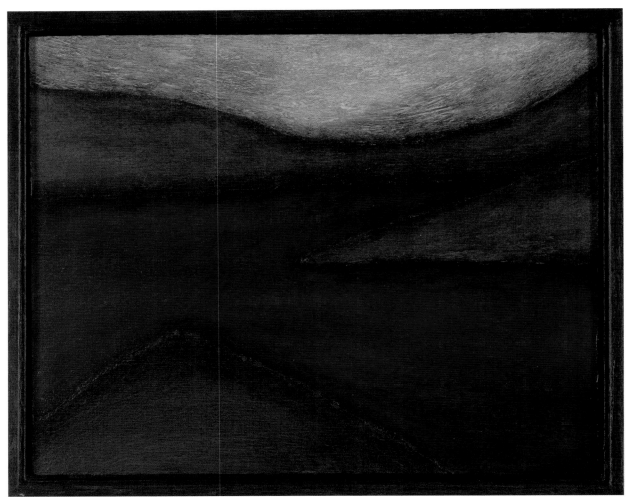

PLATE 151
Tobi Kahn
American, born 1952

O K Y N, 1985

acrylic on panel

13 3/4 x 17 3/4 in.
frame: 21 1/8 x 25 1/8 in.

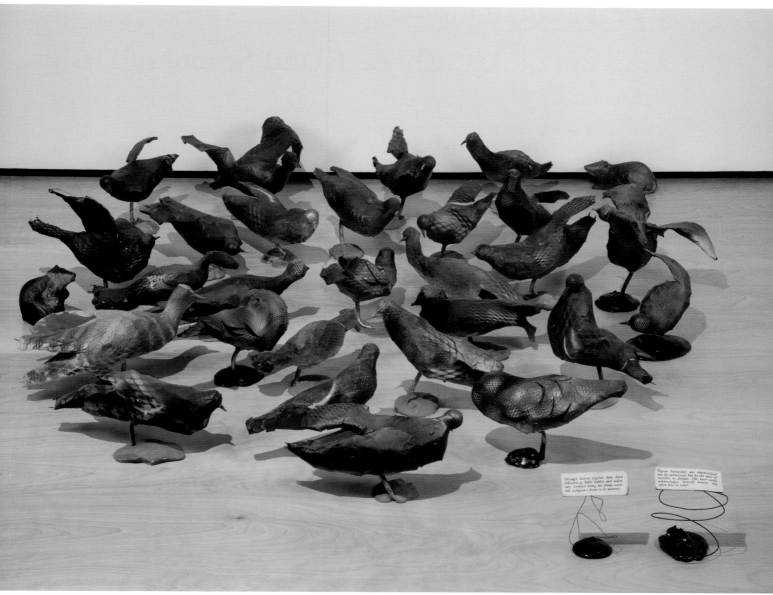

PLATE 152

Christy Rupp

American, born 1949

Pigeon Flock with Rats, 1980

29 pieces: wire mesh, newspaper,
adhesive, plaster, aluminum and
paint, plus 2 screenprinted labels,
variable installation

rats and pigeons range in size from approximately
8 x 4 x 4 in. to 14 1/2 x 13 x 9 in.

RHODE ISLAND
Museum of Art, Rhode Island School of Design
PROVIDENCE

ROBERT BARRY • LYNDA BENGLIS • WILLIAM (BILL) BOLLINGER • CHARLES CLOUGH
RICHARD FRANCISCO • DON HAZLITT • STEWART HITCH • MARTIN JOHNSON • STEVE KEISTER
ALAIN KIRILI • CHERYL LAEMMLE • WENDY LEHMAN • JILL LEVINE • MICHAEL LUCERO
JOSEPH NECHVATAL • NAM JUNE PAIK • LUCIO POZZI • EDDA RENOUF • JUDY RIFKA • JOEL SHAPIRO
ALAN SHIELDS • HAP TIVEY • DARYL TRIVIERI • RICHARD TUTTLE

PLATE 153
William (Bill) Bollinger
American, 1939 – 1988

Untitled, 1968

graphite (sprayed) on paper mounted
on board

sheet: 14 1/4 x 22 7/8 in.
mount: 16 1/2 x 25 in.

PLATE 154
Don Hazlitt
American, born 1948

Shaped Edge, 1980

oil on corrugated cardboard with
wire and painted wood dowels

29 x 18 1/2 x 1 3/4 in.
(including wire extension)

PLATE 155
Wendy Lehman
American, born 1945
Going Dotty, 1981
acrylic on wood construction
23 x 16 3/4 x 6 1/8 in.

PLATE 156

Joel Shapiro

American, born 1941

Model for Two Houses, 2000

wood and white primer

height, including base: 11 in.
base: 16 3/4 x 15 x 11/16 in.

SOUTH CAROLINA
Columbia Museum of Art

COLUMBIA

ROBERT BARRY • ZIGI BEN-HAIM • LYNDA BENGLIS • CHARLES CLOUGH • PEGGY CYPHERS
RICHARD FRANCISCO • WILLIAM L. HANEY • DON HAZLITT • STEWART HITCH • MARTIN JOHNSON
STEVEN KARR • STEVE KEISTER • ALAIN KIRILI • CHERYL LAEMMLE • JILL LEVINE • MICHAEL LUCERO
JOSEPH NECHVATAL • RAYMOND PARKER • BETTY PARSONS • LUCIO POZZI • EDDA RENOUF • JUDY RIFKA
ROBERT STANLEY • HAP TIVEY • DARYL TRIVIERI • RICHARD TUTTLE • THORNTON WILLIS • BETTY WOODMAN

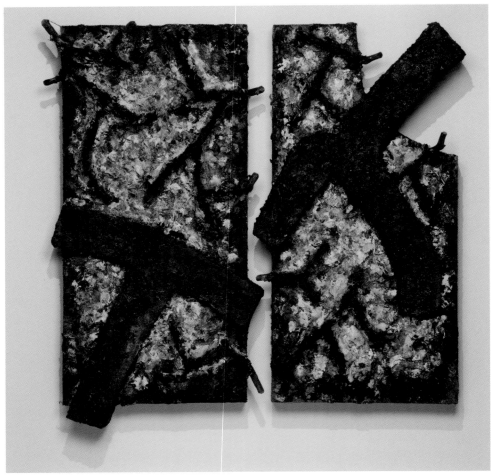

PLATE 157
Zigi Ben-Haim
American, born 1945

Just Before '84, 1983

branches, newspaper, oil, wire
mesh on burlap on wood, diptych

left: 32 x 17 in. (irregular)
right: 30 1/8 x 17 in. (irregular)

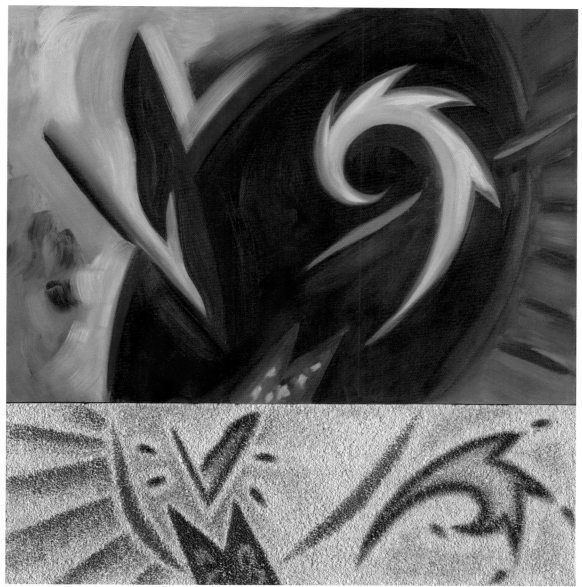

PLATE 158

Peggy Cyphers

American, born 1954

Galaxy's Empire, 1986

oil on two panels: top, oil on Mylar, laminated to
Plexi; bottom, oil and spray paint on mineralized
tar paper, laminated to wood

22 3/8 x 22 in.

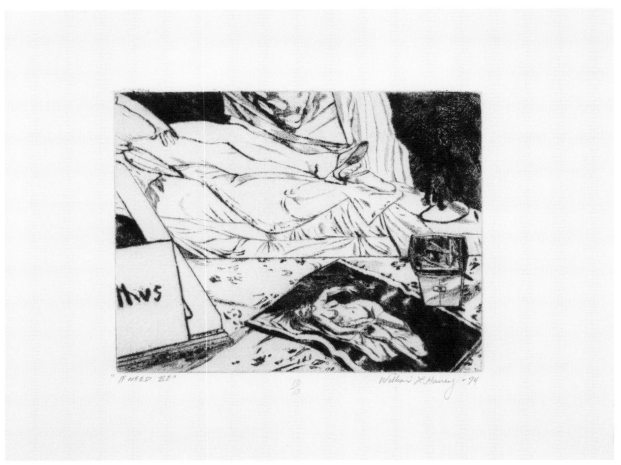

PLATE 159

William L. Haney

American, born 1939

If Need Be, 1974

softground and drypoint etching on paper
edition: 10/13

9 1/2 x 12 3/4 in.

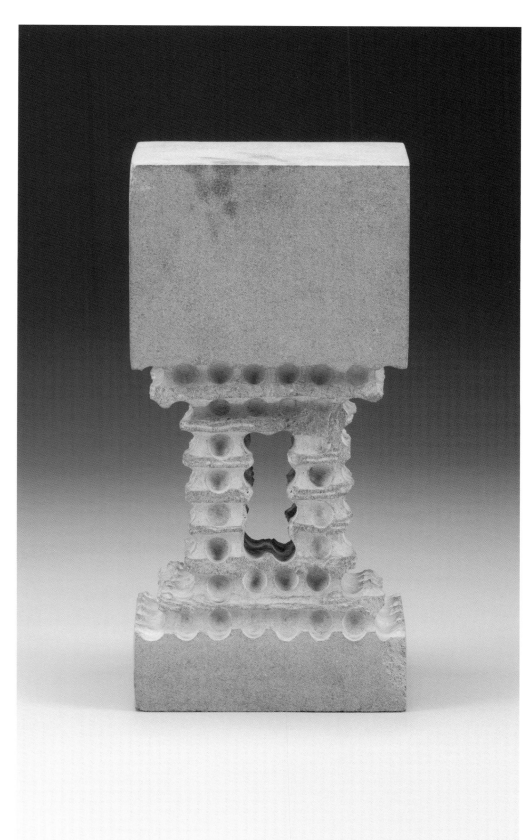

PLATE 160
Steven Karr
American, born 1923
Untitled, 1975
Limestone
12 1/8 x 6 1/16 x 4 7/8 in.

SOUTH DAKOTA

South Dakota Art Museum, South Dakota State University

BROOKINGS

ROBERT BARRY • LYNDA BENGLIS • LOREN CALAWAY • CHARLES CLOUGH • RICHARD FRANCISCO
PETER HALLEY • DON HAZLITT • MARTIN JOHNSON • STEVE KEISTER • ALAIN KIRILI • MICHAEL LATHROP
JILL LEVINE • MICHAEL LUCERO • JOSEPH NECHVATAL • BETTY PARSONS • LUCIO POZZI • EDDA RENOUF
JUDY RIFKA • ROBERT STANLEY • HAP TIVEY • DARYL TRIVIERI • RICHARD TUTTLE • THORNTON WILLIS

PLATE 161
Peter Halley
American, born 1953
Prison 7, 1995
ink and graphite on paper
5 x 7 in.

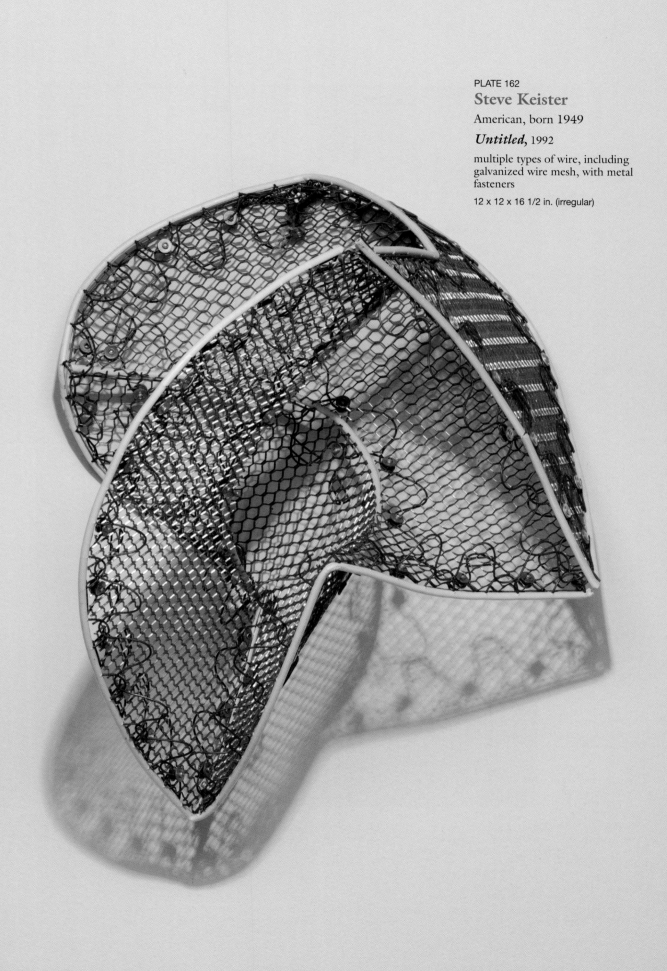

PLATE 162
Steve Keister
American, born 1949

Untitled, 1992

multiple types of wire, including
galvanized wire mesh, with metal
fasteners

12 x 12 x 16 1/2 in. (irregular)

PLATE 163

Michael Lathrop

American, born 1958/59 (?)

Vision of Nature III, 1999

acrylic on canvas board

7 x 4 15/16 in.
frame: 10 3/4 x 8 13/16 in.

PLATE 164

Joseph Nechvatal

American, born 1951

The Moral Constant, 1985
graphite and crayon on paper, diptych

each sheet: 11 x 14 in.

TENNESSEE
Memphis Brooks Museum of Art

MEMPHIS

WILL BARNET • ROBERT BARRY • LYNDA BENGLIS • CHARLES CLOUGH • RICHARD FRANCISCO
DON HAZLITT • STEWART HITCH • MARTIN JOHNSON • STEVE KEISTER • ALAIN KIRILI • CHERYL LAEMMLE
RONNIE LANDFIELD • JILL LEVINE • MICHAEL LUCERO • GIUSEPPE NAPOLI • JOSEPH NECHVATAL
HENRY C. PEARSON • LUCIO POZZI • EDDA RENOUF • STEPHEN ROSENTHAL • PAT STEIR
JOHN TORREANO • DARYL TRIVIERI • RICHARD TUTTLE • THORNTON WILLIS

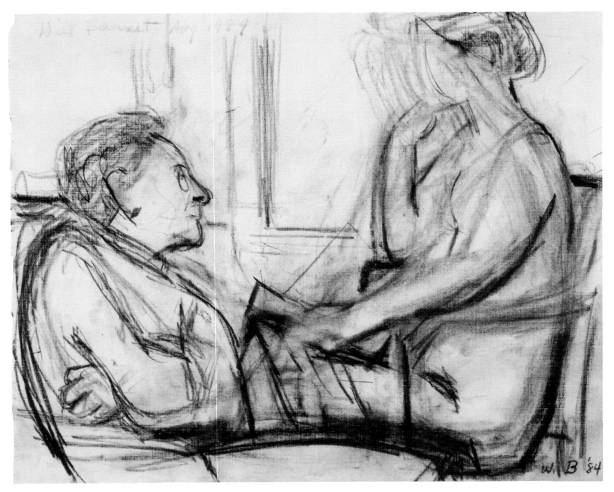

PLATE 165
Will Barnet
American, born 1911

Untitled, 1984

graphite and charcoal on paper

7 3/4 x 9 3/4 in.

PLATE 166
Cheryl Laemmle
American, born 1947
Untitled, 1987
watercolor and graphite on paper
14 1/8 x 10 3/16 in.

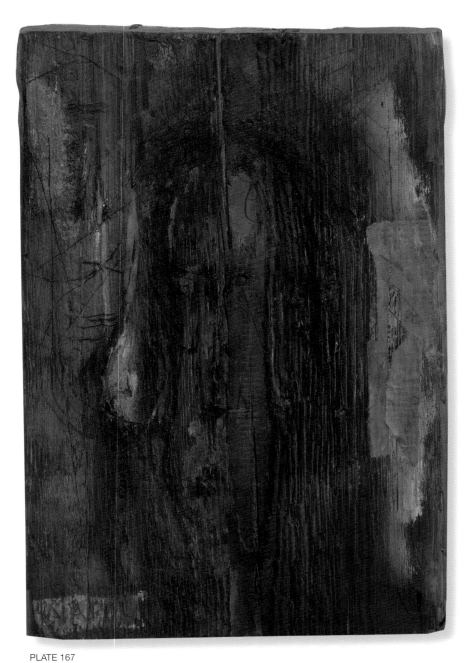

PLATE 167
Giuseppe Napoli
American, 1929 – 1967

Untitled, n.d.

wood wall relief with paint, nails,
collage and incising

13 3/8 x 9 3/8 x 3 1/8 in.

PLATE 168
Stephen Rosenthal
American, born 1935

ABRL, 1974
oil on unstretched canvas
24 1/4 x 21 in. (irregular)

TEXAS

Blanton Museum of Art, University of Texas at Austin

AUSTIN

STEPHEN ANTONAKOS • WILL BARNET • ROBERT BARRY • LYNDA BENGLIS • RONALD BLADEN
LISA BRADLEY • CHARLES CLOUGH • RICHARD FRANCISCO • MICHAEL GOLDBERG • JENE HIGHSTEIN
STEVE KEISTER • ALAIN KIRILI • MICHAEL LUCERO • SYLVIA PLIMACK MANGOLD • ELIZABETH MURRAY
JOSEPH NECHVATAL • RICHARD NONAS • RICHARD PETTIBONE • LUCIO POZZI • EDDA RENOUF
DONALD SULTAN • DARYL TRIVIERI • RICHARD TUTTLE • RUTH VOLLMER • URSULA VON RYDINGSVARD

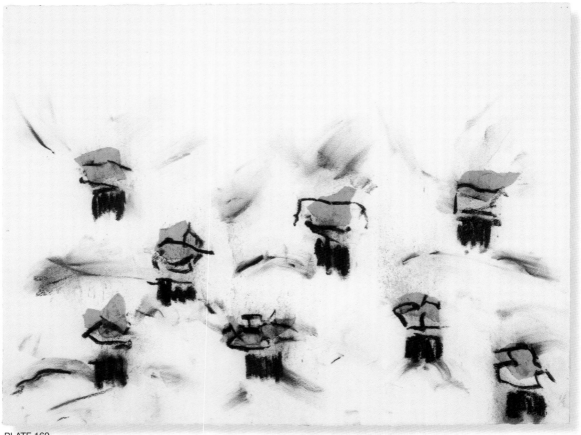

PLATE 169
Alain Kirili
French, born 1946
Commandment, 1995
collage and charcoal on paper
22 1/4 x 30 in. (irregular)

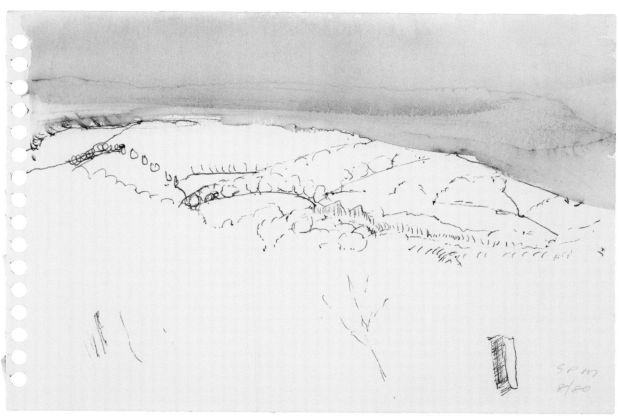

PLATE 170

Sylvia Plimack Mangold

American, born 1938

Untitled (August), 1980

ink and watercolor on paper

5 15/16 x 9 in.

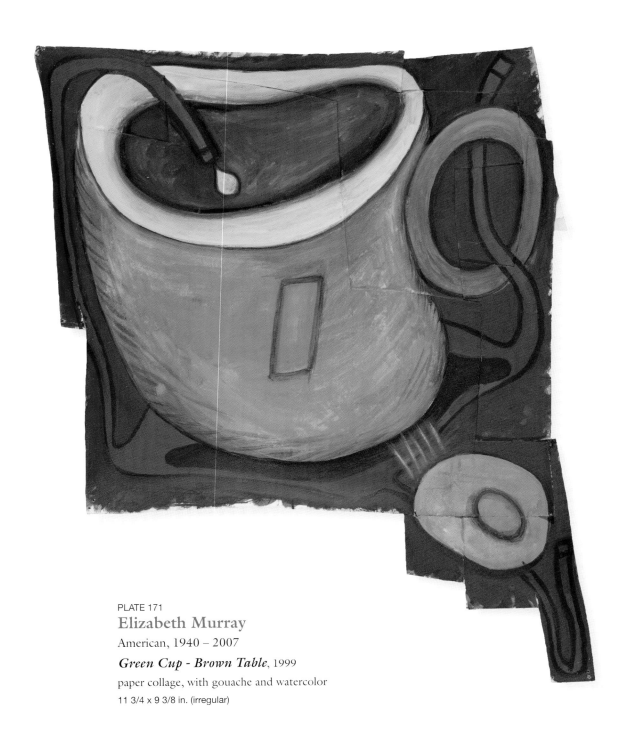

PLATE 171
Elizabeth Murray
American, 1940 – 2007
Green Cup - Brown Table, 1999
paper collage, with gouache and watercolor
11 3/4 x 9 3/8 in. (irregular)

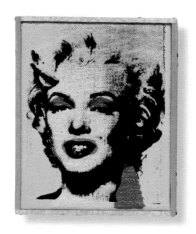
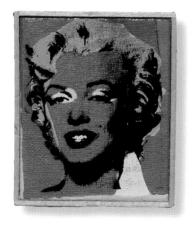
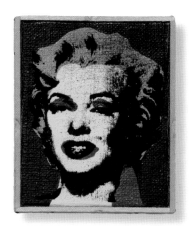
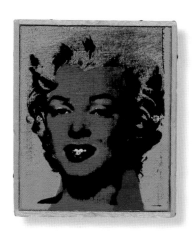
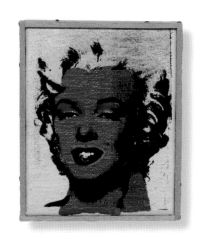
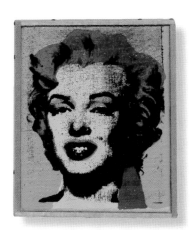

PLATE 172
Richard Pettibone
American, born 1938
Warhol's Marilyn Monroe, 1973
acrylic and silkscreen, six canvases
each: 2 3/8 x 1 15/16 x 3/8 in.

UTAH

Nora Eccles Harrison Museum of Art, Utah State University

LOGAN

JO BAER • ROBERT BARRY • LYNDA BENGLIS • CHARLES CLOUGH • RICHARD FRANCISCO
DENISE GREEN • DON HAZLITT • STEWART HITCH • MARTIN JOHNSON • STEVE KEISTER • ALAIN KIRILI
CHERYL LAEMMLE • JILL LEVINE • MICHAEL LUCERO • CATHERINE E. MURPHY • JOSEPH NECHVATAL
RICHARD NONAS • LARRY POONS • LUCIO POZZI • EDDA RENOUF • PAT STEIR • DARYL TRIVIERI
RICHARD TUTTLE • LEO VALLEDOR • THORNTON WILLIS

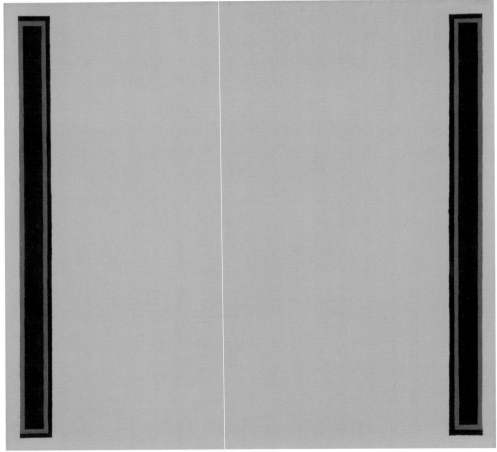

PLATE 173
Jo Baer
American, born 1929
Untitled, 1968-69
oil on canvas board
9 x 9 3/4 in.

PLATE 174
Denise Green
American, born 1946

Untitled (Steps), 1976
ink on paper
12 15/16 x 13 in.

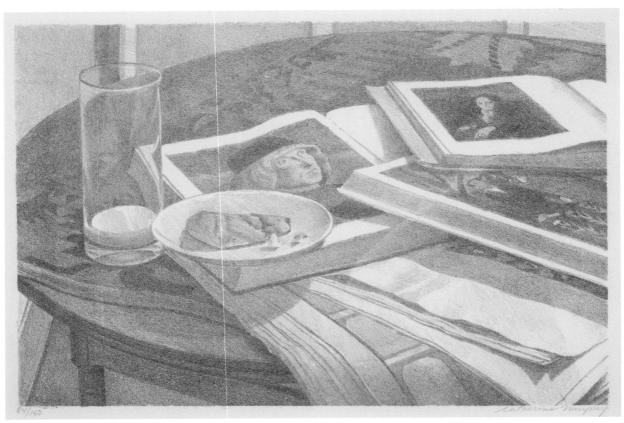

PLATE 175

Catherine E. Murphy

American, born 1946

Still Life with Reproductions, 1974

lithograph on paper
edition: 84/150

8 1/8 x 12 1/4 in.

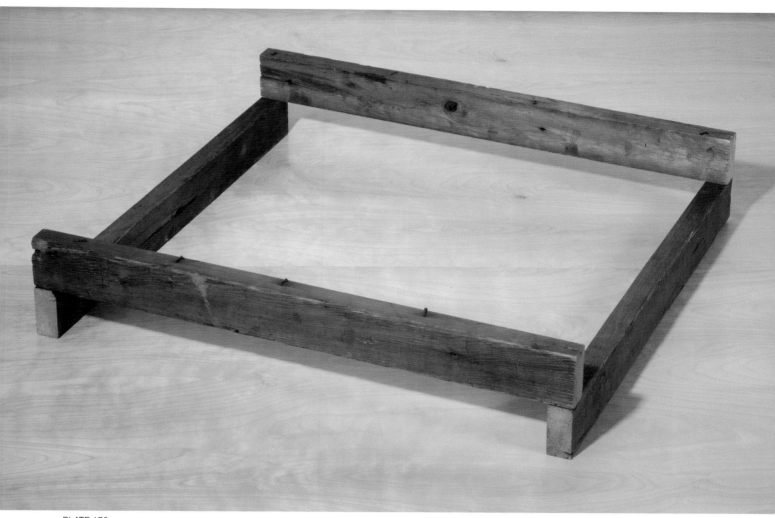

PLATE 176
Richard Nonas
American, born 1936

Dry Creek Shorty, 1972
wood with nails
7 x 36 x 34 in.

VERMONT

Robert Hull Fleming Museum, University of Vermont

BURLINGTON

CAREL BALTH • WILL BARNET • ROBERT BARRY • LYNDA BENGLIS • LOREN CALAWAY • CHARLES CLOUGH
RICHARD FRANCISCO • RODNEY ALAN GREENBLAT • DON HAZLITT • STEVE KEISTER • ALAIN KIRILI
CHERYL LAEMMLE • RONNIE LANDFIELD • JILL LEVINE • MICHAEL LUCERO • FORREST MYERS
JOSEPH NECHVATAL • LIL PICARD • LUCIO POZZI • EDDA RENOUF • JUDY RIFKA • BARBARA SCHWARTZ
PAT STEIR • JOHN TORREANO • DARYL TRIVIERI • RICHARD TUTTLE • RICHARD VAN BUREN

PLATE 177
Carel Balth
Dutch, born 1939
Line I, 1977
four color photographs mounted
on aluminum
23 1/4 x 30 11/16 in.

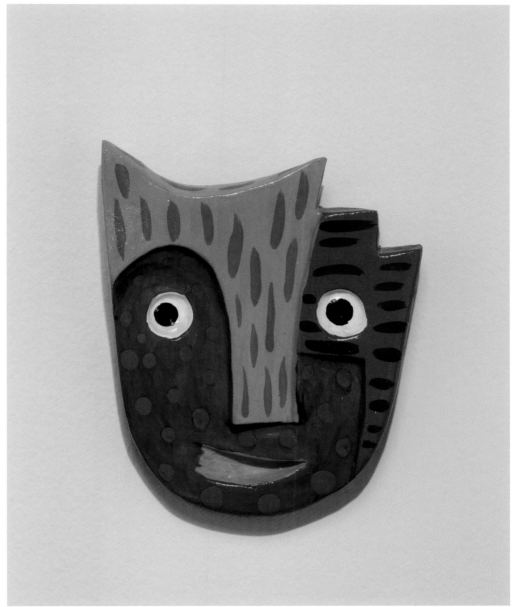

PLATE 178
Rodney Alan Greenblat
American, born 1960
Wall Pal, n.d.
paint on plaster
6 1/4 x 5 x 5/8 in.

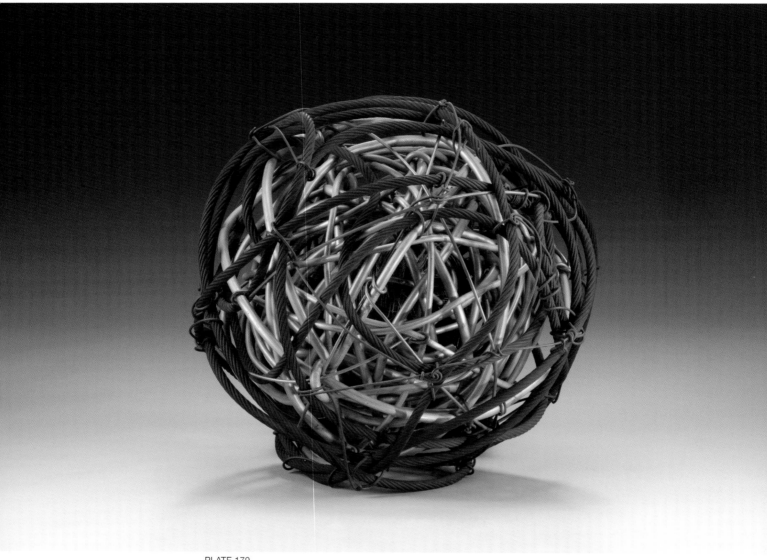

PLATE 179

Forrest Myers

American, born 1941

Untitled, 1975

metal sphere composed of various
metal tubes, ropes, wires and cables

diameter: 17 in. (irregular)

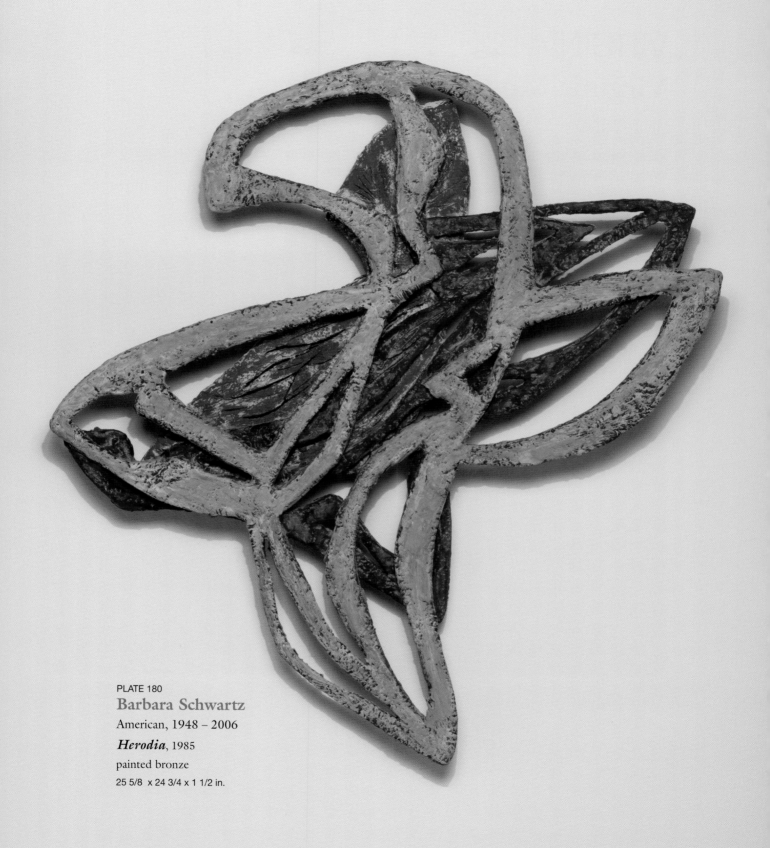

PLATE 180
Barbara Schwartz
American, 1948 – 2006
Herodia, 1985
painted bronze
25 5/8 x 24 3/4 x 1 1/2 in.

VIRGINIA

Virginia Museum of Fine Arts

RICHMOND

ANNE ARNOLD • ROBERT BARRY • CHARLES CLOUGH • RICHARD FRANCISCO • DON HAZLITT
MARTIN JOHNSON • STEVE KEISTER • ALAIN KIRILI • CHERYL LAEMMLE • JILL LEVINE
JOSEPH NECHVATAL • DAVID NOVROS • LARRY POONS • LUCIO POZZI • EDDA RENOUF • JUDY RIFKA
PAT STEIR • DARYL TRIVIERI • RICHARD TUTTLE • THORNTON WILLIS

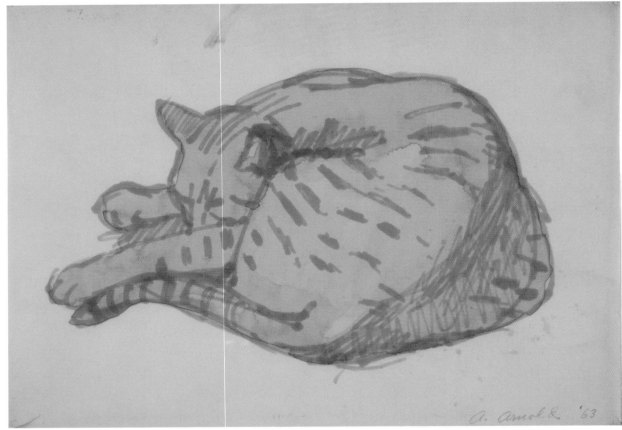

PLATE 181
Anne Arnold
American, born 1925
Cat, 1963
watercolor and marker on paper
7 x 10 in.

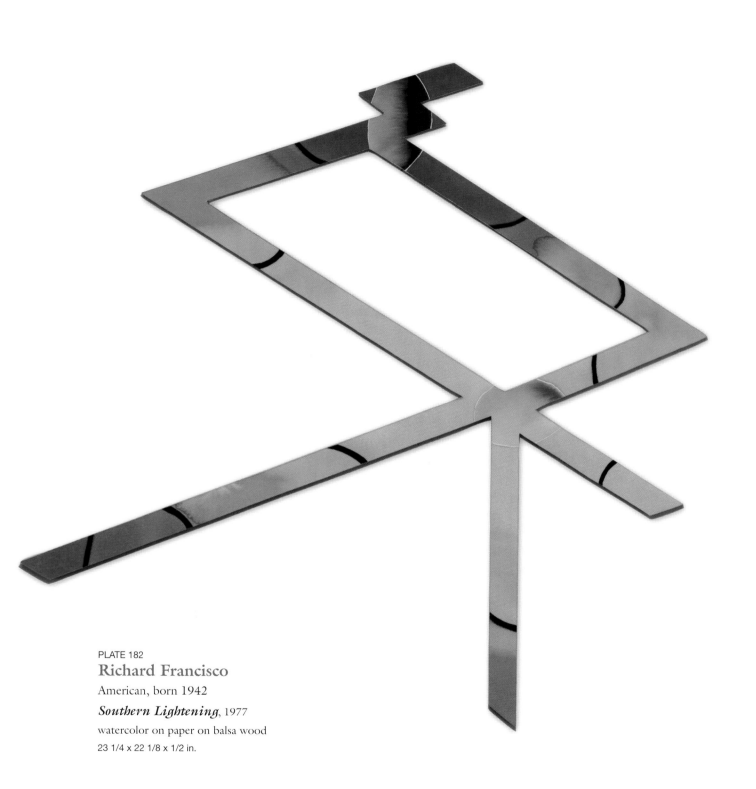

PLATE 182
Richard Francisco
American, born 1942
Southern Lightening, 1977
watercolor on paper on balsa wood
23 1/4 x 22 1/8 x 1/2 in.

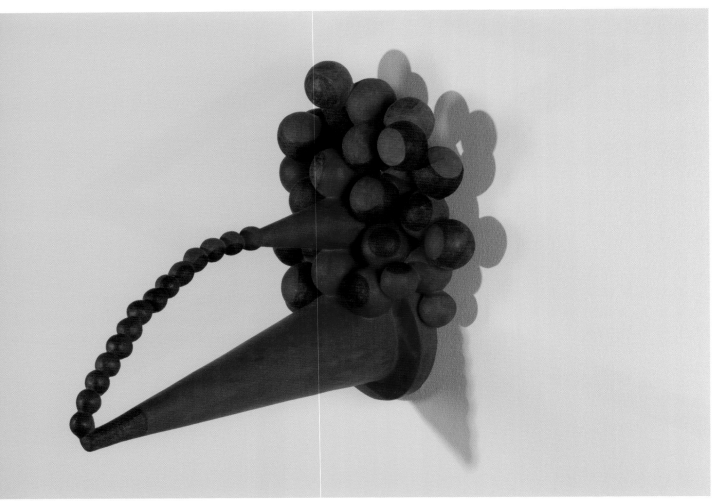

PLATE 183
Jill Levine
American, born 1953
Suzy Hates Nancy, 1989
modeling compound, paint
14 1/4 x 11 3/4 x 17 1/8 in.

PLATE 184
David Novros
American, born 1941

Untitled, 1992

ink on two joined sheets of paper

9 13/16 x 8 3/16 in.

WASHINGTON
Seattle Art Museum

SEATTLE

STEPHEN ANTONAKOS • WILL BARNET • ROBERT BARRY • LYNDA BENGLIS • CHARLES CLOUGH
PEGGY CYPHERS • RICHARD FRANCISCO • MICHAEL GOLDBERG • DON HAZLITT • ALAIN KIRILI
CHERYL LAEMMLE • RONNIE LANDFIELD • SOL LEWITT • MICHAEL LUCERO • ROBERT MANGOLD
RICHARD NONAS • LUCIO POZZI • EDDA RENOUF • JUDY RIFKA • TONY SMITH • DARYL TRIVIERI
RICHARD TUTTLE

PLATE 185
Stephen Antonakos
American, born 1926
Nov #2 1986, 1986
colored pencil on vellum
23 5/8 x 20 in.

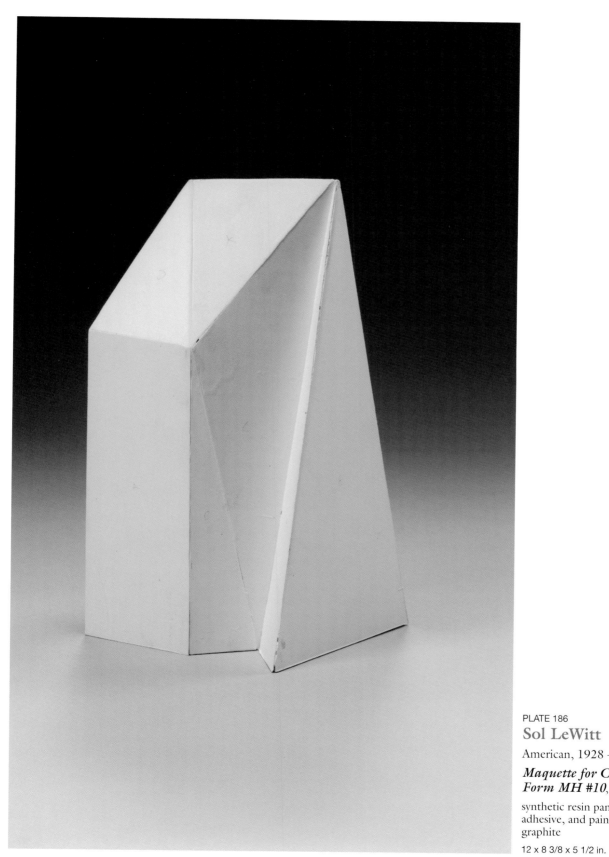

PLATE 186
Sol LeWitt
American, 1928 – 2007

***Maquette for Complex
Form MH #10***, 1990

synthetic resin panels,
adhesive, and paint, with
graphite

12 x 8 3/8 x 5 1/2 in.

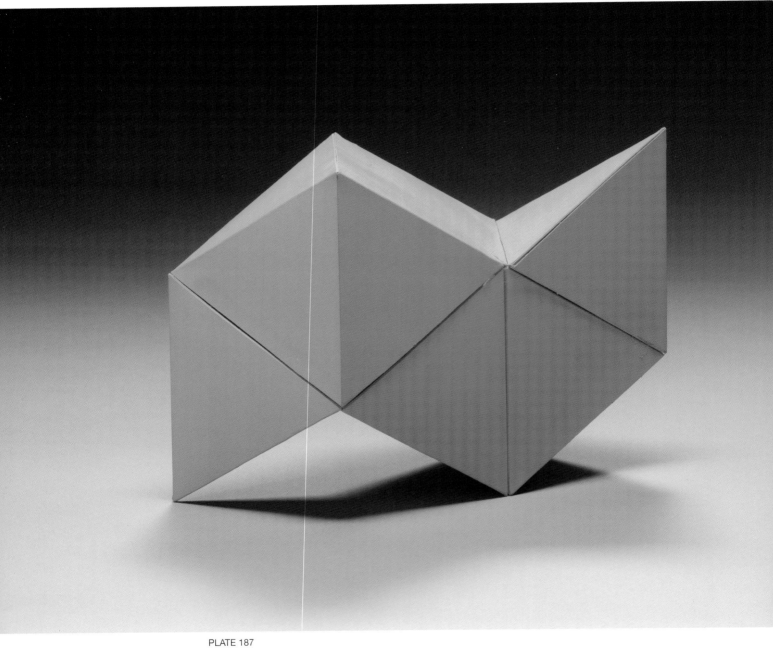

PLATE 187
Tony Smith
American, 1912 – 1980

Untitled, 1971

heavy-weight paper, adhesive, and paint

6 1/4 x 9 x 3 3/4 in.

PLATE 188

Terry Winters

American, born 1949

***Hand Line Reflection
Method 15/100***, 1995

ink on paper

13 x 8 1/2 in.

WEST VIRGINIA

Huntington Museum of Art

HUNTINGTON

NANCY ARLEN • ROBERT BARRY • LYNDA BENGLIS • CHARLES CLOUGH • RICHARD FRANCISCO
DIXIE FRIEND GAY • DON HAZLITT • STEWART HITCH • MARTIN JOHNSON • STEVE KEISTER • ALAIN KIRILI
CHERYL LAEMMLE • JILL LEVINE • ROBERT MANGOLD • VIK MUNIZ • RICHARD NONAS • LUCIO POZZI
EDDA RENOUF • EDWARD RENOUF • RODNEY RIPPS • DONALD SULTAN • DARYL TRIVIERI • RICHARD TUTTLE
THORNTON WILLIS • MICHAEL ZWACK

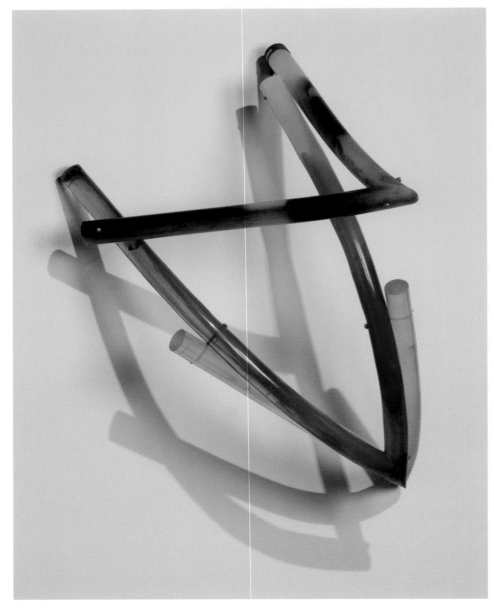

PLATE 189
Nancy Arlen
American, 1947 – 2006
Dorothy, 1979 (?)
cast polyester cylinders with
metal screws
28 x 21 x 17 in.

PLATE 190

Dixie Friend Gay

American, born 1953

Double Head #5, 1980

ink and graphite on paper

10 1/2 x 8 1/4 in.

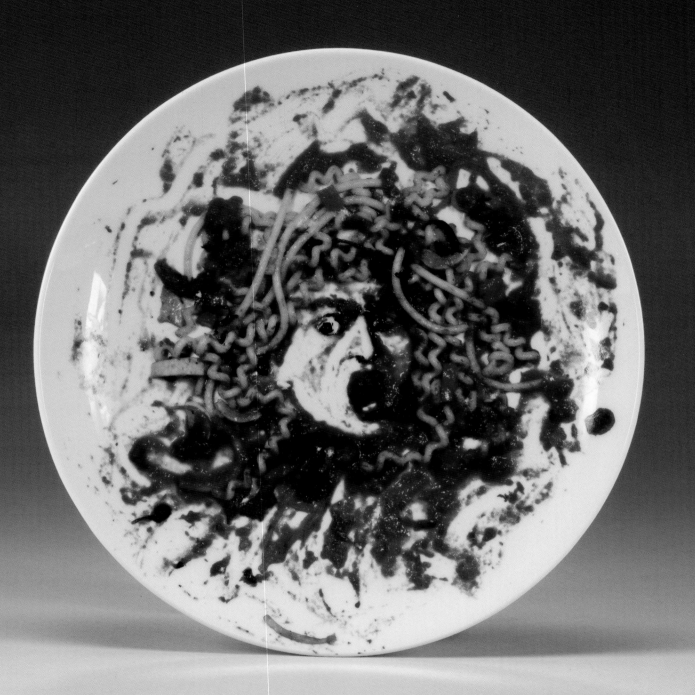

PLATE 191

Vik Muniz

Brazilian, born 1961

Untitled (Re-Creation of Caravaggio's Medusa) (Peter Norton Family Christmas Project), 1999

Bernardaud Limoges porcelain plate

diameter: 12 3/8 in.

PLATE 192
Michael Zwack
American, born 1949
The History of the World, 2003
raw pigment and oil on paper
19 1/4 x 24 5/8 in.

WISCONSIN
Milwaukee Art Museum

MILWAUKEE

JOE ANDOE • ROBERT BARRY • LYNDA BENGLIS • CHARLES CLOUGH • RICHARD FRANCISCO
MICHAEL GOLDBERG • SIDNEY GORDIN • DON HAZLITT • MARTIN JOHNSON • STEVE KEISTER
MARK KOSTABI • CHERYL LAEMMLE • JILL LEVINE • SOL LEWITT • ROBERT MANGOLD • KYLE MORRIS
RICHARD NONAS • LUCIO POZZI • EDDA RENOUF • EDWARD RENOUF • RODNEY RIPPS • DONALD SULTAN
DARYL TRIVIERI • RICHARD TUTTLE • THORNTON WILLIS • BETTY WOODMAN

PLATE 193
Joe Andoe
American, born 1955
Untitled, n.d.
lacquered acrylic on paper
9 1/2 x 6 1/2 in.

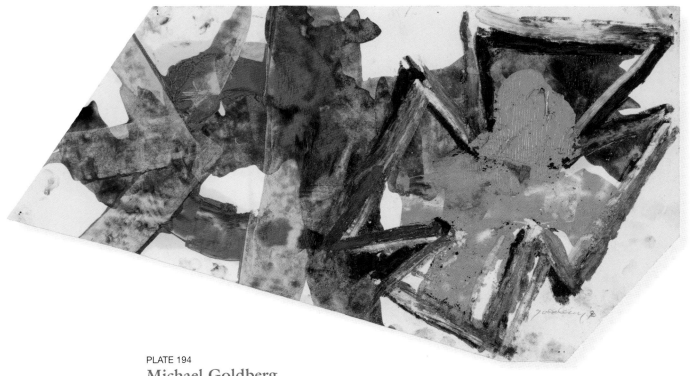

PLATE 194

Michael Goldberg

American, 1924 – 2007

Untitled, 1990

oil and charcoal on paper

10 1/2 x 19 3/4 in. (irregular)

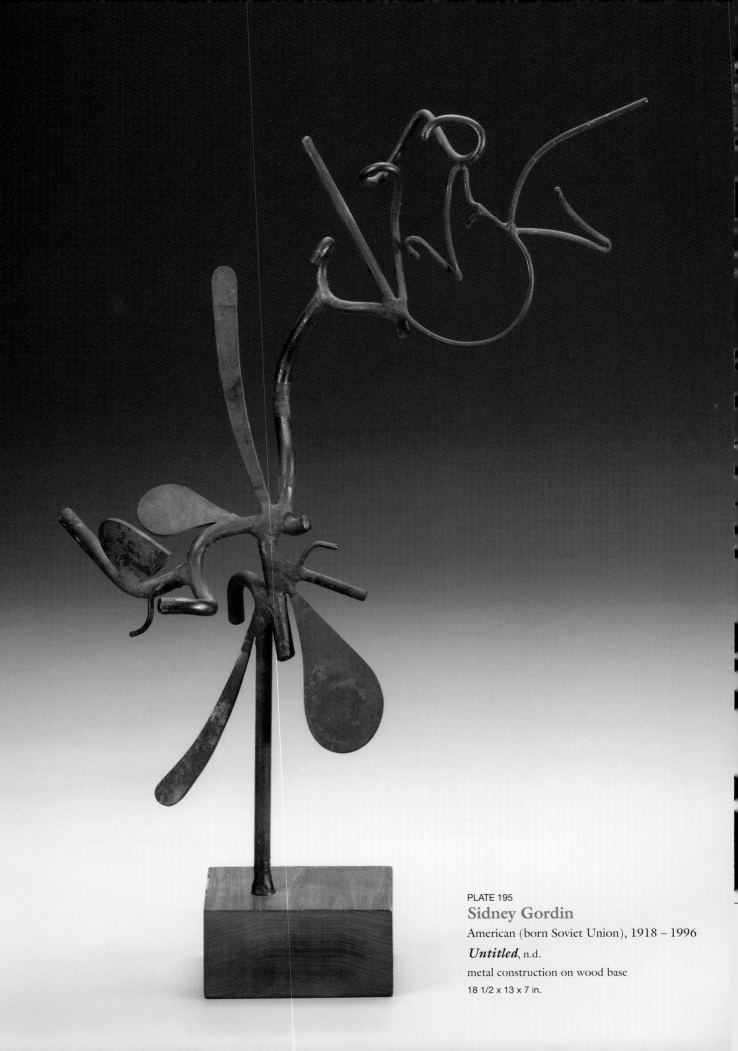

PLATE 195
Sidney Gordin
American (born Soviet Union), 1918 – 1996
Untitled, n.d.
metal construction on wood base
18 1/2 x 13 x 7 in.

PLATE 196

Kyle Morris

American, 1918 – 1979

Fall - Winter Series '72 No. 3, 1972

ink on paper

11 x 17 in.

WYOMING

University of Wyoming Art Museum

LARAMIE

GREGORY AMENOFF • ROBERT BARRY • LYNDA BENGLIS • CHRYSSA • CHARLES CLOUGH
RICHARD FRANCISCO • DAVID GILHOOLY • DON HAZLITT • STEWART HITCH • MARTIN JOHNSON
STEVE KEISTER • MARK KOSTABI • CHERYL LAEMMLE • ROBERT LOBE • ROBERT MANGOLD
JOSEPH NECHVATAL • RICHARD NONAS • LUCIO POZZI • EDDA RENOUF • EDWARD RENOUF
RODNEY RIPPS • DONALD SULTAN • LORI TASCHLER • DARYL TRIVIERI • RICHARD TUTTLE
URSULA VON RYDINGSVARD • JOE ZUCKER

PLATE 197
Gregory Amenoff
American, born 1948
Laumede #16, 1997
gouache on paper, framed
frame: 13 x 10 in.

PLATE 198

Chryssa

American (born Greece), born 1933

Analysis of Υ, n.d.

pencil and conte crayon on paper
mounted on board

sheet: 12 x 8 3/4 in.
mount: 12 3/4 x 9 1/2 in.

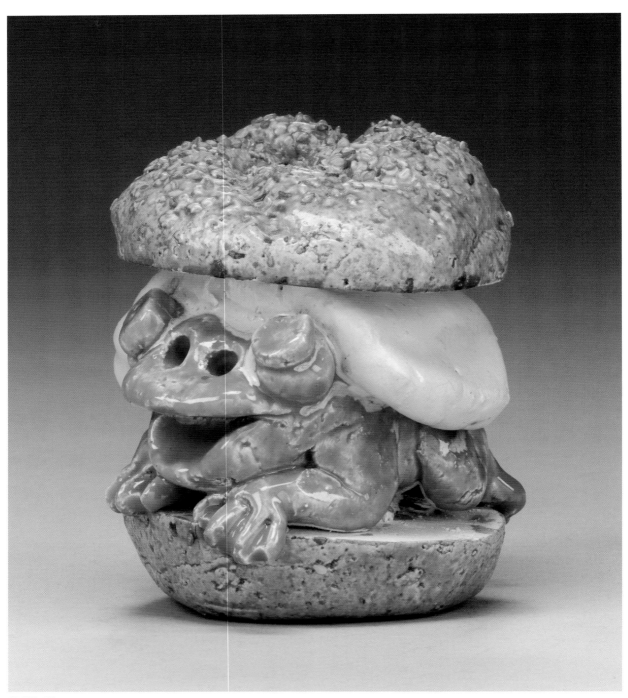

PLATE 199
David Gilhooly
American, born 1943
Frog Sandwich, 1977
glazed ceramic with sesame seeds
4 x 3 3/4 x 3 5/8 in.

PLATE 200

Joseph Nechvatal
American, born 1951

The New Sobriety, 1983
graphite and crayon on paper
11 1/16 x 13 15/16 in.

ARTIST INDEX

GREGORY AMENOFF, American, born 1948
Laumede #16, page 224

Wyoming

ERIC AMOUYAL, Israeli, born 1962
Seeds: New York #2, page 28

Alabama

WILLIAM ANASTASI, American, born 1933
Subway Drawing, page 40

Arkansas, California, Georgia

JOE ANDOE, American, born 1955
Untitled, page 220

Wisconsin

CARL ANDRE, American, born 1935
Untitled, page 44

California

STEPHEN ANTONAKOS, American, born 1926
Five Incomplete Circles, page 76; *Nov #2 1986,* page 212

Arizona, California, Delaware, Georgia, Illinois, Indiana, Iowa, Maryland, Massachusetts, Mississippi, Missouri, Montana, Nebraska, Nevada, New Hampshire, New Jersey, North Carolina, Texas, Washington

RICHARD ANUSZKIEWICZ, American, born 1930
Temple of Red with Orange, page 36

Arizona

NANCY ARLEN, American, 1947 – 2006
Dorothy, page 216

West Virginia

ANNE ARNOLD, American, born 1925
Cat, page 208

Virginia

RICHARD ARTSCHWAGER, American, born 1923
Thousand Cubic Inches Prototype, page 152

New York

JO BAER, American, born 1929
Untitled, page 200

Utah

CAREL BALTH, Dutch, born 1939
Line I, page 204

Vermont

WILL BARNET, American, born 1911
Study for Vogels (Herb with hands on chin), page 84; *Untitled*, page 192

Alabama, Arizona, Arkansas, Colorado, Connecticut, Delaware, Florida, Georgia, Idaho, Illinois, Indiana, Iowa, Kansas, Kentucky, Louisiana, Maine, Massachusetts, Michigan, Minnesota, Mississippi, Missouri, Montana, Nebraska, New Jersey, Pennsylvania, Tennessee, Texas, Vermont, Washington

ROBERT BARRY, American, born 1936
Untitled, page 128; *Silver Collage*, page 140

All states

ZIGI BEN-HAIM, American, born 1945
Just Before '84, page 184

South Carolina

LYNDA BENGLIS, American, born 1941
Gestural Study, page 92; *Tacpere Maptom*, page 112

Arizona, Arkansas, California, Delaware, Georgia, Indiana, Kentucky, Louisiana, Massachusetts, Michigan, Nebraska, Nevada, New Hampshire, New Jersey, New Mexico, New York, North Carolina, Ohio, Oklahoma, Oregon, Pennsylvania, Rhode Island, South Carolina, South Dakota, Tennessee, Texas, Utah, Vermont, Washington, West Virginia, Wisconsin, Wyoming

JOSEPH BEUYS, German, 1921-1986
Noiseless Blackboard Eraser, page 85

Iowa

JAMES BISHOP, American, born 1927
Untitled, page 108

Indiana, Louisiana, Massachusetts

RONALD BLADEN, American (born Canada), 1918 – 1988
Five Studies: 'Black Tower' and four unknown sculptures, page 144

Massachusetts, New Jersey, Texas

DIKE BLAIR, American, born 1952
Untitled, page 172

Oregon

WILLIAM (BILL) BOLLINGER, American, 1939 – 1988
Untitled, page 180

Rhode Island

GARY BOWER, American, born 1940
Untitled, page 176

Pennsylvania

LISA BRADLEY, American, born 1951
Inside Out, page 124

Louisiana, Maine, Maryland, Minnesota, Mississippi, Missouri, Pennsylvania, Texas

RICHMOND BURTON, American, born 1960
Untitled, page 173

Oregon

ANDRÉ CADÉRÉ, Romanian, 1934 – 1978
A-I 0203000 = 25 = I x 12 =, page 104

Maryland

LOREN CALAWAY, American, born 1950
Untitled, page 164

> Arizona, Colorado, Connecticut, Delaware, Georgia, Idaho, Illinois, Indiana, Iowa, Kansas, Kentucky, Ohio, Pennsylvania, South Dakota, Vermont

PETER CAMPUS, American, born 1937
Untitled, page 52

> Connecticut

MCWILLIE CHAMBERS, American, born 1951
Untitled woodcuts and *S.V. Elissa with Sun*, page 156

> North Carolina

ANN CHERNOW, American, born 1936
I Get Along Without You Very Well, page 32

> Alaska

CHRYSSA, American (born Greece), born 1933
Analysis of Y, page 225

> Wyoming

MICHAEL CLARK (CLARK FOX) American, born 1946
Dorothy, page 48

> Alabama, Arizona, Arkansas, Colorado, Delaware, Florida, Georgia, Indiana, Kentucky, New Jersey, Oklahoma

JOHN CLEM CLARKE, American, born 1937
Untitled, page 141

> New Hampshire

CHARLES CLOUGH, American, born 1951
August Fifteenth, page 100; *3/24/02*, page 160

> All states

PINCHAS COHEN GAN, American, born 1942
Figurative Circuit N1, page 129

> Louisiana, Montana

KATHLEEN COOKE, American, (born Ireland), 1908 – 1978
Untitled, page 56

> Delaware

PEGGY CYPHERS, American, born 1954
Galaxy's Empire, page 185

> Illinois, Iowa, South Carolina, Washington

GENE DAVIS, American, 1920 – 1985
Untitled, page 88

> Kansas

CLAUDIA DE MONTE, American, born 1947
Claudia with Snake, page 116

> Hawaii, Kentucky, Maine, Maryland, Michigan, Minnesota, Mississippi, Missouri, Montana, Nebraska, Nevada, New Hampshire

STUART DIAMOND, American, born 1942
Untitled, page 145
New Jersey

LOIS DODD, American, born 1927
Butternut Branches, page 53
Connecticut

KOKI DOKTORI, Israeli (?), born 1941
On the Run, page 153
New York

RACKSTRAW DOWNES, British, born 1939
Disused Weather Station, Galveston, TX, page 101
Maine, Massachusetts

ROBERT DURAN, American, born 1938
Untitled, page 41
Arkansas

BENNI EFRAT, Israeli, born 1936
From Ex to X, page 109
Massachusetts

WILLIAM FARES, American, born 1942
Untitled, page 77
Illinois

R.M. FISCHER, American, born 1947
Doctor's Lamp, page 72
Idaho, New Mexico, New York

JOEL FISHER, American, born 1947
Untitled, page 60
Alaska, Florida

RICHARD FRANCISCO, American, born 1942
Studio Garden, page 37; *Southern Lightening*, page 209
All states

ADAM FUSS, British, born 1961
Untitled, page 49
Colorado

CHARLES GAINES, American, born 1944
Walnut Tree Orchard Set L, page 42
Arkansas

DIXIE FRIEND GAY, American, born 1953
Double Head #5, page 217
West Virginia

JON GIBSON, American, born 1940
30's, page 80
Indiana

DAVID GILHOOLY, American, born 1943
Frog Sandwich, page 226

Wyoming

MICHAEL GOLDBERG, American, 1924 – 2007
Tarascon, page 110; *Untitled*, page 221

Alabama, Arizona, Arkansas, California, Colorado, Connecticut, Florida, Georgia, Idaho, Illinois, Indiana, Iowa, Kansas, Kentucky, Louisiana, Maine, Maryland, Massachusetts, Michigan, Minnesota, Mississippi, Montana, Pennsylvania, Texas, Washington, Wisconsin

RONALD GORCHOV, American, born 1930
Untitled, page 120

Kentucky, Mississippi

SIDNEY GORDIN, American (born Soviet Union), 1918 – 1996
Untitled, page 222

Wisconsin

DAN GRAHAM, American, born 1942
For Laumier Sculpture Park, St. Louis, page 125

California, Massachusetts, Missouri

DENISE GREEN, American, born 1946
Untitled (Steps), page 201

Utah

RODNEY ALAN GREENBLAT, American, born 1960
Wall Pal, page 205

Georgia, Vermont

PETER HALLEY, American, born 1953
Prison 7, page 188

Kentucky, South Dakota

WILLIAM L. HANEY, American, born 1939
If Need Be, page 186

Missouri, South Carolina

DON HAZLITT, American, born 1948
Sunset, page 50; *Shaped Edge*, page 181

Alabama, Alaska, Arizona, Colorado, Connecticut, Delaware, Florida, Hawaii, Idaho, Illinois, Indiana, Iowa, Kansas, Maine, Maryland, Michigan, Minnesota, Mississippi, Montana, Nebraska, Nevada, New Hampshire, New Jersey, New Mexico, New York, North Carolina, North Dakota, Ohio, Oklahoma, Oregon, Pennsylvania, Rhode Island, South Carolina, South Dakota, Tennessee, Utah, Vermont, Virginia, Washington, West Virginia, Wisconsin, Wyoming

JENE HIGHSTEIN, American, born 1942
Untitled, page 132; *Aluminum Casting of Room with One Door*, page 133

Alaska, Arizona, Arkansas, Colorado, Florida, Georgia, Hawaii, Idaho, Illinois, Kansas, Kentucky, Louisiana, Michigan, Minnesota, Mississippi, Missouri, Nebraska, New Hampshire, New Mexico, New York, North Carolina, North Dakota, Ohio, Oklahoma, Pennsylvania, Texas

STEWART HITCH, American, 1940 – 2002
Schenevus, page 33

Alaska, Arizona, Delaware, Georgia, Indiana, Kentucky, Louisiana, Pennsylvania, Rhode Island, South Carolina, Tennessee, Utah, West Virginia, Wyoming

JIM HODGES, American, born 1957
Blanket (Peter Norton Family Christmas Project), page 177

 Pennsylvania

TOM HOLLAND, American, born 1936
Untitled #1, page 57

 Delaware

JOHN HULTBERG, American, 1922 – 2005
Suspension 5, page 174

 Oregon

RALPH HUMPHREY, American, 1932 – 1990
Untitled, page 168

 Florida, Oklahoma

BRYAN HUNT, American, born 1947
Quarry Study, page 93

 Idaho, Illinois, Kentucky, New Jersey

DAVID HUNTER, American, born 1947
Untitled #33, page 165

 Ohio

PETER HUTCHINSON, British, born 1930
Chemical Sculpture with Four Tubes, page 161

 Iowa, Kansas, Maine, Maryland, Michigan, Minnesota, Mississippi, Missouri, Nebraska,
 North Dakota

WILL INSLEY, American, born 1929
Untitled, page 64

 Georgia

PATRICK IRELAND (1972 – 2008) AKA BRIAN O'DOHERTY, American, born 1934
Untitled, page 34

 Alaska

RALPH IWAMOTO, American, born 1927
Study Steps #3, page 157

 North Carolina

NEIL JENNEY, American, born 1945
Herb Vogel Thinking, page 148

 Montana, Nevada, New Mexico

BILL JENSEN, American, born 1945
Untitled, page 68

 Alaska, Hawaii, Louisiana, New Hampshire, New Jersey, New Mexico, New York, North Carolina,
 North Dakota

MARTIN JOHNSON, American, born 1951
Inure Self, page 113; *Exerptunis*, page 169

 Alabama, Arizona, Arkansas, Colorado, Connecticut, Delaware, Florida, Idaho, Illinois, Iowa,
 Kansas, Kentucky, Maine, Maryland, Michigan, Minnesota, Mississippi, Missouri, Montana,
 Nebraska, Nevada, New Hampshire, New Jersey, Ohio, Oklahoma, Oregon, Pennsylvania, Rhode
 Island, South Carolina, South Dakota, Tennessee, Utah, Virginia, West Virginia, Wisconsin,
 Wyoming

JOAN JONAS, American, born 1936
Dog/Decoy, page 45

California, Hawaii, New Mexico

TOBI KAHN, American, born 1952
O K Υ N, page 178

New York, Pennsylvania

STEPHEN KALTENBACH, American, born 1940
God gave Noah the rainbow sign: No More Water, The Fire Next Time, page 130

Alaska, Montana, North Carolina

STEVEN KARR, American, born 1923
Untitled, page 187

South Carolina

STEVE KEISTER, American, born 1949
Untitled, page 89; *Untitled*, page 189

Alabama, Alaska, Arizona, Arkansas, California, Colorado, Connecticut, Florida, Georgia, Hawaii, Idaho, Illinois, Indiana, Iowa, Kansas, Kentucky, Maine, Maryland, Massachusetts, Michigan, Minnesota, Mississippi, Missouri, Montana, Nebraska, Nevada, New Hampshire, New Mexico, New York, North Carolina, North Dakota, Ohio, Oklahoma, Oregon, Pennsylvania, Rhode Island, South Carolina, South Dakota, Tennessee, Texas, Utah, Vermont, Virginia, West Virginia, Wisconsin, Wyoming

ALAIN KIRILI, French, born 1946
Commandment, page 196

Alaska, Hawaii, New Jersey, New Mexico, New York, North Carolina, North Dakota, Ohio, Oklahoma, Oregon, Pennsylvania, Rhode Island, South Carolina, South Dakota, Tennessee, Texas, Utah, Vermont, Virginia, Washington, West Virginia

MARK KOSTABI, American, born 1960
Progress of Beauty 3, page 114

Alabama, Alaska, Arizona, Arkansas, California, Colorado, Connecticut, Florida, Hawaii, Idaho, Illinois, Iowa, Kansas, Louisiana, Maine, Maryland, Michigan, Minnesota, Mississippi, Missouri, Montana, Nebraska, Nevada, New Hampshire, New Mexico, New York, North Dakota, Ohio, Oklahoma, Oregon, Pennsylvania, Wisconsin, Wyoming

MOSHE KUPFERMAN, Israeli (born Poland), 1926 – 2003
Untitled, page 105

Maryland, Oregon

CHERYL LAEMMLE, American, born 1947
Specters in the Forest, page 78; *Untitled*, page 193

Alabama, Arizona, Arkansas, Colorado, Connecticut, Florida, Illinois, Louisiana, Maryland, New Jersey, Pennsylvania, Rhode Island, South Carolina, Tennessee, Utah, Vermont, Virginia, Washington, West Virginia, Wisconsin, Wyoming

RONNIE LANDFIELD, American, born 1947
Untitled, page 73

Delaware, Georgia, Idaho, Illinois, Indiana, Iowa, Louisiana, Maine, Michigan, Minnesota, Mississippi, Tennessee, Vermont, Washington

MICHAEL LASH, American, born 1961
Simon's a Sissy, page 117

Minnesota, Mississippi, Missouri, Nebraska

JOHN LATHAM, British, 1921 – 2006
One Second Drawing, page 96

 Louisiana

MICHAEL LATHROP, American, born 1958/59 (?)
Vision of Nature III, page 190

 South Dakota

WENDY LEHMAN, American, born 1945
Going Dotty, page 182

 Alaska, Hawaii, Montana, Nevada, New Hampshire, New Mexico, New York, Rhode Island

ANNETTE LEMIEUX, American, born 1957
Popular Wall Painting (after Ken), page 86

 Iowa

JILL LEVINE, American, born 1953
Suzy Hates Nancy, page 210

 Colorado, Michigan, North Dakota, Ohio, Oklahoma, Oregon, Pennsylvania, Rhode Island, South Carolina, South Dakota, Tennessee, Utah, Vermont, Virginia, West Virginia, Wisconsin

SOL LEWITT, American, 1928 – 2007
Maquette for Complex Form MH #10, page 213

 Washington, Wisconsin

ROY LICHTENSTEIN, American, 1923 – 1997
Turkey Shopping Bag, page 74

 Idaho

ROBERT LOBE, American, born 1945
Untitled, page 162

 Michigan, North Dakota, Wyoming

MICHAEL LUCERO, American, born 1953
Untitled (Standing Figure with Spotlights), page 51; *Untitled (Head Study)*, page 97

 Alabama, Alaska, Arizona, Arkansas, California, Colorado, Connecticut, Florida, Hawaii, Idaho, Illinois, Iowa, Kansas, Louisiana, Maine, Maryland, Massachusetts, Michigan, Minnesota, Mississippi, Missouri, Montana, Nebraska, Nevada, New Hampshire, New Jersey, New Mexico, New York, North Carolina, North Dakota, Ohio, Oklahoma, Oregon, Pennsylvania, Rhode Island, South Carolina, South Dakota, Tennessee, Texas, Utah, Vermont, Washington

ROBERT MANGOLD, American, born 1937
Violet/Black Zone Study, page 58

 Alabama, Arizona, Arkansas, Delaware, Indiana, Kentucky, Massachusetts, Ohio, Washington, West Virginia, Wisconsin, Wyoming

SYLVIA PLIMACK MANGOLD, American, born 1938
Untitled (August), page 197

 Colorado, Connecticut, Florida, Texas

ANDY MANN, American, 1949 – 2001
X Matrix, page 38

 Arizona, Florida

ALLAN MCCOLLUM, American, born 1944
For Presentation and Display: Ideal Setting by Louise Lawler and Allan McCollum, page 29

 Alabama

ANTONI MIRALDA, Spanish, born 1942
Untitled, page 102

 Maine

WILLIAM MOREHOUSE, American, 1929 – 1993
Untitled, page 61

 Florida

KYLE MORRIS, American, 1918 – 1979
Fall – Winter Series '72 No. 3, page 223

 Wisconsin

VIK MUNIZ, Brazilian, born 1961
Untitled (Re-Creation of Caravaggio's Medusa) (Peter Norton Family Christmas Project), page 218

 West Virginia

TAKASHI MURAKAMI, Japanese, born 1963
Oval (Peter Norton Family Christmas Project), page 121

 Mississippi

CATHERINE E. MURPHY, American, born 1946
Still Life with Reproductions, page 202

 Utah

ELIZABETH MURRAY, American, 1940 – 2007
Green Cup – Brown Table, page 198

 Indiana, Texas

FORREST MYERS, American, born 1941
Untitled, page 206

 Idaho, Illinois, Vermont

GIUSEPPE NAPOLI, American, 1929 – 1967
Untitled, page 194

 Tennessee

JOSEPH NECHVATAL, American, born 1951
The Moral Constant, page 191; *The New Sobriety*, page 227

 Alaska, Hawaii, Iowa, Kansas, Maine, Maryland, Michigan, Minnesota, Mississippi, Missouri, Montana, Nebraska, Nevada, New Hampshire, New Mexico, New York, North Carolina, North Dakota, Ohio, Oklahoma, Oregon, Pennsylvania, Rhode Island, South Carolina, South Dakota, Tennessee, Texas, Utah, Vermont, Virginia, Wyoming

RICHARD NONAS, American, born 1936
From Northern/Southern, page 175; *Dry Creek Shorty*, page 203

 Alabama, Alaska, Arizona, Arkansas, California, Colorado, Connecticut, Florida, Hawaii, Idaho, Illinois, Iowa, Kansas, Kentucky, Louisiana, Maine, Maryland, Massachusetts, Michigan, Minnesota, Mississippi, Missouri, Montana, Nebraska, New Hampshire, New Jersey, New Mexico, New York, North Carolina, North Dakota, Oregon, Texas, Utah, Washington, West Virginia, Wisconsin, Wyoming

DAVID NOVROS, American, born 1941
Untitled, page 211

 Virginia

NAM JUNE PAIK, American (born Korea), 1932 – 2006
Untitled, page 54

 California, Connecticut, Ohio, Pennsylvania, Rhode Island

RAYMOND PARKER, American, 1922 – 1990
Untitled, page 166

 Ohio, South Carolina

BETTY PARSONS, American, 1900 – 1982
Brush Up, page 43

 Arkansas, South Carolina, South Dakota

HENRY C. PEARSON, American, 1914 – 2006
The Aspects of the Case, page 170

 Oklahoma, Tennessee

JOEL PERLMAN, American, born 1943
Untitled, page 69

 Hawaii

RICHARD PETTIBONE, American, born 1938
Warhol's Marilyn Monroe, page 199

 Texas

LIL PICARD, German, 1899 – 1994
The Vogel's Napkinian Fantasy, page 98

 Louisiana, Vermont

LARRY POONS, American, born 1937
Untitled, page 154

 New Jersey, New York, Utah, Virginia

KATHERINE PORTER, American, born 1941
Untitled, page 149

 New Mexico

LUCIO POZZI, American, born 1935
Famiglia, page 81; *Nude*, page 150

 Alabama, Alaska, Arizona, Arkansas, California, Colorado, Connecticut, Delaware, Florida, Georgia, Hawaii, Idaho, Illinois, Indiana, Iowa, Kansas, Louisiana, Maine, Maryland, Massachusetts, Michigan, Minnesota, Mississippi, Missouri, Montana, Nebraska, Nevada, New Hampshire, New Jersey, New Mexico, New York, North Carolina, North Dakota, Ohio, Oklahoma, Oregon, Pennsylvania, Rhode Island, South Carolina, South Dakota, Tennessee, Texas, Utah, Vermont, Virginia, Washington, West Virginia, Wisconsin, Wyoming

DAVID RABINOWITCH, Canadian, born 1943
Linear Mass in 3 Scales I, page 82

 Alabama, Indiana

DAVID REED, American, born 1946
Working Drawing for #508, page 70

 Alabama, Arizona, Hawaii

EDDA RENOUF, American, born 1943
Wing Piece II, page 83; *August-Week 2*, page 155

 All states

EDWARD RENOUF, American, 1906 – 1999
Untitled, page 136

Arizona, Connecticut, Florida, Idaho, Illinois, Iowa, Kansas, Louisiana, Nevada, West Virginia, Wisconsin, Wyoming

JUDY RIFKA, American, born 1945
Untitled, page 71

Alaska, Delaware, Hawaii, Indiana, Maine, Maryland, Massachusetts, Minnesota, Missouri, New Hampshire, New Mexico, New York, North Carolina, North Dakota, Ohio, Oklahoma, Oregon, Pennsylvania, Rhode Island, South Carolina, South Dakota, Vermont, Virginia, Washington

RODNEY RIPPS, American, born 1950
Galaxy, page 146

New Jersey, West Virginia, Wisconsin, Wyoming

ALEXIS ROCKMAN, American, born 1962
Untitled, page 158

North Carolina

STEPHEN ROSENTHAL, American, born 1935
ABRL, page 195

Connecticut, Idaho, Tennessee

CHRISTY RUPP, American, born 1949
Pigeon Flock with Rats, page 179

Idaho, Pennsylvania

DAVID SALLE, American, born 1952
Untitled, page 111

Massachusetts

JOHN SALT, British, born 1937
Untitled (Vogel living room drawn from memory), page 167

Ohio

ALAN SARET, American, born 1944
Untitled, page 147

California, Georgia, Illinois, New Jersey

DAVID SAWIN, American, born 1922
Formal Structure, page 142

New Hampshire

F. (FRANK) L. SCHRÖDER, American, born 1950
Automatic Pilot, page 137

Nevada

HANS JÜRGEN [H.A.] SCHULT, German, born 1939
Untitled, page 134

Nebraska

PETER SCHUYFF, Dutch, born 1958
Graham, page 163

Kansas, North Dakota

BARBARA SCHWARTZ, American, 1948 – 2006
Herodia, page 207

Hawaii, Kansas, Louisiana, Maine, Maryland, Minnesota, Missouri, New Jersey, New Mexico, New York, Vermont

JOEL SHAPIRO, American, born 1941
Model for Two Houses, page 183

Rhode Island

JUDITH SHEA, American, born 1948
Untitled, page 171

Alaska, New Jersey, North Dakota, Ohio, Oklahoma, Oregon

CINDY SHERMAN, American, born 1954
Untitled, page 122

Mississippi

ALAN SHIELDS, American, 1944 – 2005
Untitled, page 118

Minnesota, Pennsylvania, Rhode Island

YINKA SHONIBARE, British, born 1962
Doll House (Peter Norton Family Christmas Project), page 115

Michigan

LORNA SIMPSON, American, born 1960
III (Peter Norton Family Christmas Project), page 106

Maryland

TONY SMITH, American, 1912 – 1980
Untitled, page 214

Washington

KEITH SONNIER, American, born 1941
BA – O – BA III, page 87

Iowa

RICHARD STANKIEWICZ, American, 1922 – 1983
Untitled, page 30

Alabama

ROBERT STANLEY, American, 1932 – 1997
Crackerjack, page 62

Florida, South Carolina, South Dakota

PAT STEIR, American, born 1940
Little Paynes Gray Brushstroke on a Paynes Gray Background, page 75; *Red Cascade*, page 94

Delaware, Idaho, Kentucky, Massachusetts, Tennessee, Utah, Vermont, Virginia

GARY STEPHAN, American, born 1942
Untitled, page 119

Minnesota

MICHELLE STUART, American, born 1938
July, New Hampshire, page 143

New Hampshire